SCHINDLER BY MAK
PRESTEL MUSEUM GUIDE

Edited by Peter Noever

Catalogue editing: Kimberli Meyer
Catalogue co-editing:
Andrea Lenardin Madden
Editorial assistance: Roberta Woods,
Nadjeschda Morawec, Sabrina Handler
Copy editing: Sonja Illa-Paschen,
Beverley Blaschke
Graphic design: Perndl+Co
Production: Prestel Verlag

This publication is made possible in part
by the Federal Ministry of Education,
Science and Culture and Federal
Chancellery, Department for the Arts
of the Republic of Austria; The LaFetra
Family Foundation; and The Los
Angeles County Arts Commission

ISBN 3-7913-2837-9
Printed in Germany

Prestel Verlag

Königinstrasse 9
D-80539 Munich
Phone (+49-89) 381 70 90
Fax (+49-89) 381 70 935

4 Bloomsbury Place
London WC1A 2QA
Phone (+44-20) 7323-5004
Fax (+44-20) 7636-8004

175 Fifth Avenue
New York NY 10010
Phone (+1-212) 995-2720
Fax (+1-212) 995-2733

E-mail: info@prestel.de
www.prestel.com

Cover: Portrait of R. M. Schindler at
Ralph Walker Residence construction
site, ca. 1935

MAK
Stubenring 5
A-1010 Vienna, Austria
Phone (+43-1) 711 36-0
Fax (+43-1) 713 10 26
E-mail: office@MAK.at
www.MAK.at

**MAK Center for Art and Architecture,
Los Angeles**
Schindler House
835 North Kings Road
West Hollywood, CA 90069, USA
Phone (+1-323) 651 1510
Fax (+1-323) 651 2340
E-mail: office@MAKcenter.org
www.MAKcenter.com

Raising the Question

What happens when the mandate is "no mandate?" When a museum creates a laboratory for artists, designers and thinkers? When there is no *a priori* beyond exploration and innovation?

The MAK Center for Art and Architecture has been and still is propelled by these questions. Taking its Schindler House setting as inspiration and example, the MAK Center is a completely independent voice, as likely to surprise, impress or offend as Rudolph M. Schindler's radical architecture and bohemian lifestyle once did.

Neither a house museum nor a memorial, the MAK Center honors Schindler's achievement: by accepting his radicality as a challenge; by taking Schindler and his theories – which have only gained in importance – as a standard for challenging norms; by living the Schindler exemplar. Much as he explored, negated and interpenetrated boundaries – between indoors and out, openness and form, work, social relations and art – the MAK Center begins at the intersection of art and architecture and finds its way to … more.

More than a museum, the MAK Center is a think tank that operates out of two landmark houses and does not even stop at their physical borders but breaches all limits as it pursues its investigations with vitality, from the culture of the everyday to political and social agendas to exhibition and publication projects. More than solely art or architecture, the MAK Center works with artists who make architecture their material, architects who find their way to space through art, and creators who happily operate *In Between*. The MAK Center challenges artists and architects to think in new ways.

Adopting Schindler's stance of art *and* architecture and operating within his very lines, following his trajectories, the MAK Center offers a refuge. Here, creativity dominates every other exigency, and artists and architects are restored by the example of Schindler's singlemindedness, even as they are stimulated by programming that develops the dialogue between art and architecture. The MAK Center exhibits rewrite history, including of the forgotten Cuban Art Schools and *Yves Klein: Air Architecture*. With *The Last Stop West,* the MAK Center completed Martin Kippenberger's "Metro Net" series, fabricating a working subway ventilation shaft in the Schindler House garden.

The Schindler House has been reactivated as a print shop, earthquake shelter, sweat shop and fashion atelier. As the subject of artistic interventions, the house has been lit by Jorge Pardo and Felix Gonzales-Torres, wired for sound by Steve Roden, transformed by Coop Himmelb(l)au into a couturier's

runway. The Mackey roof and garages are used for exhibitions and performances, its walls and windows as projection screens for video and animation.

Beyond art and architecture, the MAK Center tests all cultural boundaries. *sound. at the Schindler House* is an important experimental music venue, and film screenings such as the Kenneth Anger retrospective and *Wild Walls* urbanism series fill the Kings Road lawns. *SHOWDOWN! at the Schindler House* asks artists, architects and fashion designers to push the envelope of wearable art. MAK Center talks, panels and publications attract prominent thinkers, curators, artists and architects including Mike Davis, Norman Klein, Lebbeus Woods, Okwui Enwezor, Catherine David, Tom Hayden, Leonard Stein, Jeff Wall and Anthony Vidler.

And beyond its dual Schindler loci, MAK Center projects infiltrate the city, occupying spaces as various as a yacht, warehouse, storefronts, billboards and the FM dial. Programs such as a Daniel Libeskind lecture move off-campus, and partnerships – including with USC, the American Cinematheque, the Norton Simon Museum – continue to broaden the MAK Center reach.

MAK Center operates on an international playing field. The MAK Schindler Initiative that spawned this historic connection is one of the most elegant and least speculative ways that Austria represents itself in the international community. Informed by an historic L.A./Austria axis, the residency program cross-fertilizes both via the experiences of young artists and architects. Enthusiastically embracing Los Angeles, the MAK Center residents explore the city in depth, bringing its body builders, homeless, suburbanites and ethnic communities, as well as its topographies and the built environment, into their projects, and ultimately, a spirit of L.A. back to Vienna.

Perhaps most importantly, in emulation of the best of R. M. Schindler, the MAK Center looks beyond today's reality. In *The Havana Project, Architecture Again* and *heaven's gift: CAT – Contemporary Art Tower,* top artists and architects applied design strategies to pressing moral and urban issues. And the recent *Schindler's Paradise: Architectural Resistance* invited a stunning array of architectural talent to design "protests" to a condominium development planned neighboring the Schindler House. The jury – which included Frank O. Gehry, Michael Asher and Richard Koshalek – singled out proposals by Zaha Hadid, Odile Decq and Peter Eisenman.

Having added many years to the history of the Schindler House, the MAK Center for Art and Architecture is still surprisingly light on its institutional feet, a mobile target, hard to pin down – evolving, changing, but ever probing. In 1995, we located the spirit of R. M. Schindler in the phrase, "The question is the question." Questing onward, we can feel confident of one thing: We need not be afraid of raising the ardent questions – and so we continue!

Peter Noever, C.E.O and Artistic Director, MAK Vienna

Mission Statement

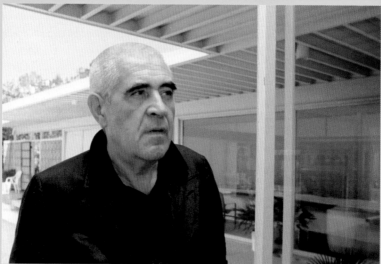

Peter Noever in the Case Study House #22 (Pierre Koenig, 1959)
Los Angeles, 2002.

The MAK is a center for ART. At the MAK, the ideas of the artist and the intentions of the work are given free rein. Often art is created on the premises; and if necessary, art is defended.

The MAK is a hub of emerging global communication. Thus, the MAK Center for Art and Architecture in Los Angeles[1] and the Artists and Architects in Residence program at the Mackey Apartments are central to an intense discourse on the interweaving of contemporary themes in art and architecture. With an extraordinary collection of applied and contemporary art, the MAK serves a dual purpose as a conservator of significant art objects and as a center for the scientific research of art with a special emphasis on its production, preservation, and reorientation. The MAK regards itself as a laboratory of artistic production and a research center of social awareness. The powerful ideas created here today will serve as models for tomorrow.

Founded in 1864 as the Imperial and Royal Austrian Museum of Art and Industry, the MAK has pursued a continued commitment to combining practice and theory, art and industry, production and reproduction. The School of Applied Arts, originally an outgrowth of the Museum, was later developed into an independent institution, known today as the University of Applied Arts.

When the Museum was restructured and remodelled in 1986, the Museum's original purpose was reconfirmed and radically expanded. The current MAK

identity was created and a fundamental agenda, bold and decentralized, was introduced. One of the significant elements of the restructuring included the exhibition design for the presentation of objects determined by the interventions of contemporary artists. The development of new display strategies for the permanent collections reorganized formal modes of presentation, allowing an unparalleled interplay of historicism and contemporary intervention. Artists involved with the re-presenting of historical artifacts have included Barbara Bloom, Eichinger oder Knechtl, Günther Förg, Gangart, Franz Graf, Jenny Holzer, Donald Judd, Peter Noever, Manfred Wakolbinger, Heimo Zobernig, Sepp Müller, Hermann Czech, and James Wines/SITE.

Another important priority of the MAK's programming is the commissioning of new works for public spaces both at home and abroad. Recent commissions include: Donald Judd's "Stage Set," Philip Johnson's "Wiener Trio," James Turrell's "the other horizon/Skyspace" and "MAKlite," Franz West's "Four Lemurheads" in Vienna, as well as Martin Kippenberger's "METRO-Net Ventilation Shaft" in Los Angeles.

Transforming a World War II antiaircraft tower in Vienna's Arenbergpark, the Contemporary Art Tower (CAT) will be an international center, showcasing important contemporary projects. Through its unique avant-garde architecture and pioneering program, this "monument of barbarism" will become Vienna's foremost venue for contemporary art.

Art functions both as an investment in, and a prophesy of, the future of society. A museum construct is the ultimate transmitter for communicating the ideas and products of individuals across generation and nationality. Through its connection to the past, a museum also serves as a projection screen and a producer of utopian potentiality, thereby articulating an alternative to the business model of the entertainment industry and its resulting lifestyle that seeks easy sensation and simulated experience.

The museum must continue to develop as a place of awareness, free of external influences, by advancing the discourse between the interplay of experience and perception. Since it navigates along the borders that separate art and awareness from innumerable forms of fashionable consumption, the museum's articulation of qualitative assessment makes it a central forum for resistance against the widespread loss of meaning pandemic in contemporary popular culture.

This is the unalterable position of the MAK.

Peter Noever
C.E.O. and Artistic Director, MAK Vienna

1 Schindler House, residence and studio of R. M. Schindler and Clyde Chase (1921–22), 835 North Kings Road, West Hollywood, and Mackey Apartments (R. M. Schindler 1939), 1137 South Cochran Avenue, Los Angeles.

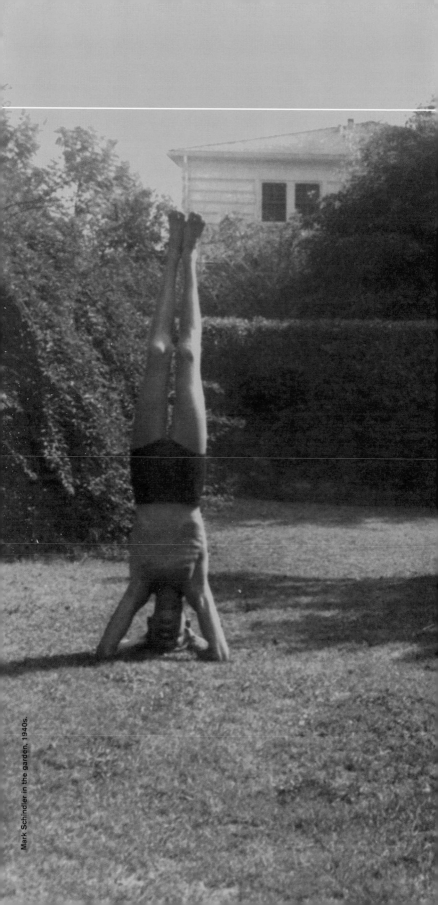

Mark Schindler in the garden, 1940s.

THE SPIRIT OF SCHINDLER'S KINGS ROAD HOUSE

TIMELINE 1921–1994

Kings Road House (Schindler House), mid 1920s.

The 1920s

Between 1915 and 1917, Albert M. Stephens, a pioneer southern California land developer, and a partner, Walter Luther Dodge, acquired significant interest in a tract of land in unincorporated Los Angeles County sandwiched between Hollywood and Beverly Hills at the foot of the Santa Monica Mountains. Most of the land was subsequently sold for residential development, though Stephens' son Raymond retained nearly two acres and built a substantial house for himself. More importantly, Dodge also built for himself, hiring Irving Gill to design a house that would become an icon of early modern architecture and a lightening rod of the historic preservation movement.

When the Schindlers arrived in Los Angeles in December 1920, they clearly intended to settle and immediately began looking for a building site for a house. Schindler's wife, Sophie Pauline Gibling, recorded their initial impressions: they wanted to live in Pasadena, the "L.A. equivalent to Lake Forest," and they didn't like Hollywood, except for "the little canyons." A few days later they had decided to build on a slope overlooking mountains, perhaps by spring. In January, Pauline noted that there were many sites to choose from and that they had found "perfect spots." No real decision was made, however, until November 1921 when they had decided, "for reasons of professional advertising, etc. it will be best to buy and build in the region of most rapid immediate growth,- which means Hollywood." They purchased a lot on Kings Road, a block south of the Dodge House and immediately across from Raymond Stevens' property.

The choice and timing were based partly on Schindler's realization of the need to establish himself professionally, that his "period of study and work for others shall have to end." There also was the impetus of the recent arrival of Pauline's college friend Marian Chace and her husband Clyde; by November the two couples had decided to build together. Writing to her father, Pauline described "one architectural unit ... a studio for them, and one for ourselves, with certain utilities in common, and ... also a third studio, to be rented out ..." The details were being "worked out ... in our many ardent conferences together."

Irving Gill, Dodge House, Kings Road, 1916.

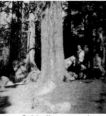

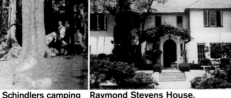

Schindlers camping in Yosemite, 1921.

Raymond Stevens House, Kings Road.

Kings Road House, 1922.

1920
December 3	Schindlers arrived in Los Angeles from Chicago
December/January	Schindlers looking for building site

1921
March 21	Schindlers living at 1719 Kane [now Clinton] Street
July	First mention of intention to build cooperatively with Clyde and Marian Chace; Chaces arrived in Los Angeles
September – October	Schindlers in Yosemite
November	Schindlers and Chaces purchased building site on Kings Road for $2,750
Ca. November	Kings Road House, scheme 1
November	Kings Road House, scheme 2
December	Kings Road House, scheme 3

1922
January	Title and deed to property
February	Schindlers and Chaces signed cooperative agreement
Late February	Excavation underway
March	Casting of walls and floors
April 24	Roof structure complete
May 10	Chaces moved into guest studio
May 17	Anne Harriet Chace born
May 22	Schindlers moved into Kings Road
June 6	Completion notice; Addition of south sleeping basket
June 8	General grading, including sunken gardens, complete
July 9	Edward Weston visited Kings Road
July 20	Mark Schindler born
August 13	Frank Lloyd Wright visited Kings Road
November 16	Lloyd Wright visited Kings Road

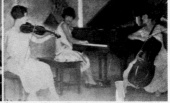

Thanksgiving dinner, Kings Road, 1924. Concert, Kings Road.

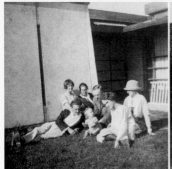

R. M. Schindler, Mark Schindler and
Pauline Schindler with Pauline's
family in the background.

Frank, Dione and Richard
Neutra, Kings Road.

Dione Neutra and Doris
Niedermann-Guinburger,
Kings Road, 1926–28.

The house was designed in November/December 1921. There were three distinct – though evolutionary – schemes. Construction began in February 1922; a certificate of completion was issued on June 6. Assessing the result, Schindler commented: "We had some lessons concerning our new system of construction. Architecturally I am satisfied – my fate is settled – one way or the other – of course it will take a couple of years, until the planting will furnish the proper and indispensable setting." The house quickly became a salon; Pauline's father and sister commented on the Schindlers' habit of "having much company & staying up till all hours."

Clyde and Marian Chace left Kings Road in the summer of 1924. Among the many tenants who followed, none occupy a more prominent position in history than Richard Neutra and his wife Dione. And never was there a period of greater architectural ferment at Kings Road than the period of their occupancy. Working alone and together, Schindler and Neutra designed the seminal Lovell Houses, a project for the League of Nations, and the Jardinette Apartments, the earliest example of contemporary European exploration – the International Style – in the United States. Here was the seedbed of the iconoclastic southern California modernism so celebrated today.

The exhilaration of achievement was offset by personal hardship, especially the rapidly deteriorating relationship between the Schindlers. Pauline left Kings Road in August 1927 and began a decade of gypsy existence, wandering up and down the California coast. Schindler remained behind and, for a while at least, architectural and social activity continued unabated. John Bovingdon, a sometime resident of Kings Road, danced in the garden, clad in a loincloth; Dione Neutra recorded her spirited impressions. And Sadakichi Hartmann, a cultural zealot of German and Japanese descent, performed several times in the late twenties and early thirties, reading poetry and impersonating historic figures.

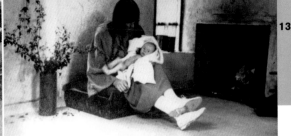

Chace courtyard,
from roof, 1920s.

Marian and Anne Harriet Chace next to fireplace, 1922.

1924

April 5 Thomas Duncan Chace born

July 26 Agreement between Schindlers and Chaces
terminated;
Chaces moved to Florida;
North sleeping basket under construction

August 1 – late Arthur and Ruth Rankin occupied Chace apartment
December 1925

Thanksgiving Dinner in Schindler patio

1925

January 9 George O'Hara living in guest studio

March 18 Richard, Dione and Frank Neutra living
in guest studio

October 24 Maurice Browne lectured at Kings Road

December 21 Christmas carol evening

December 29 Richard, Dione and Frank Neutra living in
Chace apartment;
Arthur and Ruth Rankin living in guest studio

1926

October John Bovingdon living in guest studio

October 8 Dion Neutra born

1927

June Galka Scheyer, Greta Greenbaum and Ernest
Greenbaum living in guest studio

August SPG [Sophie Pauline Gibling] left RMS [Rudolph M.
Schindler] and Kings Road, taking Mark

1928

January 8 Sadakichi Hartmann entertained at Kings Road
("A Poe Evening")

June 9 John Bovingdon and Jeanya Marling danced at
Kings Road

December 8 Sadakichi Hartmann entertained at Kings Road

1929

March 31 Sadakichi Hartmann entertained at Kings Road
("A Walt Whitman Evening")

Kings Road House (Schindler House), view from the neighboring lot (north), 1930s.

The 1930s

Richard and Dione Neutra left Kings Road in May 1930. John Bovingdon took their apartment for a few months, then Galka Scheyer, indefatigable pamphleteer of the Blue Four painters who had lived in the guest studio in 1927, returned in 1931. She was photographed there, sitting below a Diego Rivera painting she had recently purchased from the artist in Mexico. Others who passed through were an impecunious John Cage; Dudley Nichols, an upstart Hollywood screenwriter who later became prominent both for his writing and his left-wing politics; a communist lawyer and, intermittently, Pauline Schindler herself. She had, since the earliest days at Kings Road, participated in numerous radical causes; in the mid-thirties the house again became an occasional stage for her activities. Among these were a "tea" given in September 1936 by the women's committee of the League against War and Fascism [identified later as a Communist Front organization]. The following Saturday evening the editor of a "left-wing publication in New York" came for a group discussion of the situation in Spain. Pauline commented, "This is the third large party to be held here this summer. The house is perfect for such discussion, there is a very interesting group which gathers, and in these times it is good to have such a center available." She used the house again in December 1936 for a meeting of another communist front, the Regional Council of the Western Writers' Congress, organized by Carey McWilliams.

Increasingly, however, the thirties were years of extreme financial hardship at Kings Road. The house and garden were not maintained; the roof leaked badly, and in October 1935 a fire significantly damaged the kitchen and guest studio. In 1938 Pauline mentioned that Schindler himself was living elsewhere. Erskine Caldwell's tobacco road comes to mind.

Announcement flyer for
Sadakichi Hartmann's lecture
at the Kings Road House.

Galka Scheyer, Kings Road, after November 1931.

1930
February 1 Sadakichi Hartmann entertained at Kings Road
May Neutra family left Kings Road;
Hans Thorston living in guest studio
June John Bovingdon living in Chace apartment;
Danced in garden 6/6; 6/13; 6/20; 6/27

1931
Philip Johnson visited Kings Road
March Galka Scheyer moved into Chace apartment, sharing
it briefly with John Bovingdon

1932
Ca. March Guest studio painted

1933
January Mr. and Mrs. Dudley Nichols living in
Chace apartment;
Mary MacLaran living in guest studio
Ca. July Kitchen painted

1934
January 5 John Cage and Don St. Paul living in Chace apartment
January 10 Betty Kopelanoff moved into Chace apartment
April 11 Percy and Sonia Solotoy living in Chace apartment

1935
October Fire in kitchen, guest studio also damaged

1937
June – August 30 SPG and Mark lived in Chace apartment
September Tea: Women's Committee, League against War
and Fascism
December 6 Meeting of Regional Council of the Western
Writers' Congress

1938
Ca. June Chace basket (by then enclosed and serving as
Mark's room) painted French grey;
concrete floors painted

1939
June 6 Dodge House passed to Los Angeles High School
District

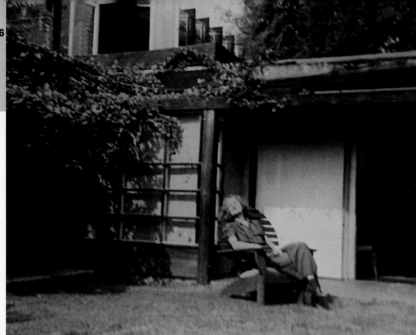

Pauline Schindler in the Chace courtyard, 1940s.

The 1940s

A lthough Pauline Schindler was in residence intermittently, the Chace apartment at Kings Road remained primarily a rental unit until 1949 when she returned permanently. She stayed with her father in Westwood after her mother's death in 1943 and was with him in his final months in 1948/49. In her absences there were once again colorful tenants at Kings Road chosen, no doubt, for their political inclinations. Edward Mosk, a left-wing attorney, and his wife Fern rented the apartment for several months in 1941. Anna Louise Strong, an American journalist who chronicled developments in Russia and Communist China, was a houseguest for two months in 1942 while she collaborated on a film about the Soviet Union. Barbara Chevalier, wife of Haakon, who is widely linked with speculation about Robert Oppenheimer's communist activities, used the apartment in 1943; Katherine Dunham, a distinguished black dancer, stayed in 1947 and Maurice Browne, founder of the Chicago Little Theater who visited Kings Road in 1925, returned for two months in 1949. For comic relief, few tenants could match Samson De Brier, a self-described Hollywood historian, who rented the guest studio during the war years.

Pauline began seriously altering Schindler's concept for the Kings Road House in 1932 when she had the guest studio painted. She painted the kitchen in 1933, and the Chace sleeping basket, by then enclosed, in 1938. In 1940 she began in earnest in the Chace apartment, painting the walls and floors and adding cabinetry; this work continued the rest of her life.

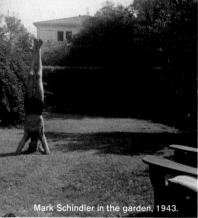

Mark Schindler in the garden, 1943.

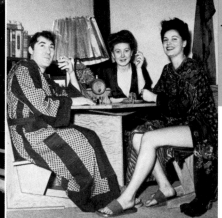

Samson De Brier, Virginia Blakeley and
Peggy Maurey, Kings Road guest studio, ca. 1944.

Pauline Schindler and Edmund Gibling,
Kings Road, ca. 1943.

1940	Chace apartment painted
1941	
May 12	Edward and Fern Mosk living in Chace apartment
1943	Samson De Brier living in guest studio
August	Barbara Chevalier rented part of Chace apartment
1944	
August	SPG living in Chace apartment
1945	
March 18	Guest studio painted
1946	
February 17	Mark and Mary Schindler moved into guest studio and stayed until March 1, 1954
1947	Katherine Dunham stayed three months at Kings Road
October	SPG began five-month stay with father in Westwood
1949	
January	Maurice Browne stayed at Kings Road
Mid March	SPG returned permanently to Kings Road

Kings Road House (Schindler House), front patio and the Chaces' rooms, 1953.

The 1950s

Schindler's death on August 22, 1953 was the seminal event in the history of the Kings Road House (Schindler House). It had been his architectural laboratory for virtually all his Los Angeles career. In addition to Richard Neutra, Gregory Ain, Harwell Hamilton Harris and the journalist Esther McCoy had worked there with him on some 450 projects, of which approximately one-fourth were built. After Pauline's departure in 1927 Schindler took her studio for his office and his original studio became his living space.

By 1953 Schindler and Pauline were completely estranged. She, nonetheless, at the end – and in innate thoroughbred fashion – wrote Schindler a remarkable note of appreciation, thanking him for the Kings Road House and the life it had made possible. Pauline remained in the Chace apartment for the rest of her life. Reciprocally, the apartment she had once shared with Schindler became a rental unit. It too was gradually compromised with paint, floor coverings and the residue of many tenants passing through. Activities at Kings Road resumed their old momentum in the fifties, though the focus was overtly political. Pauline used the house as headquarters for *Our Town*, "a liberal progressive calendar of events," she launched in April 1950. Any question about its point of view is dispelled by an advertisement for the Southern California Labor School. Also at Kings Road in the fifties, Pauline initiated a series of "Discussions in a Garden," inviting speakers to comment on current social issues.

Over the years, the lifestyle at Kings Road was increasingly affected by unwelcome zoning modifications. The seeds of change can be traced to the early 1950s. In April 1951, Schindler and Pauline attended a meeting of the Kings Road Neighborhood Association to discuss the recent abandonment of setback restrictions. Several houses of lesser setback had been constructed on property at the northwest corner of Kings and Santa Monica Boulevard, formerly owned by the Los Angeles Board of Education and subsequently sold in narrow lots. There also was a proposal for construction of a fifteen-unit apartment house, an even greater threat to the "spacious and parklike [sic] beauty of the street." Truly devastating development, however, was forestalled until the 1960s.

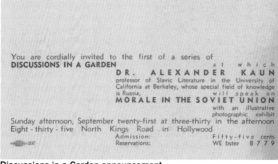

R. M. Schindler in the Schindler courtyard.

You are cordially invited to the first of a series of **DISCUSSIONS IN A GARDEN** at which **DR. ALEXANDER KAUN** professor of Slavic Literature in the University of California at Berkeley, whose special field of knowledge is Russia, will speak on **MORALE IN THE SOVIET UNION** with an illustrative photographic exhibit Sunday afternoon, September twenty-first at three-thirty in the afternoon Eight - thirty - five North Kings Road in Hollywood. Admission: Fifty-five cents Reservations: WE bster 8 7 7 9

Discussions in a Garden announcement, designed by Pauline Schindler, 1950s.

1950

April	SPG launched *Our Town*
April 16	RMS and SPG attended neighborhood meeting concerning preservation of setback restrictions on Kings Road
September 21	Petition for permanent restrictions on Kings Road

1952

January 17	RMS ill, in hospital for several weeks
October 2	SPG wrote to Anson Ford, Board of County Supervisors, opposing construction of multi-unit apartment on lot owned by Arthur J. Lubin at 850 Kings Road

1953

August 22	RMS died

1954

April	Guest studio painted

1955

April 17	Aldous Huxley living at 740 North Kings Road

1956

April	South studio painted

1957

May 22	RMS studio: tile laid over concrete floor
October	Chace entry: cabinet unit installed

1958

August 21	Kitchen: floor tiled

1959

September 16	SPG wrote to Regional Planning Board, opposing re-zoning of Kings Road from R-1 to R-4

Kings Road House (Schindler House) entrance.

The 1960s

No act of God has worked to the greater detriment of the Kings Road House (Schindler House) than the transformation of Kings Road from a street of substantial houses to a corridor of four-story condominiums; redevelopment continues today. Although there was some momentum for change in the early 1950s, substantial redevelopment became a reality in 1964 with the passage of an ordinance rezoning Kings Road from R-1 (single family) to R-4 (multiple residence). No one fought the change harder than Pauline Schindler; ironically, the first new buildings were constructed immediately across from her house in 1965. In September that same year there was a proposal for a link connecting the San Diego Freeway and Ardmore Avenue that would have bisected Kings Road at the southeast corner of the Schindler property.

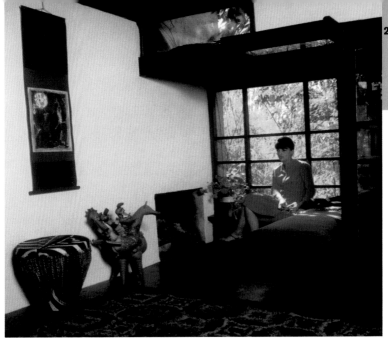

Beata Inaya in the guest apartment, 1970s.

1960
January	Marian Chace studio painted
January 13	Scott Nearing and guests at Kings Road
February 6	Clarence Stein at Kings Road
March 17–20	Holland Roberts stayed at Kings Road

1961
March	Guest studio painted

1963
March – July	Bathroom added to Chace sleeping basket
October	Letter to County Board of Supervisors re: Kings Road
November	Kings Road re-zoned for multi-unit housing

1964
Ca. February 15	Bernard and Dora Judge moved into guest studio

1965
August 29	Kings Road garden party in honor of delegates to World Peace Conference in Helsinki
September 16	Proposal for link between San Diego Freeway and Ardmore Avenue, bisecting Kings Road

1966
	Los Angeles Board of Education sold Dodge House to Lytton Savings and Loan Association

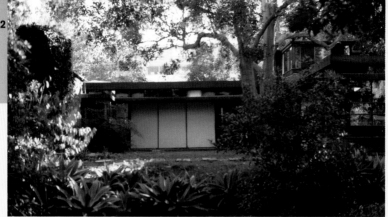

Kings Road House (Schindler House), back yard, 1970s.

The 1970s

One of the greatest losses in the history of early modern architecture occurred in 1970 with the demolition of Irving Gill's Dodge House at 950 North Kings Road. This event coupled with advancing age and diminishing financial resources led Pauline to explore means of securing the future of the Kings Road House (Schindler House). Although her many cosmetic modifications demonstrated an inability or unwillingness to live in it as it was designed, she understood its significance. She first turned to David Gebhard, keeper of the Schindler papers that Mark had deposited at the University of California, Santa Barbara, in the 1960s. Pauline's initiative gained focus in 1975 when Harriett Gold, Director of Special Projects, UCLA School of Architecture, stepped in. The next year, Peter Benzian of the law firm Latham & Watkins, working through Advocates for the Arts, a UCLA support group, agreed to donate 100 hours of service to the project. With the filing of its articles of incorporation with the State of California in September 1976, Friends of the Schindler House (FOSH) came into being as a nonprofit organization with the mission of acquiring and maintaining the house and administering it as a center for architectural activities.

Kathryn Smith, who had lived in the enclosed Schindler sleeping basket since May 1975, and has since distinguished herself as an architectural historian, assumed much of the administrative responsibility for the new organization.

Sophie Pauline Gibling Schindler died in May 1977. She left in place a fledgling organization with serious challenges to be addressed. To her enormous credit, the Schindler House is standing. The Dodge House is not.

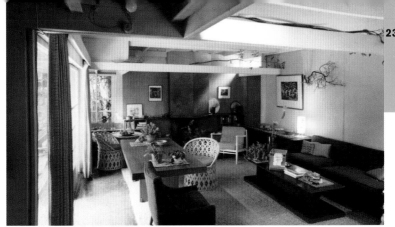

Marian Chace studio, ca. 1970.

Demolition of Irving Gill's Dodge House,
Kings Road, 1970.

1970

February 9	Dodge House demolished
	SPG formed committee to plan for future of Kings Road House

1976

September 24	Friends of the Schindler House (FOSH) incorporated

1977

May 4	SPG died
June 8	Paul Goldberger New York Times article
December 1	FOSH acquired tax-exempt status

1978

June 25	Fundraising garden party at Kings Road
November	FOSH received $50,000 grant from California Office of Historic Preservation

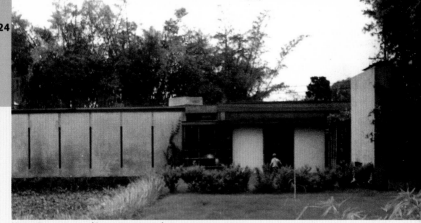

Kings Road House (Schindler House), front garden, 1980s.

The 1980s

In early 1980, as the Friends of the Schindler House (FOSH) was about to exercise its option to purchase the house on an installment basis, it learned that it would receive a total of $160,000 from the state, an amount the Schindler family was willing to accept as the full purchase price. The acquisition was modified to arrange for a full cash payment to the Schindler family for the house instead of the installment agreement that originally had been contemplated. The sale was consummated in June 1980 and the final details were resolved in December.

The house was then fifty-eight years old, and although basically intact structurally, it had suffered the ravages of time, lack of maintenance and insensitive alteration. Even so, the board of directors soon inaugurated a program of exhibitions; the first – and arguably most beautiful – was a presentation of Schindler's own drawings. This was followed by exhibitions of both historical and current topics; a total of fourteen exhibitions were presented between 1981 and the early 1990s.

When FOSH acquired the Kings Road House from the Schindler family in late 1980, it assumed the burden of restoration of a moldering icon and implementation of Pauline Schindler's desire that the house become a center for architectural education. Work proceeded more or less simultaneously on both fronts, though with extremely limited financial resources. Several weekend volunteer restoration parties were organized to remove various accretions left behind by Pauline and to make the Chace apartment more suitable for exhibitions.

In 1986, the new West Hollywood City Council approved a $50,000 allocation for a new roof for the Kings Road House. Work continued between March and October 1987. At the same time, the paint was removed from the concrete walls. This was the largest single restoration project ever undertaken at Kings Road.

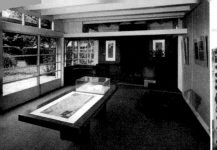

Exhibition: "R. M. Schindler Drawings, 1914–1950," January 1982.

Volunteer work party, Kings Road, August 15, 1982.

Exhibition: "Plywood Furniture: A Historic View," 1983.

Exhibition: "MOCA Builds," 1982.

1980	FOSH acquired Kings Road House from Schindler family with funding from California Office of Historic Preservation
1981	
October 24	Exhibition: "R. M. Schindler Drawings, 1914–1950"
1982	
March 19 – June 20	Exhibition: "San Juan Capistrano Public Library Competition"
July 9	Exhibition: "Juan O'Gorman"
August 15	Volunteer work party: removal of paneling, bookshelves and chimney tile in Marian Chace studio; demolition of paving in Chace patio
October 22	Exhibition: "MOCA Builds"
1983	
April 22 – July 17	Exhibition: "R. M. Schindler: Modern Architecture as Local Culture"
	West garden partially restored
November 18	Exhibition: "Plywood Furniture: A Historic View"
1984	
March 23 – June 24	Exhibition: "Jock Peters: Germany and California, 1887–1934"
1985	
June 14 – September 15	Exhibition: "John Lautner: Nine Concrete Houses"
October 14	Exhibition: "David Hertz Concrete Furniture"

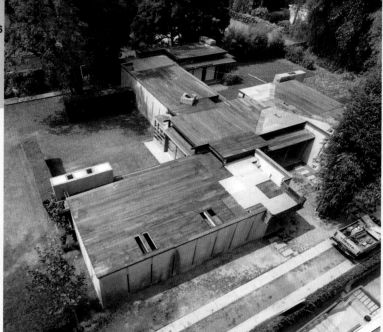

Roof during restoration, 1987.

Front garden restoration, June 1989.

Schindler's 100th birthday would have been on September 10, 1987. To honor the occasion, Kathryn Smith organized the Schindler Centennial, a dinner at the Schindler House. Hans Hollein came from Vienna as keynote speaker; Frank O. Gehry, Arata Isozaki and Dione Neutra were in the audience, and Wolfgang Puck catered the event, which was attended by some 250 guests.

A grant from the State of California enabled FOSH to underpin the listing chimneys in the Schindler and Chace patios in 1989. This work was followed by complete restoration of the front garden, giving the house, for the first time since the 1920s, in Schindler's words, its "proper and indispensable setting."

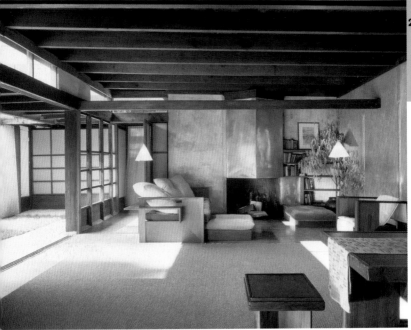

Pauline's room, 1987.

Frank O. Gehry, Arata Isozaki and Moshe
Safdie, Schindler Centennial, October 10, 1987.

1986

January 10	Exhibition: "Thrive: Works of Innovation in Architecture"
January 23	West Hollywood City Council approved funding for new roof and related work at Kings Road House
March 19 – May 18	Exhibition: "Cesar Pelli: Current Work"

1987

	All paint removed from concrete walls
Early October	Roof work complete
October 10	Schindler Centennial celebration; Exhibition: "Schindler House: Design and History"; City of West Hollywood Proclamation: R. M. Schindler Centennial Day

1988

August – January	Sliding canvas panels restored by Robert Nicolais

1989

August	Chimneys underpinned with funding from California Department of Parks and Recreation

Kings Road House (Schindler House), front garden after restoration, ca. 1995.

The 1990s

In July 1992, representatives of the MAK – Austrian Museum of Applied Arts / Contemporary Art, Vienna, approached the Friends of the Schindler House (FOSH) with a proposal for establishing a MAK outpost in Los Angeles at the Schindler House. FOSH would retain ownership of the property; MAK would assume full programming and financial responsibility. A second component of the proposal was the creation of a residency program in which young artists/architects would be selected in competition to come to Los Angeles for six months' study; Schindler's Mackey Apartments were to be acquired as their residence.

Negotiations continued for two years and focused both on lively programming possibilities and the drier legal implications of a contract between an American non-profit organization and a foreign government. The agreement was signed on August 17, 1994, creating the MAK Center at the Schindler House. Since 1996, the MAK Center has presented more than twenty exhibitions focusing on interfaces of art and architecture. Catalogues accompanied many of the exhibitions and there were numerous corollary public presentations as well. Concerts in the garden, recalling the Schindlers' own use of the Kings Road house, have been among the most popular programs. These activities continue today.

Robert Sweeney, President, Friends of the Schindler House

Robert Sweeney, Harriett Gold and Peter Noever, signing of cooperation agreement between Friends of the Schindler House (FOSH) and the Republic of Austria, August 10, 1994.

1991

April 6 – July 7 Exhibition: "Wright in Hollywood"

1992

July 27/28 First meeting between FOSH and MAK Vienna representatives

August 13 Offer from MAK for long-term "cooperation" between FOSH and MAK

1993

April 28–30 Continued discussion with MAK, in Vienna

1994

August 17 Cooperation Agreement between FOSH and the Republic of Austria creating the MAK Center for Art and Architecture at the Schindler House

Jochen Traar: "Art protects you", Los Angeles Freeways, March 20, 1996

SCHINDLER AND THE MAK CENTER

TIMELINE 1994 – NOW

The MAK Center for Art and Architecture

Testing limits, stirring up space, throwing questions into play: these are the ways of the MAK Center. Responding to the multiple challenges posed by R. M. Schindler, the MAK Center activates and explores the dynamics of art, architecture and social space.

Schindler has raised the bar very high; in both architecture and life, he was rigorous in the pursuit of his ideas. He experimented relentlessly, from radical beginnings at the Kings Road House, through the translucent houses still vital today. Schindler expanded the ways we think about walls, openings, and location; he re-examined light as a time-based mediator of space; he invited us to rethink social traditions through the combination of architecture and cultural discourse. He was architect, artist, intellectual: truly muliti-disciplinary in his concerns and practices.

For cultural ideas to grow, a hospitable climate must be cultivated and maintained. The MAK Center is a contemporary, experimental, multi-disciplinary center for art and architecture. It operates from the Schindler House and from the Mackey Apartments, offers a full scope of exhibitions, lectures, performances and publications, and hosts an international residency program for visiting artists and architects.

A magnet for creative energy, the MAK Center beckons to those who consider the exploration of space to be a multi-avenue proposition. Conceived as a think-tank, the MAK Center's role is not only to present finalized projects, but to generate critical thinking and problem-solving. The consideration of culturally important sites, such as the property next door to the Schindler House, have become opportunities for theoretical intervention and public discussion. The MAK Center has forged strong relations with practicing artists and architects and remains committed to generating new collaborations. This approach has yielded a rich variety of programs.

An emphasis has been placed on the production of new and site-specific projects that engage both contemporary thought and the ideas of Schindler's architecture. When the MAK Center presents historic programs, it does so in a way that resonates with current experimental trends in art, theory and design. Open-air events have activated the courtyards so integral to Schindler's indoor/outdoor floor plan. Concerts have drawn experimental

music lovers to enjoy the acoustics of the interlocking spaces of the house and garden. Screenings on the front lawn, always a magical evening, have offered a range of avant-garde and educational films under the stars. The MAK Center's talks have brought together curators, critics, architects and artists to discuss current concepts in art and architecture. Its publications have not only documented exhibitions, but have presented scholarly essays and material new to English speakers. The MAK architecture tours have brought understanding and appreciation of architecture to a public hungry for real-time-and-space knowledge of important buildings. The artists and architects in residence have activated not only the Schindler House, but the Mackey Apartments in which they live, work, and often exhibit. Collectively, the residents have had a lively impact on the local art and architecture scene, introducing a distinctly international perspective of Los Angeles.

At the MAK Center, architecture and art cross disciplinary axes on a daily basis. Visitors come to see one thing and may find something they didn't expect. A group of architecture tourists may unintentionally be introduced to contemporary art, while a student attending the opening of an exhibition organized by the MAK Center residents may be exposed to Schindler's architecture for the first time. Such cross-disciplinary connections are part of what makes the MAK Center unique and important in Los Angeles.

The MAK Center's programming proves that historically significant architecture stays alive when it is engaged by a constant flow of participation. The Schindler House in particular was designed to be in play; it thrives on complex exchanges between space, life, and thought. Challenged by Schindler's high standard of enquiry, experimentation, analysis, and enquiry again, the MAK Center faces unlimited possibilities for intellectual and artistic exploration. We are stimulated, exhilarated and honored by the task of keeping Schindler's work in motion.

Programs of the MAK Center
for Art and Architecture

Final Projects
March 18–24, 1996

An exhibition of works by the MAK Center Artists and Architects in Residence at the Schindler House. Swetlana Heger and Plamen Dejanov developed a virtual apartment installed in various locations around L.A.; Andrea Kocevar transformed sites in Los Angeles into performance spaces; Flora Neuwirth explored new systems for living; Jochen Traar staged an "in-motion" event in traffic.

The Havana Project, Architecture Again
April – June 1996

Exhibition with Coop Himmelb(l)au, Eric Owen Moss, Morphosis/Thom Mayne, Carme Pinós, Lebbeus Woods and C.P.P.N. Based on a conference held by the MAK and the MAK Center in the winter of 1994/95 and attended by Coop Himmelb(l)au, Eric Owen Moss, Morphosis/Thom Mayne, Carme Pinós, Lebbeus Woods and C.P.P.N. (Carl Pruscha, Peter Noever), this project concentrated on the need to define the role of architecture and to reveal the possibilities and social applications of constructed space. This was the first presentation of these architectural projects and the inaugural exhibition of the MAK Center for Art and Architecture.

The Garage Project
April 13 – July 14, 1996

An exhibition of four installations at the Mackey Garages by artists Paul McCarthy: *Diagnosis and Dissection*; Liz Larner: *The Century Plant*; Peter Kogler: *Schindler Discotheque*; Heimo Zobernig: *Untitled*.

The Garage Project, 1996.

Paul McCarthy, 1996.

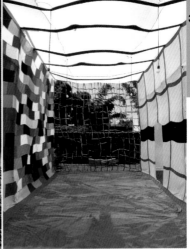

Kasper Kovitz, 1996. Gilbert Bretterbauer, 1996.

Final Projects

September 17–30, 1996

Gilbert Bretterbauer constructed his work, *The House*, on the front lawn of the Schindler House; Andrea Lenardin displayed *Instant Days*; Kasper Kovitz exhibited *God is a Butcher*; Marta Fuetterer interacted with Schindler's architecture. In two of the three rooms, the work of Los Angeles artists Liz Larner and Thomas Baldwin was presented for the duration of the exhibition.

Art in the Center

November 23, 1996

Panel discussion. The panel investigated the concept of the "center" in artistic, urban and philosophical contexts. Panelists included artists Mike Kelley, Jeff Wall, urban theorist Mike Davis, MAK Director Peter Noever, art historian Jean-François Chevrier. Moderated by curator Catherine David, artistic director of *documenta x*.

Final Projects: Open House/Open Studio

March 1997

At the Mackey Apartments Stefan Doesinger created a series of digital photographs that were "memory maps" of L.A.; Ulrike Müller created an installation in a garage; Judith-Karoline Mussel presented documentation of city cooler; Paul Petritsch and Johannes Porsch created an installation in a garage.

Silent and Violent – Selected Artists' Editions

April 1997

Exhibition at the Schindler House. In coordination with the Swiss Art Journal *Parkett*, this exhibition presented multiples by more than 60 internationally significant and controversial artists including Robert Gober, Meret Oppenheim, and Christian Boltanski.

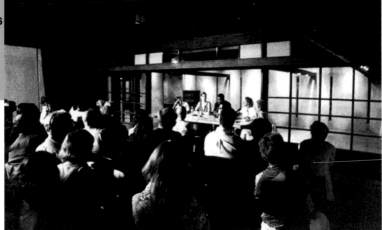

World Cup of Art – Missing the Goal? 1997.

World Cup of Art – Missing the Goal?

September 10, 1997

Panel discussion. Held on the occasion of the presentation of the MAK Vienna's and MAK Center's publication *Kunst im Abseits? Art in the Center* and moderated by MAK Center Director Carol McMichael Reese, it included panelists Okwui Enwezor, Artistic Director of the 1997 Johannesburg Biennale; Susan Kandel, art critic and U.S. editor of *art/text*; Christopher Knight, art critic of the L.A. Times; and Diana Thater, artist and participant in *Sculpture Projects in Münster 1997*. The panelists considered the impact of major exhibitions of contemporary art at the close of the 20th century and the prospects for their future.

Final Projects: Ich bin ein L>A<

September 13–28, 1997

Screening of an episodic movie by the MAK Center Artists and Architects in Residence in four parts at the Schindler House. Christine Gloggengiesser presented *Cat Walk;* G.R.A.M. presented *Ford Dreamlover 97*; Nicole Six screened short "infomercials" for her specially produced airbags.

Anarchitecture: Works by Gordon Matta-Clark

November 17, 1997 – January 18, 1998

Exhibition at the Schindler House. This exhibition illustrated works from the span of Gordon Matta-Clark's career (1971–78). It focused on his film-works, photoworks, and works on paper, and explored the relationship of the human body to natural and man-made environments.

Confessions
Roland Rainer

December 2, 1997

An informal slide presentation of the work of Vienna's internationally regarded architect and urban planner (born in 1910), who is one of Europe's most provocative designers committed to the creation of livable communities. Professor Rainer has been described as "the architectural conscience of Austria's political and cultural renewal."

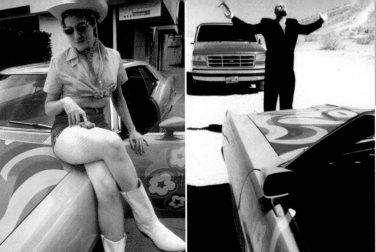

G.R.A.M., 1997. G.R.A.M., 1997.

Helena Huneke, 1997.

Twelve Projects by R. M. Schindler

February 1998

The premier of a recurring exhibition documenting 12 built projects by R. M. Schindler. Drawings and texts described a range of commercial and residential buildings from Schindler's career. Also on display were examples of furniture designed by Schindler for various houses including some of the original furniture designed for the King's Road House.

Final Projects: Befejezett Munka

March 13–29, 1998

Helena Huneke presented the installation *a Quiet. b Quilt. c Quit. d Quite*; Martin Liebscher presented a photographic installation titled *Intersection*; Isa Rosenberger showed her video *Good Luck*; Zsuzsa Schiller exhibited her black and white photographic work *Flashback*.

Martin Kippenberger, 1998.

Garage 98

Throughout the summer, 1998

A series of exhibitions at the Mackey Apartments curated by MAK Center Artist in Residence Marko Lulic, featuring works by Los Angeles-based and international artists.

Martin Kippenberger: The Last Stop West

July 9 – October 11, 1998

An exhibition of works related to the German artist's Metro Net series including the construction of the last un-built sculpture from this series – a subway ventilation shaft that emits gusts of air and the sounds of a train rushing by. The realization of this work in the front yard of the Schindler House completed the imaginary subway system suggested by the placement of the five Metro Net sculptures in odd corners of the world including the Greek Island of Syros, several sites in Germany, and Dawson City (Yukon, Canada).

Final Projects

September 19–26, 1998

At the Mackey Apartments Gerry Ammann presented a living sculpture called *L.A. ∞ Little Austria*; Constanze Ruhm showed the video and photography installation *There might be a place where one goes to feel better*; Marko Lulic

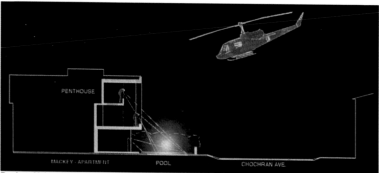

Rochus Kahr, 1998.

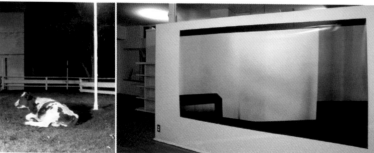

Gerry Ammann, 1998. Constanze Ruhm, 1998.

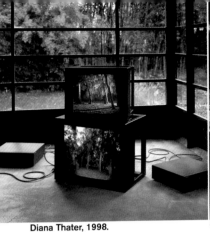

Diana Thater, 1998.

Opening night, Diana Thater, 1998.

presented recent paintings, drawings and documentary material on two projects, *GARAGE 98* and *Disco Wilhelm Reich;* Rochus Kahr presented two architectural proposals, *Skypool* and *Residential House Sailer.*

Touch Down in the Land of Superheroes, Illustrated Version

with a screening of the 1922 Buster Keaton silent film
"The Frozen North", October 9, 1998
Roberto Ohrt, art critic and curator, addressed the filmic aspects of Martin Kippenberger's Metro Net series – a metaphoric subway "system" fleshed out with "entrances," "exits," and "ventilators" in odd corners of the world, including at the MAK Center in West Hollywood. Stephen Prina, Los Angeles artist and professor, joined Roberto Ohrt in discussion.

The Best Animals are the Flat Animals – The Best Space is the Deep Space

October 28, 1998 – January 17, 1999
An exhibition of works by L.A.-based artist Diana Thater. The installation at the Schindler House included one video projection and several monitor pieces that transform the qualities of a flat time-based medium (video) into a three-dimensional spatial experience.

R. M. Schindler Residence Tour Preview and Book Signing

November 6, 1998
An informal discussion, book signing and reception at the Schindler House previewing two new books on the work of R. M. Schindler by Judith Sheine. The discussion featured Margaret Crawford, chair of history and theory program, SCI-ARC; Grant Mudford, artist and architectural photographer, Los Angeles; and Judith Sheine, architect and professor, Cal Poly, Pomona.

R. M. Schindler Residence Tour

November 7, 1998
A day-long tour of rarely seen Schindler-designed residential spaces including Falk Apartments, Grokowski House, Laurelwood Apartments, Roth House, Sachs Apartments and Yates Studio.

Architecture and Revolution, 1999: Peter Noever, Ricardo Porro, John Loomis, Vittorio Garatti, translator, Roberto Gottardi (from left).

Architecture and Revolution: Escuelas Nacionales de Arte en La Habana

March 10 – May 30, 1999

An exhibition of photographs and drawings featuring the long-forgotten architectural landmarks of the Cuban revolution, the Cuban National Art Schools (1961–1965). Curated by the MAK Center and co-sponsored by the Smithsonian's Cooper-Hewitt, National Design Museum and Columbia University, symposia were presented in Los Angeles and New York City with exhibitions running concurrently at the MAK Center and Avery Hall.

Related event:

March 8, 1999

Symposium featuring the three architects of the Cuban National Art Schools – Vittorio Garatti, Roberto Gottardi and Ricardo Porro. This event marked the first meeting of these three architects since the revolution. They were in discussion with John Loomis, author of "Revolution of Forms: Cuba's Forgotten Art Schools." The introduction was given by Al Nodal, Director of the Los Angeles Cultural Affairs Department.

Final Projects

March 19–21, 1999

At the Mackey Apartments, Åse Frid and Johan Frid created an installation of paintings and sculptures; Ali Janka and Tobias Urban, members of artistic collaborative team Gelatin, created a performative work, *The Human Elevator;* Anna Meyer performed *1:1 model L.A.;* Raw 'n Cooked, the partnership of architects Walter Kräutler and Carl Schläffer, constructed a concrete sculpture in the Mackey garden.

Ali Janka and Tobias Urban, Gelatin, 1999.

Micro Space/Global Time, 1999: Greg Lynn, Vito Acconci, Eric Owen Moss (from left).

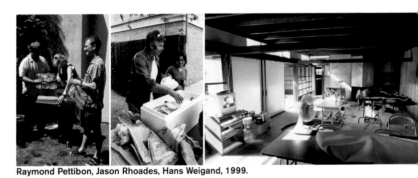

Raymond Pettibon, Jason Rhoades, Hans Weigand, 1999.

Micro Space/Global Time: An Architectural Manifesto
June 2 – July 11, 1999
An exhibition and limited edition portfolio of fine art digital prints by internationally-acclaimed artists and architects including: Vito Acconci, Neil Denari, Hodgetts & Fung, Greg Lynn, Thom Mayne/Morphosis, Eric Owen Moss, Wolf D. Prix, Helmut Swiczinsky/Coop Himmelb(l)au, Andrea Zittel with Jonathan Williams. Presented by the MAK Center for Art and Architecture, L.A. and Muse [x] Editions.

Related event:
June 1, 1999
A symposium featuring the *Micro Space/Global Time* artists and architects discussing the effects of the digital revolution on architectural space. The symposium was moderated by Peter Lunefeld, faculty member of the Media Arts Department at the Art Center College of Design. In discussion were Vito Acconci, Greg Lynn and Eric Owen Moss.

LIFE/BOAT
July 22 – September 26, 1999
Exhibition at the Schindler House. A collaboration among Jason Rhoades, Raymond Pettibon and Hans Weigand. Combining their interests in the banal, the imperfect and the act of reinterpreting the world around them, Pettibon, Rhoades and Weigand employed a 34-foot yacht named "Bust Loose" as the platform for their interactions. Their explorations in video, film and performative activities, as well as a limited-edition catalogue and *ASSAVER*, comprised the installation.

First Annual MAK DAY at the Schindler House
September 18, 1999
Tours, presentations and activities throughout the day including: *MAK Talks* by Michael Darling, curator at MOCA (Museum of Contemporary Art, L.A.) and Judith Sheine, architect and author of numerous publications on the work of R. M. Schindler; an *Art-Tour* with Jason Rhoades and Daniela Zyman, Director of the MAK Center; MINI MAK organized by architects Paul Lubowicki and Susan Lanier who conducted children's workshops on the design and construction of architectural models; and *Photo-Demo* by renowned architectural photographer Grant Mudford.

Final Projects: Some Things to Be Seen or Taking Place not Necessarily Related to Each Other
September 22–26, 1999
At the Mackey Apartments, Judith Ammann showed typographical studies, still lifes, photographic collages and a video; Mathias Poledna presented *Give, Get, Take and Have*, a publishing and research project. Michael Wallraff presented the installation *field. california. 1999;* Wolfgang Koelbl, in collaboration with Michael Wildmann, showed *supernatural (i never close),* a video projected onto the facade of the Mackey Apartments.

Numbers
October 13, 1999 – January 16, 2000
Exhibition at the Schindler House. German artist Beate Passow's work, *Numbers,* is the result of an intense human and artistic confrontation with the period of National Socialism and the phenomenon of Fascism. The exhibition consisted of large-scale color photographs, each showing a forearm tattooed with a concentration camp identification number.

Michael Wallraff, 1999.

The Girl Next Door

December 2, 1999

Slide lecture by artist Richard Prince. Richard Prince discussed his photographic work for an upcoming exhibition at the MAK Center.

Location Proposal #2

January 26 – February 20, 2000

An installation of photographs and projections by Los Angeles artist Cindy Bernard. Bernard's interest in how the perception of reality is coded by culture developed through her explorations of photography, film and memory, culminated in her project titled *Location Proposal*.

Space, climate, light, mood

February 16, 2000

Performance by Cindy Bernard, David Patton, Ron Russell and Gabie Strong, engineered by Joseph Hammer and Joe Potts at the Schindler House.
This indoor/outdoor installation of light and sound was held in conjunction with the exhibition, *Location Proposal #2.*

Recent Works by Daniel Libeskind

February 19, 2000

Lecture and slide presentation by Daniel Libeskind, architect of the Jewish Museum in Berlin. Presented by the MAK Center and held at the Pacific Design Center.

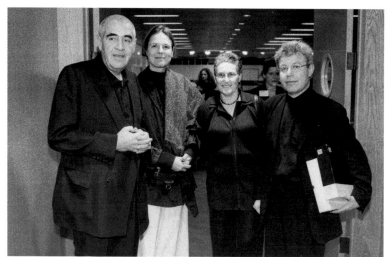

Recent Works by Daniel Libeskind: Peter Noever, Daniela Zyman, Nina and Daniel Libeskind (from left), 2000.

Richard Prince, 2000.

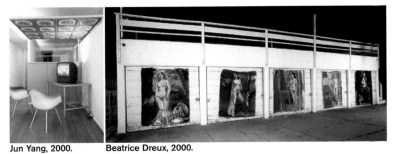

Jun Yang, 2000. Beatrice Dreux, 2000.

Upstate

March 1 – May 28, 2000

An exhibition drawn from a publication by Richard Prince, *4 x 4,* which assembled more than 150 images focusing on various icons of American culture (bikers, car culture, the American West / Marlboro Man, the Girlfriends) as well as pictures from everyday situations and objects from his home in up-state New York. Utilizing mundane objects such as cigarette advertisements, old jokes, dated cartoons, song lyrics and car parts, Prince presented the strangeness of our familiar world as he posed significant questions of meaning and authorship.

MAK Architecture Tour 2000

April 2, 2000

A day-long tour and fundraiser featuring the residential architecture of California Modernist masters, R. M. Schindler, Gregory Ain, Harwell Hamilton Harris, Raphael Soriano, Richard Neutra and John Lautner. Lectures throughout the day at the Schindler House featured Judith Sheine, Barbara Lamprecht, Frank Escher and Julius Shulman.

Final Projects: If I was in L.A.

April 14 – 16, 2000

At the Mackey Apartments Jun Yang presented the installation *coming home,* Beatrice Dreux exhibited large-scale portrait paintings, Sophie Esslinger showed two projects installed in her apartment: *pico boulevard* and *images,* and Franka Diehnelt and Karoline Streeruwitz presented two projects: *makes a living of dreaming* and *every bump, rise and stretch.*

Photography from Another Planet

April 30, 2000

Bruce Hainley, contributing editor of *Artforum* and frequent contributor to *Frieze,* discussed the work of Richard Prince and different genres of photography.

The Seductive Sixties, 2000.

American Pictures: Photographs by
Dennis Hopper, 2000.

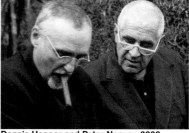

Dennis Hopper and Peter Noever, 2000.

American Pictures: Photographs by Dennis Hopper

June 2 – September 17, 2000

Exhibition at the Schindler House. Renowned actor, director and artist Dennis Hopper captured the cultural character of 1960s Los Angeles both inside and outside of Hollywood. His black and white paparazzi-style photographs document people and events such as the Civil Rights March in Louisiana, contemporary artists and the "backside" of movie sets. Hopper has directed and acted in numerous films and has exhibited his photographs and paintings at galleries and museums around the world. This exhibition focused on Hopper's role as a participant in and documentarian of the 1960s art scene, including images never previously displayed.

Related events:

The Seductive Sixties

June 2, 2000

Henry Hopkins, Professor of Art at the University of California Los Angeles (UCLA) recollects the 1960s art scene in L.A. with Dennis Hopper.

Special Outdoor Film Screening featuring films written and directed by Dennis Hopper

July 13–15, 2000

Three consecutive nights of outdoor film screenings at the Schindler House featuring *The Last Movie*, *Out of the Blue* and *Colors*.

sound. at the Schindler House

Summer, 2000

Concert series curated by Cindy Bernard
June 17: Kraig Grady/Orchestra of the Anaphoria Shadow Theatre, Voice of the Bowed Guitar
July 22: Solo Horns: Vinny Golia, Lynn Johnston, Sara Schoenbeck, Wadada Leo Smith
August 27: *Fake Party! Live Entertainment!* With Carla Bozulich and guests
September 29: Extended Organ and Solid Eye

From Beat to Pop: The Emerging Art Scene of Los Angeles in the Sixties
MAK DAY
September 16, 2000

A day-long event featuring free tours of the Schindler House and of the exhibition *American Pictures 1961–1967: Photographs by Dennis Hopper*, activities for children and complimentary refreshments. Lectures on 1960s art and culture by Peter Frank, Lewis MacAdams, David James and Steve Erickson.

Final Projects: Oxygen: Flipping through Frederick Kiesler
September 24 – October 15, 2000

The Mackey residents Birgitta Rottmann, Markus Schinwald and Meike Schmidt-Gleim conceived of a new approach to Frederick J. Kiesler's work that discusses his conditions for production, his life and his surroundings. The exhibition was a prelude to the MAK Center's exhibition, *Frederick J. Kiesler: Endless Space.*

Trans-Culture: Discussion by Eugenio Valdez Figueroa
October 7, 2000

In conjunction with "Final Projects" and the Los Angeles County Arts Commission Arts Open House, Eugenio Valdez, Havana-based curator of international exhibitions of contemporary art, presented a paper on transculturalism discussing how personal and cultural identity are impacted by the transference of cultural representation across international borders. Charles Merewether, curator at the Getty Research Institute, moderated the discussion, which was interpreted from Spanish to English by Carlos Hernandez.

A New City: The Architecture of Eric Owen Moss and the Urban Strategies of Samitaur Constructs for Culver City
October 29, 2000

A day-long guided architecture tour with exhibitions and presentations throughout the day featuring buildings designed by architect Eric Owen Moss for Samitaur Constructs, Culver City. Lectures were given by Eric Owen Moss, Frederick and Laurie Smith and Farida Fotouhi.

heaven's gift: CAT – Contemporary Art Tower
A New Programmatic Strategy for the Presentation of Contemporary Art
October 29, 2000 – February 4, 2001

This exhibition presented a project by Peter Noever/Sepp Müller/Michael Embacher, an architectural proposal to transform an enormous World War II anti-aircraft tower in Vienna into an international center for contemporary art. Presenting an architectural model, design sketches, and realization plans, the exhibition detailed the designers' ambitions for the space, includ-

ing proposed "interventions" by artists Jenny Holzer and James Turrell. Exhibition was presented at the Gateway Warehouse in the Hayden Tract, Culver City.

Related events:
Pierrot Lunaire
January 14, 2001
A performance of Arnold Schönberg's 1912 masterpiece, the song cycle *Pierrot Lunaire*, at the Conjunctive Points Complex in Culver City (Eric Owen Moss) and hosted by Samitaur Constructs. Conducted by Marc Lowenstein and performed by Jacqueline Bobak, soprano; David Shostac, flute; Gary Gray, clarinet; Connie Kupka, violin; David Speltz, cello; and Natalie Dalschaert, piano. The concert was followed by a panel discussion featuring the well-respected Schönberg expert Leonard Stein and Professor Michael Meyer, an authority on the fate of avant-garde musicians in Nazi Germany.

About Anne: A Diary in Dance
January 27, 2001
Helios Dance Theater presented a work in progress, *About Anne: A Diary in Dance*, based on the text of *Anne Frank: Diary of a Young Girl*.

Frederick J. Kiesler: Endless Space
December 6, 2000 – February 25, 2001
An exhibition featuring works by artist, architect and theatrical designer Frederick Kiesler (1890–1965). During his lifetime, Kiesler created visionary plans exploring themes of continuity, infinity, dynamism and correlation. His *Endless House* (1959) expressed his fascination for the unbounded quality of space through an organic continuum which continues to inspire the work of contemporary architects today.

Related event:
Frederick J. Kiesler Symposium
February 22, 2001
Symposium exploring the idea of "endlessness" as articulated in the work of Frederick Kiesler. Participants included Sylvia Lavin, Greg Lynn, Lebbeus Woods and Anthony Vidler. The symposium was planned in collaboration with the AIA (American Institute of Architects, L.A. chapter) and was held at the Los Angeles County Museum of Art, Bing Theatre.

Final Projects: RAIN
March 16–18, 2001
At an unoccupied storefront at 5410 Wilshire Boulevard in Los Angeles, Siggi Hofer presented the installation *Americans*; Susanne Jirkuff showed video work; Lisa Schmidt-Colinet and Alexander Schmoeger presented *subVERSION in L.A.*; Florian Zeyfang presented a video.

Jorge Pardo, 2001. Sam Durant, 2001.

February 16 – September 2, 2001
A two-part exhibition including:

This is my House
An installation of video works by international artists projected onto the surfaces of the Mackey Apartment Building. The exhibition was curated by Eugenio Valdez Figueroa (Havana, Cuba) and included works by the MAK Center Artists and Architects in Residence Siggi Hofer, Susanne Jirkuff, Lisa Schmidt-Colinet, Alexander Schmoeger and Florian Zeyfang.

In Between: Art and Architecture
A group exhibition of works in photography, painting, video, film, drawing and sculpture responding to the site of the Schindler House and engaging public space with billboards by Sharon Lockhart and Felix Gonzalez-Torres. Other participants included Sam Durant, Julia Fish, Stephen Prina, Adrian Schiess, Hiroshi Sugimoto and Christopher Williams.

Related event:
April 5 and 12, 2001
Two evenings of films organized by artist Christopher Williams. Screenings featured independent films by artists such as Otto Muehl, David Lamelas and Harun Farocki.

Visit of Mrs. Elisabeth Gehrer, Federal Minister of Education, Science and Culture of the Republic of Austria
May 3–6, 2001
After a welcome at the Schindler House by Peter Noever, Mrs. Gehrer met with the Artists and Architects in Residence at the Mackey Apartments, where she familiarized herself with their work. During her 2-day trip she was given a thorough glimpse of the cultural highlights of Los Angeles.

Readings on the Roof
May 27, 2001
Readings of recently published works by authors Michael Datcher and Jenoyne Adams, organized by the Mackey residents.

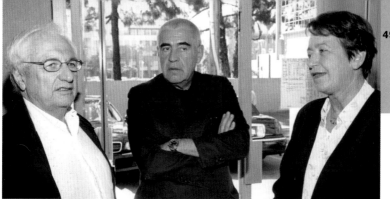

Frank O. Gehry, Peter Noever, Elisabeth Gehrer, 2001 (from left).

Civic Interventions

June 3, 2001

An evening of presentations organized by NOMADS+RESIDENTS LA in collaboration with the MAK Center Artists and Architects in Residence featuring: Klaus Weber, a Berlin-based artist; Heavy Trash, a Los Angeles-based group of anonymous architects, artists and builders; and Dispute Resolution Services, a Los Angeles-based collective.

In Between: Metropolis

June – July, 2001

A series of artist-led architecture tours offering the artist's idiosyncratic overviews of significant sites in the city of Los Angeles. This program was part of the MAK Center's educational outreach programming.

sound. at the Schindler House

June – September, 2001

A series of outdoor concerts organized by artist Cindy Bernard featuring:
June 30: James Tenney performed by percussionist William Winant
July 28: Pauline Oliveros and Phillip Gelb playing solos and duos with accordion and shakahuchi
August 24, 25: Stephen Prina performing *Sonic Dan* with vocals and keyboard
September 28, 29: Glenn Branca and Reg Bloor performing duos with loud music for electric harmonic guitars

MAK Talk

July 17, 2001

Iñigo Manglano-Ovalle, Chicago-based artist and exhibition designer of *Mies in America* at the Whitney Museum, New York, discussed his work in relation to architecture and his newly commissioned work for the MAK Center's exhibition *In Between: Outdoors*.

Glenn Branca, 2001.

Michael Wildmann, 2001.

In Between: Outdoors

July 20 – September 2, 2001

A group exhibition featuring newly commissioned site-specific works in sound, photography and sculpture by Steve Roden, Iñigo Manglano-Ovalle and Jorge Pardo.

MAK Architecture Tour

August 19, 2001

Fundraising architecture tour featuring seven sites by R. M. Schindler.

Related event:

Evening on the Roof

August 18, 2001

A concert on the roof of the Yates music studio (remodeled by Schindler in 1938). Performances were curated by Daniel Rothman and featured works by Austrian composers Bernhard Lang and Peter Ablinger as well as German composer Isabel Mundry, performed by Austrian cellist Michael Moser.

MAK Talks

August 19, 2001

Mark and Mary Schindler and historian Kathryn Smith discussed their insights about the Schindler House in a talk entitled *Life at Kings Road*. Architects Leo Marmol and Ron Radziner discussed *Transposing Modernism: From Modern Restoration to Contemporary Design*. Architect and author Judith Sheine presented her recent work on Schindler and discussed her recently completed CD Rom *R. M. Schindler: Four Houses 1933–1942*.

MAK DAY: Site and Sound

September 8, 2001

Third annual community day, featuring a sound workshop by artist Anna Homler; a lecture on the history of experimental sound by artist and curator Brandon LaBelle; and a performance by artist Steve Roden who also premiered his newly released compact disc *Schindler House*.

David Hullfish Bailey, 2001.

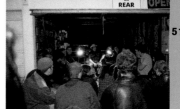

Rock Spaces at Lobby in Rear, 2001.

Final Projects: 20/35 Vision

September 20 – October 28, 2001

Curating an exhibition that included L.A. artists, the Mackey residents mounted a show in the Schindler House. Barbara Kaucky, along with Richard Sparham and Elizabeth Hesik presented an installation with videos that documented their survey in planned communities in Southern California; Dorit Margreiter presented video, photography and narrative panels in *I Like L.A.* and *L.A. too*; Michael Wildmann presented a video installation *Stop and Go*; Martha Stutteregger and Florian Pumhösl devoted their time in Los Angeles to architectural research.

Wild Walls: Berlin/Los Angeles Film Festival of Architecture and Urbanism

October 12–21, 2001

A film festival in collaboration with the University of Southern California (USC) School of Fine Art. Screenings were held outdoors at the Schindler House as well as at USC. Films focused on architecture and urbanism in the 20th century.

Wild Walls Symposium

October 14, 2001

Presentations of films featuring Norman Klein, Babette Mangolte, Ed Dimendberg, Sam Durant and Ann Friedberg with Christian Rattemeyer moderating.

Lobby in Rear

November 1, 2001 – February 28, 2002

An experimental working space established by MAK Center Artists in Residence Kobe Matthys and Richard Hoeck. A garage behind the Mackey Apartments was turned into a "lobby" space for activities focusing on the use of architecture and urbanism. *Lobby in Rear* was open to the public Saturday afternoons as well as for special presentations.

Rock Spaces at Lobby in Rear

November 3, 2001

Architect Marie-Paul MacDonald discusses her "rock spaces" (spaces for rock 'n' roll), and reflects on the garage as a hybrid architectural space for "garage bands."

Savage Signs in the Digital Realm

January 11, 2002

An evening of music and video projections at the Schindler House organized by Architect in Residence José Pérez de Lama. Artist Antonio Mendoza projected digital videos and animations while the digital collective Mr. Tamale performed live material from *Playstation Satan*.

DIY lo-fi electronic sounds

January 13, 2002

An evening of music with La Paz, L.A. hip-hop collective of two MCs and one DJ working from their garage recording studio; m.signe of the NY Soundlab collective mixing sounds from a lap-top and turn-tables; The Mountain Radio Project, site-specific live radio broadcasts on the FM dial with Retlaw Kedzu's 100 watts of stereo from a self-built transmitter.

Video screening of the film *Battle of Orgreave*

January 13, 2002

In collaboration with Low Gallery, the MAK Center presented a screening of a documentary film made by British artist Jeremy Deller. *Battle of Orgreave* featured a re-enactment of the violent clash between miners and police during the miner's strike in South Yorkshire, England, in 1984.

Ed Ruscha, *Miracle*

January 19, 2002

Organized by Artists and Architects in Residence, an outdoor screening of Ed Ruscha's 1975 film *Miracle*. Starring Jim Ganzer and Michelle Phillips.

Markings: Constructing Form through Drawing

January 23 – April 14, 2002

An exhibition of works that employ the activity of drawing to generate space, form and time. The physical and material properties of these works on paper asserted an organic and indexical presence within the Schindler House, emphasizing the macro experience of the drawn mark and contrasting the dichotomy of the materials indoors and the views to the outdoors. Artists included Hanne Darboven, Caryl Davis, Gerald Giamportone, Amanda Guest and Nancy Rubins.

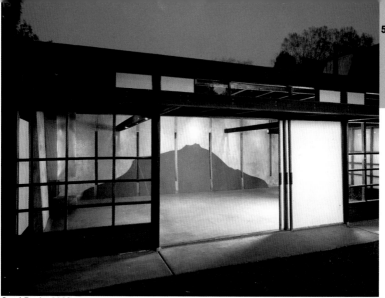

Caryl Davis, 2002.

Related event:
Hanne Darboven, *Opus 17 A-B, Opus 18 A-B*
April 6/7, 2002
Performed on double bass by Tom Peters. Hanne Darboven's musical works have contributed to the legacy of avant-garde experimental music since the 1960s. Her minimalist scores for single instruments and small ensembles reflect the structure, repetition and numerical progression that are evident in her drawings. Darboven's *O.T. Portfolio, November 1971* – a series of the artist's "daily writings" which mark out the month of November 1971 – was included in the exhibition *Markings: Constructing Form through Drawing*.

Final Projects
February 15 – April 14, 2002
Mauricio Rafael Duk Gonzáles installed his construction *The Un_Invited* at the Schindler House; José Pérez de Lama presented *Some ideas for an anarchist / zapatista urbanism*, a video screening and debut of his website at Flor y Canto, an autonomous community center in the Highland Park section of Los Angeles; Richard Hoeck and Kobe Matthys continued *Lobby in Rear*, their ongoing series of events in the Mackey Apartments garage.

Experimental Animation Screening
April 13, 2002
Presenting works by established masters as well as recent offerings from the next generation of cutting-edge animators, the outdoor screening at the Schindler House explored how the drawn line functions to confound or articulate the viewer's perception of dimensionality, pictorial space, and time. Co-curated by Maureen Selwood (Director, Experimental Animation Program, CalArts) in association with the MAK Center.

Julius Shulman, Franz Morak, 2002.

Gerald Zugmann/Coop Himmelb(l)au, 2002. Julius Shulman, 2002.

Visit of Mr. Franz Morak, Austrian State Secretary for Arts and Media

May 8–12, 2002

During his visit to Los Angeles on the occasion of the opening of the MAK Center exhibition *Gerald Zugmann: Blue Universe,* Mr. Morak was given a special Modernist architecture tour, met photographer Julius Shulman, actor Dennis Hopper and architect Eric Owen Moss, and had lunch with the current group of Artists and Architects in Residence at the Mackey Apartments.

Gerald Zugmann: Blue Universe. Architectural Manifestos by
Coop Himmelb(l)au

May 9 – September 8, 2002

An exhibition documenting the long-term collaboration of the internationally acclaimed photographer Gerald Zugmann with the renowned architects Coop Himmelb(l)au. Exhibition curated by Martina Kandeler-Fritsch, MAK Vienna.

Related event:

Gerald Zugmann: Blue Universe. Models Transforming into Pictures

August 30, 2002

The exhibition catalogue designed to accompany the traveling exhibition *Gerald Zugmann: Blue Universe. Architectural Manifestos by Coop Himmelb(l)au* was presented. In addition to the opportunity to meet Austrian photographer Gerald Zugmann, the event featured presentations by MAK Director Peter Noever and California-based architectural photographer Julius Shulman.

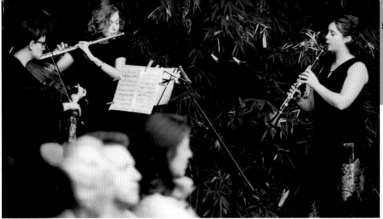

John Cage concert, 2002.

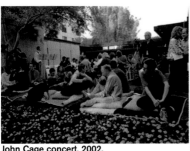

John Cage concert, 2002.

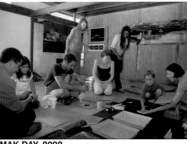

MAK DAY, 2002.

sound. at the Schindler House
June – September, 2002
The annual series of experimental concerts performed in the outdoor court-yard of the Schindler House included:
June 28, 29: John Cage performed by James Tenney
July 27: Joe Potts in collaboration with visual and performing artists
August 24: Carl Stone performing on laptop computer
September 20, 21: *Interstellar Space Revisited* by Nels Cline and Gregg Bendian

Room
August 22, 2002
A panel discussion at the Schindler House organized by Architect in Residence Lorenzo Rocha Cito. Panelists Tim Stowell, Mauricio Duk and José A. Aldrete-Haas discussed the relationship between the linguistics of the words "room" and "space" and their impact on the design and experience of architecture.

MAK DAY: Envisioning Architecture
September 8, 2002
Annual community day with free admission to the Schindler House, photography workshops and lectures by Gloria Koenig, Christophe Cornubert and Diane Piepol.

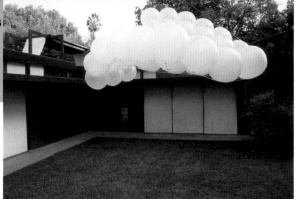

Bernhard Sommer, 2002.

Final Projects
September 18–29, 2002
Karina Nimmerfall constructed a sculptural installation on the grounds of the Schindler House; Luisa Lambri presented a photographic survey of works by R. M. Schindler and Richard Neutra; Bernhard Sommer presented *Desert Cloud: Transformer 3,* a model for an architecture light and change-able clouds on the Schindler House roof; Lorenzo Rocha Cito presented *Missing Room,* a temporary room addition to his apartment at the Mackey Apartments.

The Man We Want To Hang: A Kenneth Anger Retrospective
October 10–12, 2002
A three-night retrospective of films by renowned independent filmmaker Kenneth Anger, screened in the outdoor spaces of the Schindler House and at the University of Southern California School of Film and Television. Kenneth Anger spoke at each screening.

Desert cloud <transformer 3>
October 11, 2002 – January 15, 2003
Installation of the final project of Architect in Residence Bernhard Sommer in the public space of Santa Monica Boulevard as part of the City of West Hollywood's *Art on the Boulevard* program. The City of West Hollywood Fine Arts Commission provided support for the installation.

MAK Tour 2002
October 20, 2002
A self-driving tour of private residences in west Los Angeles featuring mid-century modernist works by Neutra, Schindler and Ellwood.

Home Scenes
December 2002
Series of temporary installations by MAK Center Artists and Architects in Residence Thomas Gombotz, Antonietta Putzu, Pia Rönicke, Una Szeemann and Zlatan Vukosavljevic that re-examined the Schindler House as a domes-tic stage.

Home Scenes, 2002.

Renée Petropoulos, 2003.

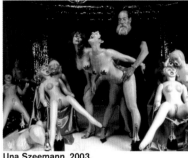

Una Szeemann, 2003.

Una Szeemann, 2003.

TRESPASSING: Houses x Artists

January – July, 2003

This two-part exhibition presented new works by nine artists working in collaboration with architects Alan Koch and Linda Taalman of Open Office. The projects engaged the house as subject, investigating its forms, functions and significance while imagining a wide variety of prototypes for living.

January 29 – April 13, 2003

Projects by Jim Isermann, Renée Petropoulos, Jessica Stockholder and T. Kelly Mason.

May 7 – July 27, 2003

Projects by Kevin Appel, Chris Burden, Barbara Bloom, Julian Opie and David Reed.

Related events:

March 1, 2003

Walkthrough of the exhibition with the project's originators, architects Linda Taalman and Alan Koch.

March 19, 2003

Artist Renée Petropoulos in conversation with MAK Center Director Kimberli Meyer spoke about her project for *TRESPASSING*.

April 12, 2003

A demonstration/artist talk featuring a member of the American Association of Rotational Molders demonstrating the fabrication process and the artist T. Kelly Mason speaking about how the reapplication of this industrial technology facilitates his house design.

May 16, 2003

Screening of videos by artist Chris Burden presented in collaboration with Los Angeles Contemporary Exhibitions (LACE) on the occasion of the exhibition *Chris Burden: "Small Skyscraper"* at LACE.

June 14, 2003

An architecture tour of Los Angeles led by David Reed.

Thomas Gombotz, 2003.

Plugged and Haunted

February 16–23, 2003

A garage project at the Mackey Apartments organized by Artist in Residence Zlatan Vukosavljevic, featuring multi-media works by Houston-based Allison Wiese and San Diego-based Wendell Kling.

Final Projects

March 21–23, 2003

At the Mackey Apartments, Thomas Gombotz and Antonietta Putzu presented an "L.A. Kit" to assist local residents in documenting favorite spots in Los Angeles through text and photography; Pia Rönicke collaborated with Los Angeles-based artist Michael Baers in a research project presented as a two-video installation; Una Szeemann developed a film project called *Montewood Hollyverita*; Zlatan Vukosavljevic created an observation tower on the Mackey roof terrace and a bunker-like sculpture in the living room of his apartment.

Schindler's Paradise: Architectural Resistance

August 6 – December 7, 2003

Architectural ideas competition, exhibition and publication. An exhibition of posters and architectural models featuring proposals for housing, cultural and multi-use facilities next door to the Schindler House on Kings Road. Highlighted in the exhibition were the jury-selected projects of Zaha Hadid, Odile Decq and Peter Eisenman.

In addition to the firms cited above, *Schindler's Paradise* participants included: Coop Himmelb(l)au, Christophe Cornubert/PUSH; Günther Domenig; Driendl Architects; Durfee/Regn; Eichinger oder Knechtl; Sandrine von Klot and Lucas Rios Giordano; Mark Mack Architects; Andrea Lenardin Madden; Eric Owen Moss Architects; the Next ENTERprise; Dominique Perrault; ROTO Architects; Bernard Sommer & Goga S. Nawara; Klaus Stattmann; Umbrella Organization/Michael Volk; and Lebbeus Woods.

Jury for Schindler's Paradise: Architectural Resistance, 2002
Chris Burden, Kimberli Meyer, Judith Sheine, Michael Asher, Frank O. Gehry, Peter Noever, Roberto Gottardi, Richard Koshalek, Carl Pruscha (from left).

Joseph Giovannini, Kimberli Meyer, Harriet Gold, 2003 (from left).

Eric Owen Moss, 2003.

Odile Decq, Carl Pruscha, Peter Noever, 2003 (from left).

The jury included leaders in the fields of architecture, art and scholarship: Los Angeles architect Frank O. Gehry; Roberto Gottardi, architect of one of the acclaimed Cuban Art Schools outside Havana; artists Chris Burden and Michael Asher; Richard Koshalek, President of Pasadena's Art Center College of Design; Peter Noever, Director, MAK, Vienna; Carl Pruscha, Professor at the Academy of Fine Arts, Vienna; and Judith Sheine, Chair of the Architecture Department at Cal Poly, Pomona and author of two books on the work of R. M. Schindler.

A public roundtable discussion opened the exhibition. The discussion was moderated by Greg Goldin, architecture and public affairs writer for *Los Angeles Magazine* and the *L.A. Weekly,* and participants included jury members Carl Pruscha and Peter Noever; "premiere" project designer Odile Decq; architect Eric Owen Moss; and Richard Loring of Kings Garden Development LLC.

Coop Himmelb(l)au

Christophe Cornunbert/PUSH

Durfee/Regn

Eichinger oder Knechtl

Andrea Lenardin Madden

Eric Owen Moss

Bernhard Sommer and Goga S. Nawara

Klaus Stattmann

Lebbeus Woods

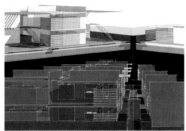
ROTO Architects

Odile Decq

Driendl Architects

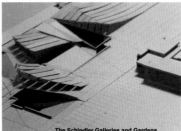

The Schindler Galleries and Gardens

Peter Eisenman Architects

Zaha Hadid Architects

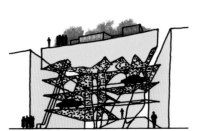

the Next ENTERprise

Dominique Perrault

Umbrella Organization/Michael Volk

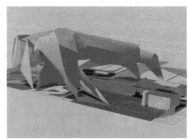

Sandrine von Klot and Lucas Rios Giordano

Günther Domenig

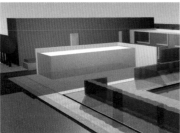

Mark Mack Architects

Related events:

June 11, 2003

Jury met at Schindler House to review architecture proposals for *A Tribute to Preserving Schindler's Paradise.* Jury followed by press reception.

July 2, 2003

Architect Roberto Gottardi (Havana, Cuba) hosted an Italian dinner, prepared by MAK Center director Kimberli Meyer, and presented his work in the context of architecture and politics at the dawn of the 21st century. Gottardi served on the jury for *Schindler's Paradise.*

August 6, 2003

Opening reception and panel discussion for the exhibition *Schindler's Paradise: Architectural Resistance.*

November 23, 2003

Presentation of the publication *Architectural Resistance: Contemporary Architects face Schindler Today.* Contributors Norman Klein and Joseph Giovannini were in conversation.

sound. at the Schindler House

Summer, 2003

Co-curated by Cindy Bernard, Sam Durant and Christopher Williams
June 28: Danny Cohen with guests John La Pado, Christine La Pado and Charles Mohnike
July 26: Polar Goldie Cats
August 22, 23: Rüdiger Carl on solo accordion and solo clarinet, with guest Raymond Pettibon performing spoken word
September 19, 20: Joseph Jarman on horns, woodwinds and percussion

Eva Schlegel: LA Project

July 23, 2003

Artist Eva Schlegel presented her book project, a series of photographs of Los Angeles women artists and architects in their studios.

Carl Pruscha in conversation with Michael Rotondi

July 27, 2003

This event featured a slide presentation of vernacular architecture in Asia and conversation about how globalized agriculture affects indigenous architecture. MAK Center Artist in Residence Suwan Laimanee cooked and served Thai food.

Summer Time at the Mackey Apartments

August 15 – September 7, 2003

An exhibition by the MAK Center Artists and Architects in Residence, held in association with the Absolut L.A. International at the Mackey

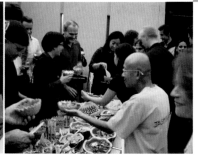

Suwan Laimanee serving food, 2003.

Apartments. Nicolas Février and Roland Oberhofer built an architectural intervention on the site; Corinne L. Rusch presented a photographic diptych; Christoph Kumpusch designed and built an archetypal outdoor object for the rooftop space of the Mackey Apartments; Suwan Laimanee shared the cultural traditions and practices of his homeland (Thailand) as an artistic performance, offering food, drink and/or massage to visitors.

Related events:

Thai Cooking Workshop

August 17, 2003

Artist Suwan Laimanee offered workshops in Thai cooking at the Mackey Apartments. Teaching about cooking techniques, the healthful qualities of foods and the politics of food importation and exportation, the artist created a colorful and aromatic display of food offering a wonderful sensory experience in a social atmosphere.

Summer Time presents works by the Villa Aurora residents

August 20, 2003

Readings, video screenings and music presented in the context of the Summer Time exhibition featuring works by the Villa Aurora's former and current Artists in Residence: Rainer Merkel with Georg Fick, Philipp Lachenmann, Lutz Seiler and Jens Brand with Michael Intriere and Anna Homler.

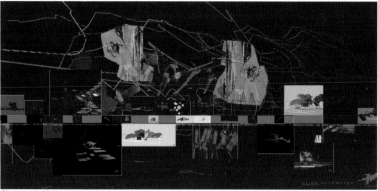

Christoph Kumpusch, 2004.

GRAFT, 2004.

August 29, 2003
A presentation of videos related to the work of current and former MAK Center Artists and Architects in Residence: Lorenzo Rocha Cito, Christoph Kumpusch, Suwan Laimanee, and Una Szeemann.

Cooking for the Homeless
September 8, 2003
Resident artist Suwan Laimanee prepared a Thai meal for 130 homeless people at All Saint's Church, Beverly Hills.

From Bauhaus to Hollywood: Avant-Garde Film in America
August 8/9, 2003
A screening of avant-garde films by European and American filmmakers in association with the exhibition *From Europe to California: Galka Scheyer and the Avant-Garde* at The Norton Simon Museum. The screenings featured the American avant-garde from the post-war years, including works by Stan Brakhage and Maya Deren.

MAK DAY: Seen and Heard in L.A.
October 4, 2003
The MAK Center's 5th annual MAK Day sought to reexamine the roles of selected Los Angeles cultural institutions in the wake of the current economic climate and the changing focus of more traditional arts venues. This free event featured family workshops, demonstrations, readings, lectures, and performances from various Los Angles-area cultural institutions.

Sundown Salon
October 22, 2003
Curated by Fritz Haeg, the evening included musical performances by Los Super Elegantes (Milena Muzquiz and Martiniano Lopez-Crozet); D'Argento (Anna Sew Hoy, Giles Miller, Jason Taylor and Amy Yao); art performance by

3 Fireplaces and 2 Bathtubs, 2004.

Dawn Kasper; improvisional ballet by Adam Hundt and Hitomi Yamada; belly dancing by Paige Clark; short story readings by writers Jennifer Krasinski and Trinnie Dalton; video works by Alice Könitz and Yoshua Okon; Cristina Forrer and Piper Olf; balloon installation and ice bar by Justin Beal; light installation in the vegetable garden by GRAFT; sculpture by Anna Sew Hoy.

Intersecting Architecture and Health: The Lovell Houses
November 1, 2003
A fundraising architecture tour featuring two houses designed for Phillip Lovell: the Lovell Health House (Richard Neutra, 1929) and the Lovell Beach House (R. M. Schindler, 1926).

3 Fireplaces and 2 Bathtubs
February 6 – March 17, 2004
Acting as curators and exhibition participants, MAK Center Artists in Residence Catrin Bolt, Oliver Croy, Robert Gfader, Marlene Haring and Deborah Ligorio selected works for exhibition by emerging local artists Bankhead, Chris Bassett, Piero Golia, Skylar Haskard, Marc Herbst, Marie Jager, Myungwhan Lim, Earnest C. Merritt III, Joshua Mittleman, Arthur Ou, Wanda Smans, Christina Ulke and Eric Wesley.

Final Projects: It's Time to Stay Home and Get Some Audience
March 12–14, 2004
At the Mackey Apartments Oliver Croy presented an installation based on the real estate market; Deborah Ligorio showed a video focusing on her "pilgrimage" to Robert Smithson's *Spiral Jetty* in Utah; Catrin Bolt exhibited photographs; Robert Gfader offered a carpet made from discarded street banners, a sculpture based on backyard clothesline "umbrellas" and an "armed response" security sign; Marlene Haring presented a performance, *Secret Service.*

MAK Salon hosted by Francesca von Habsburg, 2004.

Francesca von Habsburg, 2004.

First MAK Salon
March 7, 2004
The Schindler House enjoyed a vibrant social-intellectual life from 1922 through the 1950s. Salons, dinners, and political meetings brought the discussion of far-reaching ideas to the intimacy of domestic space. The MAK Center has continued that thread with MAK SALON. Hosts are invited to curate an intimate dinner for 22 guests, coordinated to maximize the interplay between intellectual content, menu and setting. The first salon was hosted by Francesca von Habsburg.

Tom Peters on Double Bass
April 23, 2004
Peters presented compositions for bass and computer, including new or recent works by five living composers: Eckart Beinke, Anne LeBaron, Cort Lippe, Mary Lou Newmark and Kaija Saariaho.

Yves Klein: Air Architecture
May 13 – August 29, 2004
Renowned French conceptualist Yves Klein (1928–1962) produced a prescient body of work concerning the concept of air architecture – an immaterial architecture. For the first time, this aspect of Klein's work was the focus of an exhibition organized by the MAK Center. *Yves Klein: Air Architecture* offered an opportunity to consider the artist's architectural projects and theories, featuring drawings, texts, photography, sculpture and film from the Yves Klein Archive in Paris. The exhibition was guest curated by architect François Perrin, who also designed a site-specific installation for the Schindler House.

Related events:
François Perrin: Microclimates
June 3, 2004
Kicking off the season's LA Forum Lecture series/On The Map and held in the Schindler House's outdoor courtyard, this lecture presented Perrin's latest built projects and comments on the environmental aspect of Yves Klein's

Yves Klein: Air Architecture, 2004. Japanese tea ceremony and
judo demonstration, 2004.

architectural works, including climate control, global warming, and sustainable energy.

The Movies of Yves Klein at the American Cinematheque
July 1, 2004

Site(ing) Yves Klein
July 14, 2004
Panel discussion with Juli Carson, Peter Lunenfeld, Rachel Kushner, François Perrin. Moderated by Kimberli Meyer.

Yves Klein: Architecture and the Future
August 10, 2004
Panel discussion with Michael Speaks, Norman Klein, Sylvia Lavin, François Perrin. Moderated by Lauri Firstenberg.

Japanese Tea Ceremony and Judo Demonstration
August 15, 2004
Held in the Schindler courtyard and garden, these demonstrations illuminated an important aspect of Klein's practice. An accomplished Judo master, Klein visited Japan and cited his Judo skills in reference to his work. The Japanese Tea Ceremony was demonstrated by Soyu Yamashita and the Judo demonstration was taught by Korean Grand Master Seok Pil Jang.

Second MAK Salon
May 16, 2004
Hosted by publisher Angelika Taschen, this dinner for 26 guests was held in the Schindler courtyard.

Wolff House Reception
June 30, 2004
Reception at newly renovated Wolff House (R. M. Schindler, 1938). Present were owner Michael LaFetra and restoration architect Jeff Fink.

Reception at the the Wolff House (R. M. Schindler, 1938), 2004.

sound. at the Schindler House
Summer, 2004
June 26: Los Angeles minimalist composers, performers Jim Fox, Michael Jon Fink, Chas Smith and Rick Cox.
July 24: A musical interpretation of the surrealist technique of Exquisite Corpse with Joseph Berardi, Mitchell Brown, Dan Clucas, Weba Garretson, Petra Haden, G. E. Stinson.

Final Projects: Mandatory
September 7–9, 2004
Miriam Bajtala presented *Swing,* a video installation; transparadiso, the team of Barbara Holub and Paul Rajakovics, offered *Plastique Bertrand,* a performative work in the format of an exclusive art fundraising dinner that was staged during the opening; Constanze Schweiger exhibited *Chameleons,* a series of photographic portraits, and *Quilts,* a sculpture made from moving blankets; Florian Hecker offered an interactive piece in which viewers navigated the Schindler House with headphones.

Discussions in a Garden
September 22 – October 7, 2004
A thought-provoking series of author talks held in the garden. Modeled after Pauline Schindler's salons of the same name held in the 1950s, the first group of talks was politically themed.

September 22, 2004
Laura Flanders, *BUSHWOMEN: Tales of a Cynical Species*
October 3, 2004
Carol Brightman, *Total Insecurity: The Myth of American Omnipotence*
October 7, 2004
Tom Hayden, *Street Wars: Gangs and the Future of Violence*

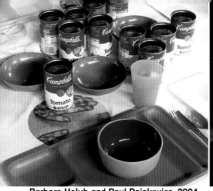

Barbara Holub and Paul Rajakovics, 2004.

10Y MAK CENTER: AUSTRIA / ARCHITECTURE / NIGHT OPEN AIR
September 29, 2004

The MAK Center kicked off its 10th year anniversary with a party. This evening presented music curated by Peter Wolf, Austrian sweets by Wolfgang Puck, slide projections curated by Diana Thater, and featured speakers Austrian State Secretary of Arts and Media Franz Morak, Los Angeles-based architect Thom Mayne, former MAK Center resident Andrea Lenardin Madden, City of West Hollywood Council member Jeffrey Prang, and Peter Noever.

10Y MAK Center: Austria / Architecture / Night Open Air, 2004 – Peter Launsky-Tieffenthal, Thom Mayne (middle). Wolfgang Puck (left), Peter Noever, 2004.

MAK DAY: Fashion Statement
October 10, 2004

This MAK DAY focused on ideas about fashion and ways of making clothing. It featured hands-on workshops with Oscar Santos and Tina Marrin. The Garment Worker Center gave a presentation on sweatshops in Los Angeles.

SHOWDOWN! at the Schindler House
September 15 – December 5, 2004

This multi-phased presentation brought together an array of artists, architects, designers, musicians and performers to explore and present current frontiers of fashion. In the first phase, the Schindler House was utilized as a studio by L.A. rock band My Barbarian, who wrote a musical morality play and performed it at the Schindler House and garden. New York fashion design duo Feral Childe filled another studio with their sewing machines, made many clothes, choreographed a dance and staged its performance in

the garden. Architect/designer Elena Manferdini also took a studio. During these studio residencies the house was abuzz, filled with artists hard at work. The program was co-curated by MAK Center Director Kimberli Meyer and Sundown Salon Impresario Fritz Haeg.

Related events:

Runway Show
October 22/23, 2004

A spectacular runway show, held on a catwalk designed and built by the Los Angeles office of Vienna-based architecture firm Coop Himmelb(l)au. Designed to accommodate audiences on both sides of the Schindler House and to maximize views, the catwalk featured sculptural two-story stair towers. Presenting 75 pieces produced by 20 participants, the show incorporated sound, music, light, spoken word and architecture. Participants included Andrew Andrew; Bon & Ging; Ingrid Bromberg & Blain Kennedy; Dioscuri; Escher GuneWardena Architects; Feral Childe; Fugue / Andrea Lenardin Madden and Raegan Kelly; Gizmo; L.A. Eyeworks; Liz Larner; Claudia Rosa Lukas; Michael Mahalchick; Elena Manferdini; Tina Marrin; My Barbarian; Renée Petropoulos; Jessica Rath with Millie Wilson; Ujein; We Are Lucid Dreaming; Wooden Moustache; and Amy Yao. Live music was by Giles Miller's Shifty Disco Band.

My Barbarian vs. Feral Childe
October 30, 2004

Performance at the Schindler House. On the Chace side of the house, My Barbarian presented "Nightmarathon 3: Web of the Ultimate," a tangled musical legend that read the Schindler House like a modern Da Vinci Code. On the Schindler side of the house, Feral Childe presented its latest collection, Kung Fu Shek, set up a mosh pit for *Baby Dingo Derby* and presented live music by Butterknife Krüsh.

Michael Mahalchick
November 4, 2004

Performance at the Schindler House. Much as fashion cannibalizes styles from earlier eras, Mahalchick's Frankenstein-ish creations brought old clothes back from the dead. At the Schindler House, the artist orchestrated an invasion by an "army of zombies," guest performers and the artist himself.

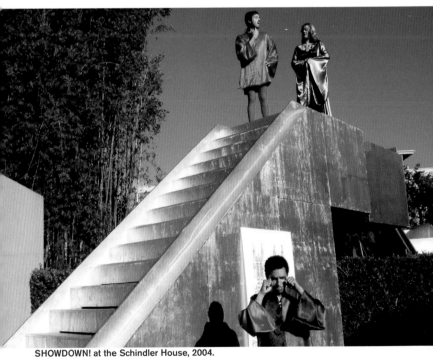

SHOWDOWN! at the Schindler House, 2004.

SCHINDLER'S GUESTS TODAY

MAK CENTER ARTISTS AND ARCHITECTS IN RESIDENCE

The Mackey Apartments (1939)

The Mackey Apartments are the home for the MAK Center's residency program designed for visiting artists, architects, and students of architecture. The building was purchased by the Republic of Austria in 1995, and made available for the activities of the MAK Center.

Located on a flat lot in a residential neighborhood, the originally four-unit (since converted to five) apartment building is one of a series of residential projects built in the 1930s. Unlike international-style architects, Schindler seldom designed identical apartment units; his apartments are as complex, individual, and innovative as his houses. The Mackey possesses typical Schindler characteristics: compact apartment layout, exceptional incorporation of natural light, built-in furniture, variable ceiling heights, and private outdoor gardens or mini-balconies.

Restoration work on the Mackey Apartments began in 1995 by the Central Office of Architecture, and continued with architects Space International in 2001 and 2004, thanks to funding by the Austrian Federal Ministry of Economic Affairs and Labor. In all phases of renovation, the objective was to recreate the room layout, complex lighting, and the use of materials for surfaces and color schemes in keeping with the architect's original intentions. Ultimately, the renovation has created a refreshing building that testifies to Schindler's love of open spaces, airiness, and versatility.

The MAK Center Archive

Housed in the Mackey Apartments, the MAK Center Archive catalogues MAK Center programs. Emphasis is placed on collecting and documenting the development and progress of artworks and programs created at the MAK Center and its residency program. The archive includes working models, sketches, details, and ephemera, allowing access to the research of artistic processes and methodologies. The physical archive is available for research purposes by appointment, and an online archive is accessible through the web site at www.MAKcenter.org.

Artists and Architects in Residence Program

The Artists and Architects in Residence program at the Mackey Apartments is a six-month residency offered twice annually to two artists and two architects. Completed works are presented to the public toward the end of each residency period. Although not open for public tours on a regular basis, the Mackey Apartments are available for special functions and open during project installations.

The Mackey scholarships are awarded to independent projects dealing with the relation between art and architecture. Recipients of the awards are encouraged to participate in the activities of the Schindler House, attend meetings, workshops and project discussions with other artists and students, in order to allow constant artistic activity within the context of the institutionalized museum.

Emphasis is placed on the location of the residency in Los Angeles. Although regarded as the second artistic metropolis after New York, L.A. is possibly the most trend-setting example of a decentralized and un-rulable urban complex in the US. The residents' projects must reflect and incorporate specific aspects of the city and its social fabric, addressing its unique aspects such as expressways, automobiles, and ghettoization.

One of the most critical mandates of the MAK Center is that new projects and processes are more relevant than their subsequent preservation by museum curators and historians. The Artists and Architects in Residence program is particularly important in this respect because it presents young artists and architects with the opportunity to develop new projects linked not only to Schindler's experimental work but also to the specific urban situation prevailing in Los Angeles.

Plamen Dejanov Swetlana Heger Andrea Kocevar

GROUP I
October 1995 – March 1996

se: solo exhibition
ge: group exhibition

Swetlana Heger & Plamen Dejanov
collaboration from 1994 to 2003

Swetlana Heger, born 1968 in Brno, Czech Republic, lives in Vienna; studied painting and graphic at the University of Applied Arts, Vienna

Plamen Dejanoff*, born 1970 in Sofia, Bulgaria, lives in Vienna; studied sculpture at the University of Applied Arts, Sofia, Bulgaria, and at the Academy of Fine Arts, Vienna
*changed his name for solo projects

1997	"Three Wishes (Plenty Objects of Desire)", Air de Paris, Paris (se)
1998	"Plenty Objects of Desire", Kunstverein Ludwigsburg, Berlin (se)
1999	"Y-1", Moderna Museet, Stockholm; Mehdi Chouakri Gallery, Berlin (se)
2000	"On Holliday", Muzej suvreme umjetnosti, Zagreb; Air de Paris, Paris (se)
2001	"Quite Normal Luxury (Test the world)", MAK, Vienna (se) "Economical Visions", Deichtorhallen, Hamburg (ge)
2004	"Noch einen Wunsch/Auf Sendung", Galerie für Zeitgenössische Kunst, Leipzig, Germany (Plamen Dejanoff, ge) "Performative Installation #4. Body Display. Körper & Ökonomie", Secession, Vienna (Swetlana Heger, ge)
2005	"Swetlana Heger", Artists Space, New York (Swetlana Heger, se)

Andrea Kocevar
born 1960 in Vienna, lives in Vienna; studied architecture at the Technical University, Vienna

1986	"Homerlesen, 22 Stunden Lesung der Ilias", Künstlerhaustheater, Vienna (theater project)
1988	"Transsibirische Eisenbahn. 16 Tage Projekt", Vienna, Moscow, Chabarowsk, Russia (theater project)
1998	"Stadtentwicklung Wien", Kashiwashobo, Tokyo (publication)
2000	"Die Nicht-Utopie des japanischen Theaters", Forum Stadtpark, Graz, Austria (publication/lecture)

Flora Neuwirth

Gilbert Bretterbauer

Jochen Traar

2003 "Umbau eines Einfamilienhauses", St. Leonhard, Austria (architecture)

Flora Neuwirth
born 1971 in Graz, Austria, lives in Vienna; studied sculpture at the Academy of Fine Arts, Vienna, and visual communication at the University of Art, Berlin

2000 "Zeitwenden", Künstlerhaus Wien, Vienna; Kunstmuseum, Bonn, Germany; Museum Moderner Kunst Stiftung Ludwig/Palais Liechtenstein, Vienna (ge)
 "Schindler Workshop", as part of "Rirkrit Tiravanija", Secession, Vienna (ge)

2003 "GegenLicht", BUWOG-Kundenzentrum, Vienna (ge)

2004 "… and in between", Grita Insam Gallery, Vienna (ge)
 "WEB.CAM.PING", Lisi Hämmerle Gallery, Bregenz, Austria (ge)

Jochen Traar
born 1960 in Essen, Germany, lives in Vienna; studied sculpture at the Academy of Fine Arts, Vienna

1998 "Lifestyle", Kunsthaus Bregenz, Austria (ge)

1999 "1. Kärntner Kurzschluss-Handlung", Universitätskulturzentrum UNIKUM, Klagenfurt, Austria (ge)

2001 "Art protects you. Man made skies", Eugen Lendl Gallery, Graz, Austria (se)

2004 "Niemandsland. Modelle für den öffentlichen Raum", Künstlerhaus Wien, Vienna (ge)

2004 "Wiener Linien. Kunst und Stadtbeobachtung seit 1960", Wien Museum Karlsplatz, Vienna (ge)

GROUP II
April – September 1996

Gilbert Bretterbauer
born 1957 in Vienna, lives in Vienna; studied painting and textile design at the University of Applied Arts, Vienna

Marta Fuetterer

Kasper Kovitz Andrea Lenardin Madden

2000	"Schindler Workshop", as part of "Rirkrit Tiravanija", Secession, Vienna (ge)
2003	"Textilwelt", MAK, Vienna (se)
	"all about: female sex. 20 Positionen", Academia Gallery, Salzburg, Austria
2004	"Gegen-Positionen. Künstlerinnen in Österreich 1960–2000", Museum Moderner Kunst, Passau, Germany (ge)

Marta Fuetterer

born 1966 in Milan, lives in Bozano, Italy; studied architecture at the Academy of Fine Arts and at the Technical University, Vienna

1994	"nichts geht schnell", Tenuta Forte, Vienna (se)
2003	"Talferpromenade" (photo documentation)
2004	"Das Herz ist die Zukunft des Wohnens", Bozano, Italy (social studies)
2005	"House Guncina" (architecture)

Kasper Kovitz

born 1996 in Vienna, lives in New Mexico; studied painting and experimental expression at the University of Applied Arts, Vienna

1996	"Echo", Lawrence Gallery, Los Angeles (ge)
1997	"L/M/S", Menotti Gallery, Baden, Austria (ge)
2003	"637 Running Feet. Black on white wall drawing by 14 Artists", Queens Museum of Art, New York (ge)
	"never no more [abstract wood]", Maria Walsh Sharpe Space Program, New York (ge)
	"Cosmorama", Akus Gallery, Connecticut (ge)

Andrea Lenardin Madden

born 1969 in Mödling, Austria, lives in Los Angeles and Vienna; studied architecture at the University of Applied Arts, Vienna

2003	"LA eXtract", Center for Design and Community Outreach, Hollywood (se)
2004	"Whistleblower series/vote responsibly", as part of "Showdown", MAK Center, Los Angeles (ge)
	"7daysLA", Architecture and Design Museum, Los Angeles (ge)
2005	"Sprinkles bakery", Beverly Hills (architecture)
	"Seaview residence", Santa Monica (architecture)

Stephan Doesinger Judith-Karoline Mussel Ulrike Müller

GROUP III
October 1996 – March 1997

Stephan Doesinger
born 1968 in Salzburg, Austria, lives in Munich, Germany; studied sculpture, painting and design at the Academy of Artistic and Industrial Design, Linz, Austria

2001 "Kino24", public space, Munich, Germany (ge)
2002 "Schindler Workshop", as part of "Rirkrit Tiravanija", Secession, Vienna (ge)
2004 "Life After Death. Drawings With The Magic Board", RSVP, Munich, Germany (se)
 "Saloniki Soccer Club Art Project", public space, Thessaloniki, Greece (se)
 "BMW Mobile Movies – One Line Loop", public space, Munich/Hamburg/Düsseldorf, Germany (ge)

Judith-Karoline Mussel
born 1966 in Mainz, Germany, lives in Los Angeles; studied architecture at the University of Applied Arts, Vienna

2000 The Grand Museum of Egypt, Cairo (competition)
2002 Administrative & Cultural Complex in Montreal, Canada (competition)
2003 Museumsquartier, Vienna (competition)
 Nam June Paik Museum, Korea (competition)
2004 "Eintagsfliegen", as part of "Showdown", MAK Center, Los Angeles (ge)

Ulrike Müller
born 1971 in Brixlegg, Austria, lives in Vienna; studied painting at the Academy of Fine Arts and at the University of Applied Arts, Vienna

2002 "Die Gewalt ist der Rand aller Dinge", Generali Foundation, Vienna (ge)
2003 "Public Affairs. Performance als politisches Handeln", Museum Moderner Kunst Stiftung Ludwig, Vienna (se)
 "Mothers of Invention. Where is Performance coming from?", Museum Moderner Kunst Stiftung Ludwig, Vienna (ge)

Paul Petritsch Johannes Porsch

| 2004 | "Visa for Thirteen", P.S.1 Contemporary Art Center/MoMa, New York (ge) |

Paul Petritsch & Johannes Porsch

Paul Petritsch, born 1968 in Friesach, Austria, lives in Vienna; studied architecture at the Technical University and at the University of Applied Arts, Vienna; collaboration with Nicole Six since 1997

2002	"CAT Open. Artists' choice", MAK Depot of Contemporary Art Gefechtsturm Arenbergpark, Vienna (ge) "Schindler Workshop", as part of "Rirkrit Tiravanija", Secession, Vienna (ge)
2003	"Fenster zum …", Galerie der Stadt Wels, Austria; Olliwood Studios, Vienna (ge)
2004	"Permanent Produktiv", Kunsthalle Exnergasse, Vienna (ge) "1-33-33", Atelier & Gallery AREA 53, Vienna (ge)

Johannes Porsch, born 1970 in Innsbruck, Austria, lives in Vienna; studied architecture at the University of Applied Arts, Vienna

2000	"Rudi Gernreich. Fashion will go out of fashion", DuMont, Cologne, Germany (publication)
2001	"Sturm der Ruhe. What is Architecture?", as part of "9. Wiener Architekturkongress" and the exhibition "Sturm der Ruhe. What is Architecture?", Architekturzentrum Wien, Vienna (lecture) "Sturm der Ruhe. What is Architecture?", Pustet, Regensburg, Germany (publication)
2002	"Schindler Workshop", as part of "Rirkrit Tiravanija", Secession, Vienna (ge)
2004	"The Austrian Phenomenon. Konzeption Experimente. Wien Graz 1958–1973", Architekturzentrum Wien, Vienna (curator)
2005	"Ottokar Uhl. Nach allen Regeln der Architektur", Architekturzentrum Wien, Vienna (curator)

Christine Gloggengiesser

Günther Holler-Schuster (left),
Martin Behr

GROUP IV
April – September 1997

Christine Gloggengiesser
born 1962 in Munich, Germany, lives in Purkersdorf, Austria; studied
visual media design at the University of Applied Arts, Vienna

1999	"Give the Self a Home", Forum Stadtpark, Graz, Austria (ge)
2001	"Selegna Sol", Charim Klocker Gallery, Vienna (se)
2002	"Semiotic Landscape", Charim Klocker Gallery, Vienna; National Museum, Warsaw (ge)
	"Schindler Workshop", as part of "Rirkrit Tiravanija", Secession, Vienna (ge)
2004	"Born to be a Star", Künstlerhaus Wien, Vienna (ge)

G.R.A.M.
In 1987, Günther Holler-Schuster, Ronald Walter, Armin Ranner and
Martin Behr founded the group G.R.A.M.

Martin Behr, born 1964 in Graz, lives in Graz, Austria; studied art history
at the Karl Franzens University, Graz, Austria

Günther Holler-Schuster, born 1963 in Altneudörfl, Austria, lives in Graz,
Austria; studied art history at the Karl Franzens University, Graz, Austria

Armin Ranner, born 1964 in Graz, lives in Linz, Austria; studied medicine
at the Karl Franzens University, Graz, Austria

Ronald Walter, born 1961 in Graz, lives in Graz, Austria; studied art
history at the Karl Franzens University, Graz, Austria

1997	"G.R.A.M. Paparazzi", Atelier Augarten, Vienna; Grazer Kunstverein, Graz, Austria (se)
2002	"Wiener Blut", Christine König Gallery, Vienna (se)
	"Schindler Workshop", as part of "Rirkrit Tiravanija", Secession, Vienna (ge)
2003	"Cameron Jamie & G.R.A.M.", Christine König Gallery, Vienna; Kunsthalle K2, Semriach, Austria (ge)
2004	"Flashart Fair", Projektraum Viktor Bucher, Milan, Italy (ge)

Christian Teckert Christof Schlegel Nicole Six

2004 "Wiener Mischung", Museum in progress & Christine König
Gallery, Vienna (se)
„Jagdausflug im Stillen Ozean", Lisi Hämmerle Gallery, Bregenz,
Austria (se and publication)

Christian Teckert & Christof Schlegel

Christian Teckert, born 1967 in Linz, Austria, lives in Vienna and Berlin;
studied architecture at the Academy of Fine Arts, Vienna

1999 "Studiocity. Der mobilisierte Blick", Kunstverein Wolfsburg,
Germany (ge)
"Studiocity. Die televisionierte Stadt", International Press Center,
Vienna; Kunstverein Wolfsburg, Germany (ge)
2000 "Screenclimbing. Vormoderne Körper in nachmodernen Räumen",
Kunstverein Hamburg (se, in collaboration with Christof Schlegel)
2001 "Total Living Industry", Yokohama Museum of Art, Japan (ge)
2003 "Suburban Happiness", Tokyo Designer's Block, Tokyo (ge)

Christof Schlegel, born in 1968 in Innsbruck, Austria, lives in Vienna;
studied architecture at the Academy of Fine Arts, Vienna

2000 "Sukima Projekt 1", Command N Space, Tokyo (ge)
2001 "Sukima Projekt 2", Command N Space, Tokyo (ge)
2003 "Experimental intermedia: Offwalk", Art Centre Vooruit, Ghent (ge)
2004 Participation on the Thailand New Media Art Festival, Bangkok
2005 Participation on the Artist in Residence Program, Nanjing, China

Nicole Six
born in 1971 in Vöcklabruck, Austria, lives in Vienna; studied sculpture at
the Academy of Fine Arts, Rome, and at the Academy of Fine Arts, Vienna;
collaboration with Paul Petritsch since 1997

2002 "CAT Open. Artists' choice", MAK Depot of Contemporary Art
Gefechtsturm Arenbergpark, Vienna (ge)
"Schindler Workshop", as part of "Rirkrit Tiravanija", Secession,
Vienna (ge)
2003 "America", bgf_plattform, Berlin (ge)
2004 "Permanent Produktiv", Kunsthalle Exnergasse, Vienna (ge)
"1-33-33", Atelier & Gallery AREA 53, Vienna (ge)

Martin Liebscher Isa Rosenberger

GROUP V
October 1997 – March 1998

Helena Huneke
born 1967 in Lübeck, Germany, lives in Hamburg; studied industrial design
at the Academy of Fine Arts, Hamburg

2001	"Chamaeleon", Nomadenoase Gallery, Hamburg; Golden Pudel Club, Hamburg (se)
2002	"Neisz' Drap", Maschenmode, Guido W. Baudach Gallery, Berlin (se)
2003	"Fallen Angels", Greene Naftali Gallery, New York (ge)
2004	"Formalismus. Moderne Kunst, heute", Kunstverein Hamburg (ge)

Martin Liebscher
born 1964 in Naumburg, Germany, lives in Berlin; studied art at the
Slade School of Fine Arts, London, and at the Städelschule, Academy of
Fine Arts, Frankfurt

2001	"Visurbia", Kunstverein Ludwigshafen, Germany (se)
2002	"Liebscher Bros. & Friends", Kunsthalle Bremerhaven, Germany (se)
2003	"Kuratoren", Museum für Moderne Kunst, Frankfurt, Germany (se)
2004	"Lange Nacht der Museen", Sammlung Deutsche Börse, Frankfurt, Germany (se)
	"Lost in Tomorrow 2", Asbaeck, Copenhagen, Denmark (ge)

Isa Rosenberger
born 1969 in Salzburg, Austria, lives in Vienna; studied visual arts at the
University of Applied Arts, Vienna

2002	"… Wirklichkeit …", Kunstverein Wolfsburg, Germany (se)
	"Schindler Workshop", as part of "Rirkrit Tiravanija", Secession, Vienna (ge)
2003	"Schöne Aussicht. Modelle in verdichteten Räumen", Kunstverein Langenhagen, Germany (se)
2004	"Sign of the times", Kunst im Porschehof, Porsche Holding; Salzburger Kunstverein, Salzburg, Austria (se)
	"Trading Places", Pump House Gallery, London (ge)

Zsuzsa Schiller Gerry Ammann Rochus Kahr

Zsuzsa Schiller

born 1968 in Budapest, lives in Budapest; studied graphic design at the
Hungarian School of Journalism, studies interior design at the Krea Art
University, Budapest

1995	"Gipsies Living in Cave homes", Hungarian press photo competition, Budapest
1996	"Eastern Europe anno 1995", Amsterdam, Netherlands (ge)
2001	"Continental Breakfast", Hungarian Journalist House, Budapest (se)
2004	Krea Art University, Budapest (ge)

GROUP VI
April – September 1998

Gerry Ammann

born 1962 in Bregenz, Austria, lives in Vienna; studied sculpture at the
Academy of Fine Arts, Vienna

2000	"Gerry Ammann", Johanniterkirche Feldkirch, Austria (se)
2001	"Platons Höhle", Kunsthaus Bregenz, Austria (se)
2002	"Arbeiten am Mann", Secession, Vienna (se)
	"Schindler Workshop", as part of "Rirkrit Tiravanija", Secession, Vienna (ge)
2003	"Art Position", Kunstverein Baden, Austria; Ottakringer Brauerei, Vienna (se)

Rochus Kahr

born in 1966 in Graz, Austria, lives in Vienna; studied stage design at the
University of Music and Dramatic Art and architecture at the Technical
University, Graz, Austria, at Städelschule, Frankfurt, and the École d'architecture de Lille; since 2004 office "monomere" with Thomas Maierhofer

2001	"Primary school Katharinengasse", Vienna (architecture)
2002	"Schindler Workshop", as part of "Rirkrit Tiravanija", Secession, Vienna (ge)
	"Airport Graz Tahlerhof", Graz, Austria (architecture)
2003	"Medical Care Center Wiesenstadt", Vienna (architecture)
2004	"Kitchen-living room, Heinrichstraße", Graz, Austria (architecture)

Marko Lulic Constanze Ruhm

Johan & Åse Frid

Marko Lulic

born 1972 in Vienna, lives in Vienna and New York; studied painting at the
Academy of Fine Arts, Vienna

2000	"Disco Wilhelm Reich", department of art history, Vienna; Medienturm, Graz; Projektraum, Innsbruck, Austria, MAK Center, Los Angeles (se)
2002	"Schindler Workshop", as part of "Rirkrit Tiravanija", Secession, Vienna (ge)
2003	"Ein amerikanisches Geschenk", Salzburger Kunstverein, Austria (se)
2004	"Lulic survived the Titanic", Quartier 21, Vienna (se)
	"Belgrade art inc. Momente des Umbruchs", Secession, Vienna (ge)

Constanze Ruhm

born 1965 in Vienna, lives in Vienna and Berlin; studied visual media
design at the University of Applied Arts, Vienna, and new media at the
Städelschule, Academy of Fine Arts, Frankfurt

1999	"OFF", Kerstin Engholm Gallery, Vienna (se)
2001	"Memory of the Players in a Mirror at Midnight, Version 1.0", Kerstin Engholm Gallery, Vienna (se)
2003	"blindstorey/silencetracks", Sammlung Stift Admont, Austria (se)
2004	"Subroutines", Kunsthalle Bern, Switzerland (se)
	"Virtual Frame by 3", Hutchison 3G Austria; Kunsthalle Wien/ project space, Vienna (ge)

GROUP VII
October 1998 – March 1999

Johan & Åse Frid
collaboration since 1998

Johan Frid, born 1971 in Malmö, lives in Sandviken, Sweden; studied
visual art at the Umea University, Sweden

Åse Frid, born 1969 in Uppsala, lives in Sandviken, Sweden; studied visual
art at the Umea University, Sweden

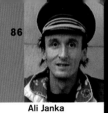

Ali Janka

Tobias Urban Anna Meyer

2000	Ahnlund Gallery, Umea, Sweden (Johan Frid, ge)
	Uppsala Konstmuseum, Uppsala, Sweden (Åse Frid, se)
2002	Valfisken Gallery, Simrishamn, Sweden (Johan Frid, se)
	"Schindler Workshop", as part of "Rirkrit Tiravanija", Secession, Vienna (ge)
	"Wet dreams", Nordic Watercolour Museum, Skärhamm, Sweden (Åse Frid, ge)
2003	Ping Pong Gallery, Malmö, Sweden (Åse Frid, se)
2004	Gävle Hospital, Sweden (workshops)

Ali Janka & Tobias Urban (Gelatin)

In 1995, Wolfgang Gantner, Ali Janka, Florian Reither and Tobias Urban founded the group "Gelatin"

Tobias Urban, born 1966 in Munich, Germany, lives in Vienna; studied painting at the University of Applied Arts, Vienna

Ali Janka, born 1970, lives in Vienna; studied painting at the University of Applied Arts, Vienna

2000	"Lebt und arbeitet in Wien", Kunsthalle Wien, Vienna (ge)
2003	"Dessinez avec Desirée", Meyer Kainer Gallery; kunstbuero; Mezzanin, Vienna (ge)
2004	"Gelatin. Möbelsalon", Meyer Kainer Gallery, Vienna (se)
	"From Above", Georg Kargl Fine Arts, Vienna (ge)
2005	"Dionysac. L'art en flux", Centre Georges Pompidou; Musée National d'Art Moderne, Paris (ge)

Anna Meyer

born 1964 in Schaffhausen, Switzerland, lives in Vienna; studied design at the Academy of Design, Zurich and Lucerne, Switzerland

2000	"Billboards Performance", Krobath Wimmer Gallery, Vienna (se)
2001	"Shopping", Generali Foundation, Vienna (ge)
2002	"Schindler Workshop", as part of "Rirkrit Tiravanija", Secession, Vienna (ge)
2003	"Schach", Krobath Wimmer Gallery, Vienna (se)
2004	"Nippon", Christa Burger Gallery, Munich, Germany (se)

Walter Kräutler & Carl Schläffer

Wolfgang Koelbl

Judith Ammann

Walter Kräutler & Carl Schläffer (Raw 'n Cooked)
collaboration from 1995 to 1999

Walter Kräutler, born 1974 in Hohenems, Austria, lives in Vienna; studied architecture at the Technical University and the Academy of Fine Arts, Vienna

Carl Schläffer, born 1973 in Mittersill, Austria, lives in Vienna; studied architecture at the Technical University and at the Academy of Fine Arts, Vienna

1997	"moving velum", Semperdepot, Vienna (ge)
	"Imaginary Cairo", Semperdepot, Vienna (Walter Kräutler, ge)
1998	"Buthan", Academy of Fine Arts, Vienna (Walter Kräutler, ge)
	"dokumenta X kassel" (video presentation, ge)
2000	"Las Vegas", Albertina, Vienna (Walter Kräutler, ge)
2001	"Art Factory Chengdu", Chengdu, China (Walter Kräutler, ge)

GROUP VIII
April – September 1999

Judith Ammann
born in Grosswangen, Switzerland, lives in Frankfurt, Germany; studied graphic design at the Academy of Design, Lucerne, Switzerland

1987	"Who's Been Sleeping In My Brain? Interviews Post Punk", Suhrkamp, Frankfurt (publication)
1997	"Henri Rollins (sort of a portrait 1983_1989)", Museum of Modern Art; Institute for New Media; Hessisches Filmfestival; Anita Beckers Gallery, Frankfurt; Hochschule für Gestaltung, Offenbach, Germany (video)
2002	Martina Detterer Gallery, Frankfurt, Germany (se)
2003	Ars Electronica Center/Off-Screen, Linz, Austria (ge)
2004	Martina Detterer Gallery, Frankfurt, Germany (se)

Wolfgang Koelbl
born 1965 in Tulln, Austria, lives in Vienna; studied architecture at the Technical University, Vienna, at the University of Michigan and at the University of Strathclyde, Glasgow

Mathias Poledna

Michael Wallraff

Franka Diehnelt &
Karoline Streeruwitz

2000	"Tokyo Superdichte", Ritter, Klagenfurt (publication)
2004	"Architektur-Innereien. Über Innovation, Pornografisierung und renitente Amateure", Ritter, Klagenfurt (publication)

Mathias Poledna

born 1965 in Vienna, lives in Los Angeles; studied art at the University of Applied Arts, Vienna

2000	"Pop Unlimited", Short Film Festival Oberhausen, Germany (ge)
2002	"Tu m' ", Meyer Kainer Gallery, Vienna (ge)
2003	Museum Moderner Kunst Stiftung Ludwig, Vienna (se)
	"Mixtapes", Wattis Institute for Contemporary Art, San Francisco (ge)
2004	Meyer Kainer Gallery, Vienna (se)

Michael Wallraff

born 1968 in Munich, Germany, lives in Vienna; studied stage design at the Academy of Fine Arts and architecture at the Academy of Applied Arts, Vienna, and at the Southern California Institute of Architecture, Los Angeles

2000	"Muthgasse", Vienna (city planning project together with F. Haydn)
2002	"MAK Design Shop", MAK Vienna (architecture)
	"Schindler Workshop", as part of "Rirkrit Tiravanija", Secession, Vienna (ge)
2003	"Kurt Kocherscheidt. The Continuing Image", MAK Vienna (technical coordination)
	"Gilbert Bretterbauer. Textilwelt", MAK Vienna (technical coordination)

GROUP IX
November 1999 – March 2000

Franka Diehnelt & Karoline Streeruwitz

Franka Diehnelt, born 1972 in Magdeburg, Germany, lives in Los Angeles and Vienna; studied architecture at the Academy of Fine Arts, Vienna, and at the Kongelige Danske Kunstakademi, Copenhagen, Denmark

Jun Yang

Sophie Esslinger

Beatrice Dreux

2000 "Rebeka Headquarter", Kunstverein Wolfsburg, Germany (ge)
2003 "Outside In", Fresh Art at Clover Park, Santa Monica (installation)
2004 "Habitat 825", Los Angeles (architecture)

Karoline Streeruwitz, born 1977 in Vienna, lives in Vienna; studied
architecture at the University of Applied Arts and at the Academy of
Fine Arts, Vienna, and at the University of Buenos Aires, Argentina

1999 "Nicht aus einer Position", Academy of Fine Arts, Vienna (ge)
2000 "Rebeka Headquarter", Kunstverein Wolfsburg, Germany (ge)
2004 "Der Büromat, Schönbrunner Straße 88a", Vienna (street project)
2005 "Das Neue Europa. Kultur des Vermischens und Politik der
 Repräsentation", Generali Foundation, Vienna (ge)

Beatrice Dreux
born 1972 in Versailles, France, lives in Vienna; studied painting at the
Academy of Fine Arts, Vienna

2002 "Schindler Workshop", as part of "Rirkrit Tiravanija", Secession,
 Vienna (ge)
2003 "Propos de Peinture", Erban Gallery, Nantes, France (ge)
2004 "Amoureux Solitaires", Menotti Gallery, Baden, Austria;
 Latal Gallery, Zurich (se)
2004 Hubert Winter Gallery, Vienna (se)

Sophie Esslinger
born 1970 in Graz, Austria, lives in Vienna; studied architecture at the
Academy of Fine Arts, Vienna, and at the Escola Tècnica Superior
d'Arquitectura de Barcelona, Spain

2001 "Ra'mien, Gumpendorferstraße 9", Vienna (architecture)
2002 "Mega", Künstlerhaus Wien, Vienna (ge)
2003 "Ra'an, Währinger Straße 6_8", Vienna (architecture)
2004 "Tien-tien, Ramperstorffergasse 47", Vienna (architecture)

Jun Yang
born 1975 in Tiensin, China, lives in Vienna; studied media at the Gerrit
Rietveld Akademie, Amsterdam, Netherlands, and at the Academy of Fine
Arts, Vienna

Birgitta Rottmann Markus Schinwald Meike Schmidt-Gleim

2001	"Coming Home. Daily Structures of Life – Version D00", Galerie für Zeitgenössische Kunst, Leipzig, Germany; MAK, Vienna; Art Statement, Basel, Switzerland (se)
2002	"Get out!", Arsenale Gallery, Bialystok, Poland (ge)
2003	Martin Janda Gallery, Vienna (se)
	"Transkulturell", Overbeck-Gesellschaft, Lübeck, Germany (ge)
2004	Büro Friedrich, Berlin (se)

GROUP X
April – September 2000

Birgitta Rottmann
born 1974 in Kufstein, Austria, lives in Rotterdam, Netherlands; studied architecture at the Technical University, Innsbruck, Austria, and at the Technical University, Delft, Netherlands

2000	"Virtual Island", Delft, Netherlands (video)
2001	"Art-Land", Biennial on media and architecture, Graz, Austria (se)
2003	"Koninginnen van de Nacht", Kunsthal Rotterdam, Netherlands (se)
2004	"Bulb&Breakfast", Lisse, Netherlands (competition)

Markus Schinwald
born 1973 in Salzburg, Austria, lives in Vienna; studied visual design at the Academy of Artistic and Industrial Design, Linz, Austria, and cultural studies at the Humboldt University, Berlin

2001	"diction pii", Moderna Museet, Stockholm, Sweden (se)
2002	"... seconds", Kunstverein Goldegg, Austria (se)
2003	"Bewitched, Bothered and Bewildered", Migros Museum, Zurich (ge)
2004	"Tableau Twain", Frankfurter Kunstverein, Germany (se)
	"Black Friday Exercises in Hermetics", Kamm Gallery, Berlin (ge)

Meike Schmidt-Gleim
born 1972 in Wolfsburg, Germany, lives in Paris; studied philosophy at the University of Vienna and painting at the Academy of Fine Arts, Vienna

2001	"Das Experiment", Secession, Vienna (ge)
2002	"Schindler Workshop", part of "Rirkrit Tiravanija", Secession, Vienna

Siggi Hofer Susanne Jirkuff Lisa Schmidt-Colinet

2003 "Did you ever dream of becoming", Public>Gallery, Paris (ge)
2004 "Dass die Körper sprechen, das wissen wir seit langem",
 Generali Foundation, Vienna (ge)
 "Born to be a star", Künstlerhaus Wien, Vienna (ge)

GROUP XI
October 2000 – March 2001

Siggi Hofer
born 1970 in Brunico, Italy, lives in Vienna; studied painting at the Master
School of Painting, Graz, Austria, and graphic design at the University of
Applied Arts, Vienna

2000 "whippersnapper", Vedanta Gallery, Chicago (ge)
2002 "Schindler Workshop", as part of "Rirkrit Tiravanija", Secession,
 Vienna (ge)
2003 "My life is your life", Austrian Cultural Forum, London (se)
2004 "Wiener Linien. Kunst und Stadtbeobachtung seit 1960",
 Wien Museum Karlsplatz, Vienna (ge)

Susanne Jirkuff
born 1966 in Linz, Austria, lives in Vienna; studied sculpture at the
Academy of Artistic and Industrial Design, Linz, Austria, and at the
University of East London, London

2002 "About Being Away", Oberösterreichische Landesgalerie im
 Francisco-Carolinum, Linz, Austria (se)
2003 "Tricky Women", Animation Festival, Vienna; Screening
 Imageforum, Tokyo (ge)
 "Present Perfect", gb agency Gallery, Paris (se)
2004 "I make you dance, Motherf*****", 5020 Gallery, Salzburg, Austria (se)

Lisa Schmidt-Colinet & Alexander Schmoeger
collaboration since 2000

Lisa Schmidt-Colinet, born 1975 in Munich, Germany, lives in Vienna;
studied architecture at the Technical University, Munich, Germany, and at
the Academy of Fine Arts, Vienna

Alexander Schmoeger Florian Zeyfang

1999	"Pudong project", Tongji University, Shanghai, China (ge)
2002	"Oh wie schön ist Panama", Künstlerhaus Wien, Vienna (ge)
2003	"dori–dorak", Műcsarnok, Budapest (ge)

Alexander Schmoeger, born 1971 in Augsburg, Germany, lives in Vienna; studied architecture at the Academy of Fine Arts, Vienna

| 2002 | "The Antagonists", McAllister Art Institute, New York (ge) |
| | "Oh wie schön ist Panama", Künstlerhaus Wien, Vienna (ge) |

Florian Zeyfang

born 1965 in Stuttgart, Germany, lives in Berlin; studied architecture at the University of the Arts, Berlin

2002	"A Portrait A Design", Galerie im Parkhaus, Berlin (se)
	"The Antagonists", The McAllister Institute, New York (ge)
2003	"Unbekannte Schwester, unbekannter Bruder", Kunsthaus Dresden, Germany (ge)
2004	"Transmission Attempts Relocated", Vector Gallery, Iasi, Romania (se)

In 2000, Siggi Hofer, Susanne Jirkuff, Lisa Schmidt-Colinet, Alexander Schmoeger, Florian Zeyfang and Eugenio Valdez Figueroa founded the group "Rain".

2001	"Hallway", MAK, Vienna (se)
2002	"Schindler Workshop", as part of "Rirkrit Tiravanija", Secession, Vienna (ge)
	"Super-Mover", photo festival, Houston (se)
2003	"4 D four dimensions, four decades", Havanna Biennial, Cuba (se)

GROUP XII
April – September 2001

Dorit Margreiter
born 1967 in Vienna, lives in Vienna and Los Angeles; studied media at the University of Applied Arts, Vienna

| 2002 | "Plus Ultra", Kunstraum Innsbruck, Austria (ge) |

Barbara Kaucky

| 2003 | "Under Construction", Rupertinum, Salzburg, Austria (ge) |
| 2004 | "SHAKE im O.K.", Zentrum für Gegenwartskunst, Linz, Austria (ge) |

"10104 Angelo View Drive", Museum Moderner Kunst Stiftung
Ludwig, Vienna (se)

"Performative Installation #4. Body Display. Körper & Ökonomie",
Secession, Vienna (ge)

Barbara Kaucky

born 1970 in Vienna, lives in London; studied architecture at the
University of the Arts, Berlin, and at the Academy of Fine Arts, Vienna;
2003 founding member and since partner of "erect architecture", London

1998	"Out of Focus", Urban Issue Gallery, Berlin (se)
2000	"Studio Weil", Port d'Andratx, Spain (architectural collaboration in the studio Libeskind)
2002	"Gourmet Coffee Warehouse", Los Angeles (architecture)
2003	"New built media gallery in Hayes", London (architecture)

Florian Pumhösl & Martha Stutteregger

Florian Pumhösl, born 1971 in Vienna, lives in Vienna; studied graphic
design at the University of Applied Arts, Vienna

2000	"Humanist and Ecological Republic and Lac Mantasoa", Secession, Vienna (se)
2001	"Du bist die Welt", Künstlerhaus Wien, Vienna (ge)
2002	"Nachgemacht. Künstliche Natürlichkeit – Simulierte Natur", Kunstraum Innsbruck, Austria (ge)
2004	Centre d'édition contemporaine, Geneva, Switzerland

Martha Stutteregger, born 1970 in Gmunden, Austria, lives in Vienna;
studied graphic design at the University of Applied Arts, Vienna

2001	"Sturm der Ruhe. What is Architecture?", Pustet, Regensburg, Germany (graphic design)
2003/05	"Sala Rekalde", Bilbao, Spain (book design)
2004/05	Schirn Kunsthalle, Frankfurt, Germany (book design)
2005	"Cerith Wyn Evans", Bawag Foundation Edition, Vienna (graphic design)

Michael Wildmann Mauricio Rafael Duk Gonzáles José Pérez de Lama

Michael Wildmann

born 1966 in Linz, Austria, lives in Vienna; studied architecture at the
Technical University, Vienna, and at the McGill University Montreal,
Canada; 2003 founding member of raum+

1998	"ca 900 … multitastasking", Rotterdam, Netherlands (architecture)
2001	"ilmc69", Villach, Austria (architectural project)
2002	"Instant fireplace", Secession, Vienna (ge)
	"Schindler Workshop", as part of "Rirkrit Tiravanija", Secession, Vienna (ge)

GROUP XIII
October – February 2002

Mauricio Rafael Duk Gonzáles

born 1971 in Mexico City, lives in Los Angeles; studied architecture at the
Universidad La Salle, Mexico City

2002	"Laurelway Residence", Los Angeles (architecture)
2003	"Magnolias Residence", Mexico City (architecture)
2004	"Kepler Tower", Puebla, Mexico (architecture)
	"Wetherly Residence", Los Angeles (architecture)

Richard Hoeck

born 1965 in Hall, Austria, lives in New York; studied painting and
graphic design at the University of Applied Arts, Vienna

1999	"Hard Hat", Kunstwerke, Berlin (se)
2003	"Faking Real", Leroy Nieman Gallery, New York (ge)
2004	"The Big Nothing", University of Pennsylvania (ge)
2005	"Spiegel Archiv Projekt", Deichtorhallen, Hamburg (ge)

José Pérez de Lama

born 1962 in Sevilla, Spain, lives in Sevilla and Los Angeles; studied
architecture at the University of Sevilla, Spain, and at the University of
California, Los Angeles

2001	"Entre Blade Runner y Mickey Mouse. Nuevas arquitecture en Los Angeles", Madrid, Spain (curator)

Lorenzo Rocha Cito

2002 "Some ideas about anarchic urbanism" (video)
"The EZLA (Zapatista Army of Architectural Liberation) takes
Rudolf Schindler's Kings Road House" (video)
"Schindler Workshop", as part of "Rirkrit Tiravanija", Secession,
Vienna (ge)

Kobe Matthys
born 1970 in Ghent, Belgium, lives in Brussels, Belgium; studied
communication sciences and culture at the Free University of Brussels,
Belgium, and visual arts and media at the University of Fine Arts,
Frankfurt, Germany

1998 Stella Lohaus Gallery, Antwerp, Belgium (se)
2002 "Ideas for living", Foundation Art and Public Space, Amsterdam,
Netherlands (ge)
2003 "Legal space/public space", établissement d'en face, Brussels,
Belgium (ge)
2004 "Vollevox #7", Royal Museum of Fine Arts, Brussels, Belgium

GROUP XIV
May – September 2002

Lorenzo Rocha Cito
born 1967 in Mexico City, lives in Mexico City; studied architecture at the
Universidad Nacional Autónoma de México

1999 "Creación en Movimiento, Jóvenes Creadores, Novena Muestra",
Main Gallery at the National Center for the Arts, Architecture
and Urbanism Institute and Housing Institute of Mexico City (ge)
2000 "Guest Apartment on calle Río Grijalva", Mexico City
(architecture)
2003 "L'Isola dell'Arte in Milano", Galleria Giocca Arte Contemporanea,
Milan, Italy; Musée d'art moderne et contemporain, Geneva,
Switzerland (ge)

Luisa Lambri
born 1969 in Como, Italy, lives in Milan, Italy, and in London;
studied visual arts at the Università Statale di Bologna, Italy

Karina Nimmerfall

Bernhard Sommer

Antonietta Putzu

2001	"Chain of Visions", Hara Museum of Contemporary Art, Tokyo (ge)
2002	"The Secret of the Light", Deutsches Architektur Museum, Frankfurt, Germany (ge)
2003	Studio Guenzani, Milan, Italy (se)
2004	"Locations", Menil Collection, Houston (se)
2005	Marc Foxx Gallery, Los Angeles (se)

Karina Nimmerfall

born 1971 in Deggendorf, Germany, lives in Berlin; studied art history at the University of Vienna and arts at the Academy of Fine Arts, Hamburg

2001	"Glück statt Plastik", Kunstverein Glückstadt, Germany (ge)
2002	"Schindler Workshop", as part of "Rirkrit Tiravanija", Secession, Vienna (ge)
2003	"Echo Sparks", Ars Electronica Center, Linz, Austria; kunstbuero, Vienna (ge)
2004	"... and in between", Grita Insam Gallery, Vienna (ge)
	"Day for Night", Bucket Rider Gallery, Chicago (se)
2005	"Second Unit", Grita Insam Gallery, Vienna (se)

Bernhard Sommer

born 1969 in Mödling, Austria, lives in Vienna; studied architecture at the Technical University, Vienna

2002	"Niederecker House", Berndorf, Austria (architectural project)
2003	"wolken <transformer 3> 03", Museumsquartier, Vienna (installation)
2004	"Falnbigl Apartments Lindengasse", Vienna (architectural project)

GROUP XV
October 2002 – March 2003

Thomas Gombotz & Antonietta Putzu

Thomas Gombotz, born 1973, lives in Vienna; studied architecture at the Academy of Fine Arts, Vienna

Antonietta Putzu, born 1975 in Zurich, lives in Vienna; studied architecture at the Academy of Fine Arts, Vienna

Pia Rönicke Una Szeemann Zlatan Vukosavljevic

2003 "Home Scenes", Schindler House, Los Angeles (ge)

Pia Rönicke

born 1974 in Roskilde, lives in Copenhagen, Denmark; studied architecture at the Kongelige Danske Kunstakademi, Copenhagen, Denmark, and at the California Institute of the Arts, Valencia

2001 "Dedalic Convention", MAK, Vienna (ge)
2002 "A Place Like Any Other", Tommy Lund Gallery, Copenhagen, Denmark (se)
2003 "Plunder", Dundee Contemporary Arts, Dundee, Scotland (ge)
2004 "Without a Name", G&B Agency Gallery, Paris (se)

Una Szeemann

born 1975 in Locarno, Switzerland, lives in New York and Zurich; studied drama at the Scuola per lo Spettacolo and Teatri possibili, Milan, Italy

2003 "The crystal massacre" (video installation)
2004 "The Beauty of Failure, The Failure of Beauty", Fondacion Miró, Barcelona, Spain (se)
 "Video, Video, Film!", Ausstellungsraum 25, Zurich (se)
 "Thrill me" (video production)

Zlatan Vukosavljevic

born 1958 in Pozarevac, Serbia, lives in San Diego; studied architecture at the University of Belgrade, Serbia

1999 "Incontro con Franz West", Kalb Gallery, Vienna (ge)
2001 "12 Scores for electronic music", Repair Department, San Diego (se)
2002 "Kiss me deadly", Digitaria, San Diego (se)
2004 "Manual", Q21, Vienna (se)
 "Moving Parts", Kunsthaus Graz, Austria (ge)

Nicolas Février &
Roland Oberhofer

Christoph a. Kumpusch

Suwan Laimanee

GROUP XVI
April – September 2003

Nicolas Février & Roland Oberhofer

Nicolas Février, born 1976 in Nice, France, lives in Paris; studied architecture at the School of Architecture, Paris-LaSeine, France, at the Technical University of Delft, Netherlands, and at the Academy of Fine Arts, Vienna

Roland Oberhofer, born 1976 in Bressanone, Italy, lives in Vienna; studied architecture at the Technical University and at the Academy of Fine Arts, Vienna, and at the School of Architecture Paris-LaSeine, France

1998	"Landscape + E", Technical University of Delft, Netherlands (Nicolas Février, ge)
1999	"Paris IntraMuros", School of Architecture Paris-LaSeine (se) "Sorkin Studio", Technical University of Berlin (Roland Oberhofer, ge)
2000	"Vienna-Bratislava", Academy of Fine Arts, Vienna (se)
2001	"Histoire(s) de Marseilles", School of Architecture Paris LaSeine (se)

Christoph a. Kumpusch
born 1979 in Graz, Austria, lives in Vienna and Los Angeles; studied philosophy at the Webster University, Vienna and architecture at the University of Applied Arts, Vienna, at the Berlage Institute, Rotterdam, Netherlands, and at the Cooper Union, New York

2002	"WW-Warped Wave", Musée des Confluences, Lyon, France (architecture)
2002/03	"AA-Alien Automaton", Highline Reactivation, New York (architecture)
2003	"LA-Archetypes", Absolut L.A. Art Biennial, Los Angeles (architecture)
2004	"Showdown", Los Angeles (architecture)

Suwan Laimanee
born 1951 in Prathet Thai, lives in Chiang Mai, Thailand, and Vienna; studied visual communication at the University of Applied Sciences, Dortmund, Germany, and sculpture at the Academy of Fine Arts, Vienna

Corinne L. Rusch

Catrin Bolt

Marlene Haring

1998	"Raum", Künstlerhaus Wien, Vienna (ge)
2000	"Year Zero", Cittadellarte, Biella, Italy (ge)
2004	"Art Market", The National Gallery of Art, Bangkok, Thailand (ge)

Corinne L. Rusch

born 1973 in Guatemala, lives in Vienna; studied stage design and film at the University of Applied Arts, Vienna

2001	"Der zweite Sonntag im Mai", Gessnerallee, Zurich (stage design and costumes)
2003	"suitetalk", Laurin Gallery, Zurich (se)
2004	Laurin Gallery, Zurich (ge)
2005	"That's New", IG Bildende Kunst, Vienna (ge)

GROUP XVII
October – March 2004

Catrin Bolt & Marlene Haring

in 1999, Catrin Bolt and Marlene Haring founded "halt+boring"

Catrin Bolt, born 1979 in Friesach, Austria, lives in Vienna; studied computer and video art at the Academy of Fine Arts, Vienna

Marlene Haring, born 1978 in Vienna, lives in Vienna; studied computer and video art at the Academy of Fine Arts, Vienna

2000	"cartoons", MAK, Vienna (MAK NITE©)
2002	"Double heart – hear the art", Kunsthalle Exnergasse, Vienna (ge)
2003	"Cracks in the wall", Lisi Hämmerle Gallery, Bregenz, Austria (se)
	"Anger", Academy of Fine Arts, Vienna (ge)
2004	Pavel House, Radkersburg, Austria (ge)
	"Schöne Aussichten", public space, Reinsberg, Austria; Secession, Vienna (Catrin Bolt, ge)
	"Just what it is… #1", Kunstraum Innsbruck, Austria (Marlene Haring, ge)
2005	"That's New", IG Bildende Kunst, Vienna (Catrin Bolt, ge)

Oliver Croy

Robert Gfader

Deborah Ligorio

Miriam Bajtala

Oliver Croy
born 1970 in Berlin, lives in Berlin; studied sculpture at the University of Applied Arts, Vienna

2000 "Lebt und arbeitet in Wien", Kunsthalle Wien, Vienna (ge)
2001 "Sondermodelle", Deutsches Architektur Museum, Frankfurt, Germany (ge)
2002 "Sub-Urban", loop – Raum für aktuelle Kunst, Berlin (ge)
2004 "Papierarbeiten von Männern", Oderbergerstr. 61, Berlin (ge)

Robert Gfader
born 1967 in Munich, Germany, lives in Innsbruck, Austria; studied architecture at the Technical University of Innsbruck, Austria

2002 "Flüchtig daheim", Soho in Ottakring, Vienna (photo installation)
2003 "Von Dackel bis Nilfisk", Theodor von Hörmann Gallery, Imst, Austria (se)
2004 "Papierarbeiten von Männern", Oderbergerstraße 61, Berlin (ge)
2005 "Fundamental Surface", Kunstraum Innsbruck, Austria (se)

Deborah Ligorio
born 1972 in Brindisi, Italy, lives in Milan, Italy, and Berlin; studied architecture at the Brera Academy of Art, Milan, and at the Academy of Art, Bologna, Italy

2003 "Defrag", Suite 106, New York (architecture)
2004 "Deborah Ligorio and Laura Horelli", Kunstbank, Berlin (ge)
 "3+", Kopenhagenerstraße 72, Berlin (architecture)
2005 "Follow your Shadow – Premio FURLA per l'arte", Galleria d'Arte Moderna, Bologna, Italy (ge)

GROUP XVIII
April – September 2004

Miriam Bajtala
born 1970 in Bratislava, Slovakia, lives in Vienna; studied at the University of Vienna and at the Academy of Fine Arts, Vienna

2002 "facing 1", Galerie der Stadt Wels, Austria (ge)

Florian Hecker Barbara Holub & Paul Rajakovics Constanze Schweiger

	"CAT Open. Artists' choice: so als ob", MAK Depot of Contemporary Art Gefechtsturm Arenbergpark, Vienna (se)
2003	"drei Projektionsflächen", Fotogalerie Wien, Vienna (ge)
2004	"no risk no glory", loop _ Raum aktueller Kunst, Berlin (ge)
2005	"can't see nothing", dreizehn zwei, Vienna (ge)

Florian Hecker

born 1975 in Augsburg, Germany, lives in Vienna; studied media arts at the Ludwig Maximilian University, Munich, Germany, and at the Academy of Fine Arts, Vienna

2001	"Mutations", TN Probe Gallery, Tokyo (ge)
	"Ausgeräumt…", Secession, Vienna (ge)
2004	"Off the Record", Musée d'Art Moderne, Paris (ge)
	"KW", Institute for Contemporary Art, Berlin (audio presentation)

Paul Rajakovics & Barbara Holub (transparadiso)

in 1999, Paul Rajakovics and Barbara Holub founded "transparadiso"

Paul Rajakovics, born 1963 in Bruck/Mur, Austria, lives in Vienna studied architecture at the Technical University in Graz, Austria

Barbara Holub, born 1959 in Stuttgart, Germany, lives in Vienna studied architecture at the Technical University, Stuttgart, Germany

2003	"Wonderland", Zumtobel Lichtforum; Architekturzentrum, Vienna (se)
2004	"One in a million", Austrian Cultural Forum, New York (se)
	"Das Indikatormobil – urbane Intervention", MAK, Vienna (se)
	"Paula's home", Lentos Kunstmuseum, Linz, Austria (Barbara Holub, se)
2005	"Geschlossene Gesellschaft", MAK, Vienna (MAK NITE©)

Constanze Schweiger

born 1970 in Salzburg, Austria, lives in Vienna; studied painting at the University of Applied Arts, Vienna and at the Jan van Eyck Academy, Maastricht, Netherlands

1997	"Salon Maison", kunstbuero, Vienna (se)
2001	"Constanze Schweiger", Galerie 5020, Salzburg, Austria (se)
2003	"Friends", Priska Juschka Fine Art, New York (se)
2004	"Chameleons and Quilts", Priska Juschka Fine Art, New York (se)
	"Born to be a star", Künstlerhaus Wien, Vienna (ge)

Juries of the MAK Center Artists and Architects in Residence Program 1995–2004

1995: Daniela Zyman, Erika Billeter, Gunter Damisch, Gregor Eichinger, Peter Noever, Achille Bonito Oliva (clockwise from left)

1996: Brigitte Kowanz, Erika Billeter, Peter Noever, Gregor Eichinger, Daniela Zyman, Catherine David

1997: Peter Noever, Lebbeus Woods, Isabelle Graw, Veit Görner, Daniela Zyman, Peter Kogler

1998: Daniela Zyman, Carl Pruscha, Peter Noever, Isabelle Graw, Veit Görner, Peter Kogler

1999: Daniela Zyman, Jannis Kounellis, Ute Meta Bauer, Elisabeth Schweeger, Helmut Richter, Michelle Coudray, Peter Noever

2000: Renée Green, Peter Noever, Beat Wyss, Bart Lootsma, Okwui Enwezor

2001: Hans-Ulrich Obrist, Peter Noever, Herbert Muschamp, Viktor Misiano, Vito Acconci

2002: Boris Groys, Peter Noever, Franz Graf, Zvi Hecker, Egidio Marzona

2003: Farshid Moussavi, Francesco Bonami, Peter Noever, Martina Kandeler-Fritsch, Martin Prinzhorn, Heinrich Pichler

2004: Martina Kandeler-Fritsch, Kimberli Meyer, Eric Alliez, Harald Falckenberg, Eva Schlegel, Greg Lynn, Peter Noever

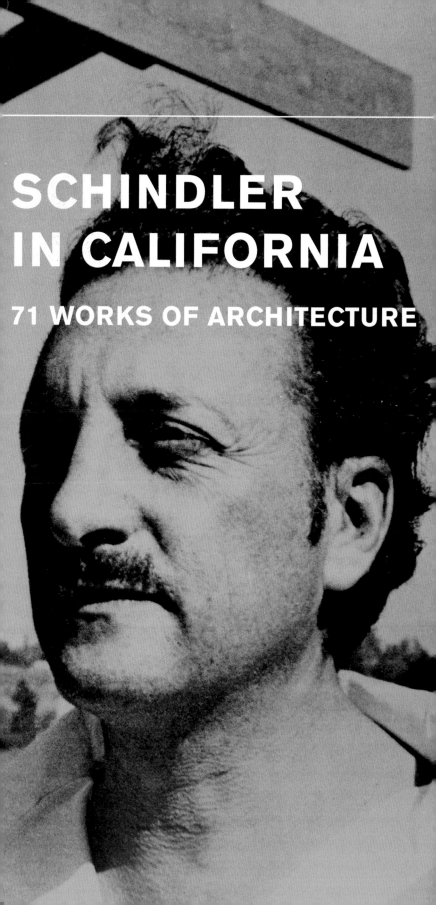

SCHINDLER
IN CALIFORNIA

71 WORKS OF ARCHITECTURE

Biographical Notes on R. M. Schindler Architect, 1939

I n the summer of 1911, in the Austrian mountains, a young architectural student on vacation stood in one of the earth-bound cottages of Styria. As he looked around the bulky little house, at the walls built clumsily from the stone of the mountain, the realization came to him that here, in a primitive state, was the essence of all architecture of the past – a piling up of building material in such a way as to form hollows for human use. All effort to give form to the pile had resolved itself into carving and embellishing. No matter how skillful the architects subsequently became at creating a sculptural beauty, the historical architectural styles of the Occident remained sculpture.

But, as the young architect realized as he stepped from the dark peasant cottage and faced the wide sky, outside was the new medium of the architect: SPACE – the use of which has been made possible in our time by modern science and engineering.

This young architect was R. M. Schindler, now of Los Angeles. His life work has particular significance because of this early recognized and long developed concentration on space itself as the medium of architectural design. Schindler states that architecture is actually being born in our time; that in all truly modern buildings the attitude of the architect is fundamentally different from that of the sculptor. His concern is to create space forms, dealing with a new medium of expression as rich in possibilities as are the other media of art: color, sound, mass, etc.

Schindler received his conventional architectural training in Vienna, graduating from the University of Vienna and from the Academy of Arts. He realized the full direction of his life's work as an architect in his association with his teacher at the Academy of Arts, Otto Wagner, a man taking a lone

stand in Vienna against the stuffiness and architectural deadness of the past. Wagner's ideas, along with the work of the moderns beginning to appear in Europe and, a little later, rumors of a new architect in America – Frank Lloyd Wright – greatly interested and stimulated the young architect's thoughts.

After graduation, Schindler entered the firm of Hans Mayr in Vienna as a student associate, remaining for two years. During this time he had the chief part in the designing and building of the Österreichischer Bühnen-Verein, a structure with definitely modern lines, although restricted by building-department regulations to conform with the architecture of the neighbor-hood. Rebelling against such restrictions, Schindler's interest in America and its possibilities continued to be dominant. Everything he heard about America at this time stirred him: its vastness, the vigor and freshness of its outlook, its Frank Lloyd Wright. When, early in 1914, he read an advertise-ment of the firm of Ottenheimer in Chicago, seeking the services of archi-tectural draftsmen, Schindler answered it and came to America, intending to

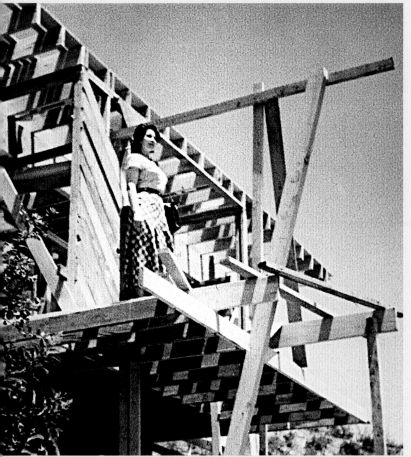

Ellen Janson at her house during construction, ca. 1949.

stay for a year. He never returned to Europe, but remained in the United States and became a citizen. He was with Ottenheimer for four years, supervising the building for the Elks Club, designing the Buena Shore Club in Chicago, and teaching at the Church School of Arts.

During this early time in America, Schindler was studying the work of Frank Lloyd Wright and the ideas of Wright's brilliant and idealistic teacher, Louis Sullivan. Schindler was convinced that Wright was the only one of the moderns with a viewpoint essentially creative and American. In 1918, Schindler went to Spring Green, Wisconsin, and joined Wright, living and working with him at his home, Taliesin. Schindler assisted Wright on the plans for the Imperial Hotel in Tokyo, and remained in charge of Wright's office when the older architect went to Japan.

In 1921, Schindler came to Los Angeles to superintend completion of the building of the Barnsdall house on Olive Hill. This residence, Hollyhock House, because of personal conflicts between the owner's secretary, the builder, and Wright, complicated by the owner's inconsistencies, had a long and difficult construction period. Without Schindler's devotion and patience the building would probably never have been finished. By the time it was completed, Schindler had decided to remain in Los Angeles and establish his own practice. He believed that the West, with its spaciousness and wide possibilities for wholesome living, its freer aspect toward new ideas, might welcome an architect with a dream.

Shortly after this decision he built his own home (1922). This residence is an early experimental example of Schindler's work, built with a minimum of time and expense, and designed at a time when other modern work was rigidly adhering to the classical syntax of base and shaft and crown, is still an outstanding example of his theories: using space itself as the material of architecture, and utilizing every possibility of light, view, privacy, and outdoor living. This low-built house turns its back to the street and opens wide arms upon garden spaces and a view of distant mountains. In the construction Schindler used prefabricated slabs of natural colored concrete, cast flat on the floor and raised after setting, in a system invented by him – the "Slab-Tilt" system. Each unit of the house encloses and is a part of its own garden.

The main features as first applied to this house, such as the cellarless rambling one-story construction, low on the ground, the floor extending without steps into the garden, the full height glass wall with large sliding door on the patio side, under ample overhangs, the flat shed roof with clearstory windows, the solid back wall for privacy, the movable partitions for flexibility – all these features have become standards for the modern house. The construction, also, introducing standardized prefabricated wall units, was ahead of contemporaneous experiments, with their pre cast full-length walls containing conventional window openings.

Schindler was the first modern architect to settle in Los Angeles. Since 1921, he has practiced there, although he has also designed several buildings in other cities, and has lectured and held exhibitions up and down the California coast to introduce contemporary thought against the resistance of schools and publications. Like all innovators, particularly those with creative genius, his way has never been an easy one. Often he had worked under the most difficult of circumstances, against adverse criticism, hampered by bankers and building officials whose taste has been crystallized along traditional lines, and by conventionally trained workmen. In fact, he has had to be able to do everything himself – he has had to be expert carpenter, mason, electrician, as well as architect. Experience has shown him that it is not practicable or even possible to leave to a general contractor the building of a modern house with individuality – and all truly modern houses are individual. The architect must be able to undertake the whole job himself. But Schindler has never compromised, never departed from his ideal of creating space forms that exist as integral parts of the surrounding atmosphere, articulated functionally for the dwellings and working places of men and women. Slowly and surely he has developed his technique, based on what he calls his "form vocabulary." It means just that: the careful selection and invention of the details or elements with which an architect expresses, in construction, his creative ideas.

Schindler's clientele has been for the most part among intellectuals, who are seldom wealthy: therefore he has had to develop a modern house for the cost of a conventional one. He was the first architect to accomplish this successfully, using standard techniques and materials, and producing a moderately-priced modern house instead of the luxury product which was publicized as "modern" at that time.

Since living in Southern California, Schindler has concentrated on developing an architecture particularly suited to this section of the United States, with its slight seasonal variations, its strong but moderated sunlight, its subtle colorings of atmosphere, and its possibilities of almost year-long outdoor living. He believes that many of the modern architectural ideas developed in Europe since the First World War and since transferred to the United States and to some degree developed there, are, in their so-called "functionalism", their very insistence upon a bleak and unimaginative efficiency, as unsuited to the West as are the outworn conventional styles. California life has space and leisure to express light-heartedness, charm, imagination; Schindler believes the homes of Californians, too, should include these qualities.

An example of Schindler's outstanding work in moderately priced homes is the residence of William Oliver, overlooking Silverlake, in Los Angeles. Clinging to the hilltop as if with a winged lightness, it still is strongly articulated, with horizontal planes and wide expanses of glass, a pale golden-tan house that blends harmoniously with both the hill and the sky. The living

Pueblo Ribera Apartments.

room, which overlooks the lake and valley, framed in clear reaches of glass, has a startling effect of space, light, cleanliness, of simplicity, of a complete and unified whole. Unadorned walls, of the same soft golden tan as the out-side walls, are made interesting by patterns of light and shade. Actually the house is a weave of a few colors and materials, its walls not used as a means of expression in themselves but to enclose space forms. Partitions of frame-less glass reaching from door height to ceiling between rooms heightens the affect of oneness. In order to make large unbroken expanses of glass possible, Schindler developed the "bar-sash," a horizontally sliding sash of sheet metal.

An earlier and effective hillside residence by Schindler is the Wolfe house on Catalina Island (1928), called the "house on tiptoe," because instead of adding to the hill mass it gives an effect of hovering over it, greatly increas-ing the sense of airiness that characterizes this summer home, with its superb sea-edge setting. Another early construction is the Pueblo Ribera, a court group in La Jolla, which employs a new concrete construction of Schindler's own – "Slab-Cast" – articulating the concrete wall into slabs con-nected by link members. The design, at the same time, is basic for a struc-tural scheme of vertically sliding forms cast in layers. The Pueblo Ribera group is a repetition of twelve houses, actually made with one form, but grouped and turned so as to make each house an individual and give each a completely private patio in spite of the restricted lot area.

The Packard house, in Los Angeles, (1924) is built of gunite, with wells of gunite panels and frames blown against light removable form units of Schindler's "Slab-Gun" construction system. The owner in this case desired the traditional high roof, reminiscent of the houses of the Atlantic coast and of Europe. Therefore a high roof was provided by the architect, with all its dignity intact; but the "roofiness" was removed and the heavy unnecessary snow-protection elements eliminated by a new treatment of gables and by opening the roof itself to the sunny skies of the south.

Oliver House. Packard House.

The Lovell beach house at Balboa Beach (1926) is called the House on Piles – piles being, of course, indigenous to beach construction. But, in contrast to Le Corbusier's designs, this house is not a heavy body set on stilts. The piles grow upward and develop into five concrete frames, reaching to the roof and supporting all floors and walls from the top.

Schindler has built many houses on hill slopes, and all of these follow one of three possible schemes. There is the house moving up from the slope (as the Van Patten home, 1936); the house moving down with the slope (the Walker house); and the house standing horizontally out from the slope (the Wilson residence). In his apartment houses (the Bubeshko apartment house, the Falk apartments, etc.) Schindler has eliminated the central long hall, which has been the pattern of almost all previous apartment buildings. Instead, the rooms open into courts, each room with windows looking into front or back gardens, a plan that does much to overcome the usual bad subdivision of lots.

The furniture in Schindler houses, also designed by the architect, is unit-furniture, low, with simple pure lines. The "Schindler Units" (1933) are so designed and constructed that they can be combined and recombined and separated variously to make up all desired units, such as sideboards, bookcases, double and single seats, tables, couches, and can be arranged and rearranged so as to follow the lines of the room and give an added effect of spaciousness. No single piece of furniture is static; the units are not symmetrical and self-centered like so many boxes forming mechanical pigeon-holes, but are designed to combine into groups, which again achieve design on a larger scale. Color schemes in Schindler houses harmonize with those of nature; background tones are always neutral, as in walls, floors, hangings; brightness and the individual desire for change is supplied by notes that can be removed or renewed at will, in flowers, cushions, perhaps an occasional strong primitive or modern painting that will not compete with the views framed by the windows.

Schindler has created a group of plans for the use of prefabricated units in small house construction, designed particularly to solve the problem of housing in working men's colonies. Only in certain parts, however, are these houses designed for prefabrication. Schindler refutes the belief held by some that the complete house should be standardized, thereby destroying the possibility for individuality. Though the plans are assembled from more or less standardized utility units as they develop from average living needs, the type of construction permits various arrangements without detracting from the savings gained through the widest reasonable use of prefabricated interior parts and equipment.

In all plans for these houses, which he calls "Schindler Shelters" (1933), each room has at least two exposures and in most cases the living room has three. Originally planned to meet California conditions, both design and construction can easily be adapted to meet any condition of location. The house enclosure itself, including floor and roof, is a shell of hollow reinforced concrete construction. There are no interior supports, rooms being formed by means of standardized wall-closet units, which include communication doors and which can be moved to satisfy the changing requirements of the owner. The structural shell is monolithic, formed by means of Garrett Construction. In 1935 Schindler developed his "Panel-Post" construction, which provides wood or plastic prefabricated units to build houses according to variable floor plans. It introduces the principle of skeleton construction into prefabrication. This makes for complete freedom in the design of individual houses and the possibility of changing the house at any time to meet requirements.

When a house is to be designed by this architect, every detail of location, slope, winds, light, view, etc., along with the client's personal ideas and desire for living, are carefully studied and digested before a line is put to paper. Even then the architect works up the preliminary plans tentatively, testing, watching reactions, solving problems practical and otherwise. Finally, somewhere along the line of experimental work, an idea crystallizes in his creative imagination and becomes the controlling and dynamic force of the design.

Schindler is convinced that the idea of space architecture differs vitally from that of many architects calling themselves modern. The Modernistic School, he believes, is the backwash of several moments of modern art in Europe, such as Cubism and Futurism. It plays with forms, expressing the present civilization with all its shortcomings, without any vision for developing a frame for the human life of the future.

The realization that architecture in its historical sculptural sense is dead has led to still another school of modern architecture – the Functionalists, who ask us to dismiss architecture as an art altogether. Born in the arid soil of militarized post-war Europe, the Functionalists want to build houses as an engineer does, producing types without any meaning other than that of

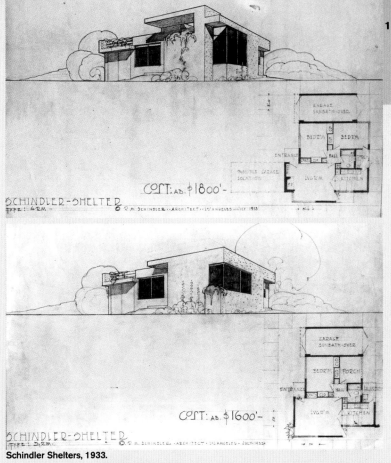

Schindler Shelters, 1933.

function. Problems of form are completely dismissed. The results are as untouched by the life-giving influences of the local, the personal, the social, as were imitations of the historical architectural styles of the past.

Schindler, the artist, whose art has been nurtured by years of thought and work and experiment, knows that modern architecture cannot be developed by accepting one-sided slogans or by adopting the ideal of the machine. Its growth is not in the hands of the engineer, the efficiency expert, the machinist or the economist. It is being born in the minds of those artists who can grasp space and space-forms as a new medium for human expression. It will be helped neither by the architect who imitates the forms of the past nor by the one who follows fashion, subject to all the inhuman features of our industrial age. It will spring from a vision of life as it may be possible in the future. And, regardless of the perfection of its mechanical functioning, the modern house will not have achieved its fullest possibilities until it also achieves that ultimate trait of personal integration – charm.

Ellen Janson

From: "An informal collection of papers to clarify my work",
R. M. Schindler, 1948

Kings Road House (Schindler House), 1921
835 N Kings Rd, West Hollywood, CA 90069
> p 124 / map 1

Floren Duplex House, 1921
West Hollywood

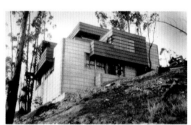

Popenoe Cabin, 1921
Coachella

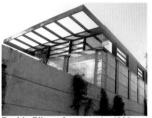

Pueblo Ribera Apartments, 1923
230 Gravilla St, La Jolla, CA 92037 > p 127

CP Lowes House, 1923
Eagle Rock

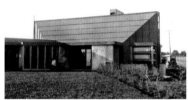

Packard House, 1924
South Pasadena

Levin House, Remodel, 1924
Los Feliz

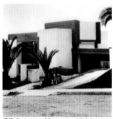

Lovell Cabin, 1924
Wrightwood

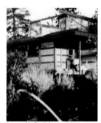

How House, 1925
2422 Silver Ridge Ave, Los Angeles, CA 90039
> p 128 / map 4

Wading Pool and Pergola for A. Barnsdall, 1925
4808 Hollywood Blvd, Los Angeles, CA 90027
> p 130 / map 4

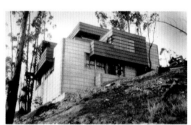

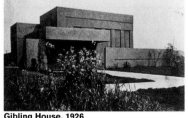

Gibling House, 1926
Westwood

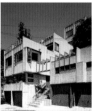

Sachs Apartments – Manola Court, 1926 (and 1940)
1809–1830 Edgecliff Dr, Los Angeles, CA 90026
> p 133 / map 4

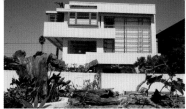

Lovell Beach House, 1926
1242 West Ocean Front, Newport Beach,
CA 92661 > p 131

Leah-Ruth Store with R. Neutra, 1927
Long Beach

Sorg House with R. Neutra, 1927
San Gabriel

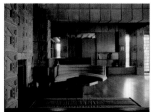

**Furnishings and Remodel of FLW
Freeman House, 1928** 1962 Glencoe Way,
Los Angeles, CA 90068 > p 134 / map 3

Wolfe Summer House, 1928
Catalina Island

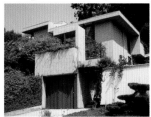

Grokowski House, 1928
816 Bonita Dr, South Pasadena 91030
> p 135

Braxton Gallery, 1928
Hollywood

Park Moderne: Cabins, 1929
Calabasses

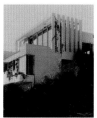

Elliot House, 1930
4237 Newdale Dr, Los Angeles, CA 90027
> p 136 / map 4

Von Koerber House, 1931
408 Via Monte D'Oro, Hollywood Riviera,
CA 90277

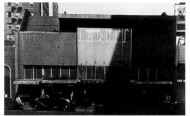

Sardi's Restaurant, 1931
Hollywood

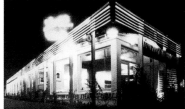

Lindy's Steak House, 1931
Los Angeles

Oliver House, 1933
2236 Micheltorena Ave, Los Angeles, CA 90039
> p 137 / map 4

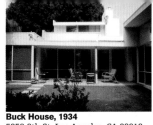

Buck House, 1934
5958 8th St, Los Angeles, CA 90019
> p 138 / map 1

Haines House, 1934
Dana Point

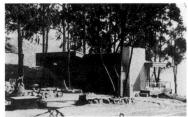

Kaun Beach House, 1934
Richmond

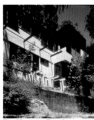

De Keyser Duplex, 1935
1911 N. Highland Ave, Los Angeles, CA 90068
> p 141 / map 3

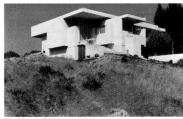

McAlmon House, 1935
2717 Waverly Dr, Los Angeles, CA 90039
> p 143 / map 4

Van Patten House, 1935
2320 Moreno Dr, Los Angeles, CA 90039
> p 140 / map 4

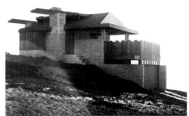

Zaczek Beach House, 1936
Playa del Rey

Walker House, 1936
2100 Kenilworth Ave, Los Angeles, CA 90039
> p 142 / map 4

Fitzpatrick House, 1936
8078 Woodrow Wilson Dr, Los Angeles,
CA 90046 > p 144 / map 3

Rodakiewicz House, 1937
9121 Alto Cedro Dr, Beverly Hills, CA 90210

Bennati Cabin, 1937
Lake Arrowhead

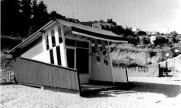

Rose Beach Colony, 1937
Prototypical Unit

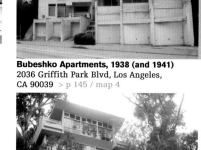

Bubeshko Apartments, 1938 (and 1941)
2036 Griffith Park Blvd, Los Angeles,
CA 90039 > p 145 / map 4

Modern Creators Shops, 1938
West Hollywood
> p 148

Wilson House, 1938
2090 Redcliff St, Los Angeles, CA 90039
> p 146 / map 4

Wolff House, 1938
4000 Sunnyslope Ave, Sherman Oaks, CA 91423

Southall House and Studio, 1938
1855 Park Dr, Los Angeles, CA 90026

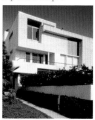

Yates Studio, 1938–1947
1735 Micheltorrena St, Los Angeles, CA 90026
> p 151 / map 4

Westby House, 1939
1805 Maltman Ave, Los Angeles, CA 90026
map 4

Mackey Apartments, 1939
1137 S Cochran Ave, Los Angeles, CA 90019
> p 150 / map 1

Falk Apartments, 1939
1810 Lucille St and 3631–3635 Carnation St,
Los Angeles, CA 90026 > p 147 / map 4

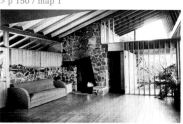

Van Dekker House, 1940
19950 Collier St, Woodland Hills, CA 91364

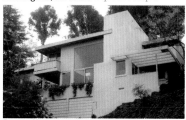

Droste House, 1940
2025 Kenilworth Ave, Los Angeles, CA 90039
> p 152 / map 4

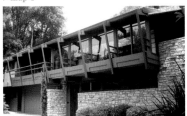

Goodwin House, 1940
3807 Reklaw Dr, Studio City, CA 91604
> map 3

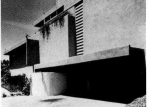

Hiler House and Studio, 1941
West Hollywood

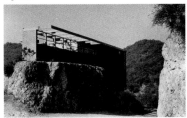

Rodriguez House, 1942
1845 Niodrara Dr, Glendale, CA 91208
> p 153

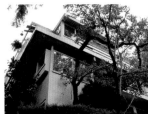

Druckman House, 1942
2764 Outpost Dr, Los Angeles, CA 90068
> map 3

Harris House, 1942
Los Angeles

Bethlehem Baptist Church, 1944
4900 Compton Ave, Los Angeles, CA 90011
> p 154

Roth House, 1945
3634 Buena Park Dr, Studio City, CA 91604
> map 3

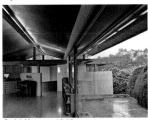

Gold House, 1945
3758 Reklaw Dr, Studio City, CA 91604
> map 3

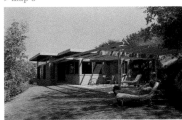

Presburger House, 1945
4255 Agnes Ave, Studio City, CA 91604
> map 3

Daugherty House, 1946
Encino

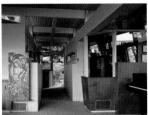

Kallis House, 1946
3580 Multiview Dr, Los Angeles, CA 90068
> p 156 / map 3

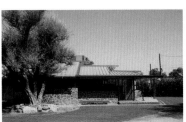

Toole Desert House, 1948
44–870 Cabrillo Ave, Palm Desert, CA 92260
> p 158

Lechner House, 1948
11600 Amanda Dr, Studio City, CA 91604
> map 3

Laurelwood Apartments, 1949
11837 Laurelwood Dr, Studio City, CA 91604
> p 157 / map 3

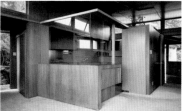

Armon House, 1949
470 Canyon Vista Dr, Los Angeles, CA 90065

Janson House, 1949
8704 Skyline Dr, Los Angeles, CA 90046
> p 159

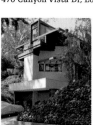

Tischler House, 1950
175 Greenfield Ave, Los Angeles, CA 90049
> p 160 / map 2

Ries House, 1950
140 Miller Dr, West Hollywood, CA 90069

Tucker House, 1950
8010 Fareholm Dr, Los Angeles, CA 90046
> map 3

Gordon House, Remodel, 1950
6853 Pacific View Dr, Los Angeles, CA 90068
> map 3

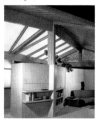

Erlik House, 1952
1757 N Curson Ave, Los Angeles, CA 90046
> map 3

Skolnik House, 1952
2567 Glendower Ave, Los Angeles, CA 90027

Note: projects listed without address have
disappeared or have been altered beyond
recognition.

Schlessinger House, 1952
1901 Myra Ave, Los Angeles, CA 90027
> map 4

Good News and Bad News

It has been ten years since the last edition of the Schindler Guide was published. During the last decade, the work of Rudolph M. Schindler has been the subject of a lot of attention. New publications and monographs have helped to clarify the architect's unique contribution to the history of modern architecture. The exhibition "The architecture of R. M. Schindler" at the Museum of Contemporary Art in Los Angeles in 2001 (that traveled to the MAK in Vienna) presented a large selection of drawings and photographs from the Schindler archives and an overview of his work.

This long overdue reevaluation of Schindler's work also had some positive consequences on the preservation of his work. Some houses that ten years ago were in poor condition, or had been damaged by the Northridge earthquake, have been renovated with the help of architects committed to the preservation of Schindler's architecture. Among those fortunate houses are the Grokowski, the Elliot, the Walker, the Fitzpatrick, the Droste, the Gold, the Wolfe, and the Yates Studio.

Other houses have simply remained in good condition thanks to the care of their owners. One of the great discoveries of these restorations is the architect's original color scheme. Schindler rarely painted his houses white. On the contrary, he chose brown, grey and green tones to "organically" blend the building with the site. This unusual color palette significantly changes the reading of the work.

Unfortunately some houses have also disappeared. During the last decade, two important houses have been demolished. The Packard House, built in 1924 in South Pasadena, was an important example of Schindler's early work. The house had an unusual typology, a Y-shaped plan, as a result of the triangular geometry of its lot. It exemplified the architect's on-going experimentation with concrete (using "gunnite," an industrial technique of sprayed-on concrete). Here, one could feel Schindler's tribute to Frank Lloyd Wright and, perhaps more profoundly, to the work of the early modernist California architect Bernard Maybeck. The last time I visited the Packard House was in the early '90s. The original design had been altered, the concrete walls painted white, but the tall gable roof, which gave the house its awkward shape, had survived. The house was inhabited by some students

**Wolfe House,
demolished 2001.**

who were unaware of the importance of the building they lived in. But the
Y-shaped plan with its central kitchen seemed to perfectly fit their relaxed
communal way of life.

The second great loss of this decade is the destruction in 2001 of the Wolfe
House in 2001, built on Catalina Island in 1928. Although the house was in
poor condition, structurally unsafe, and merely abandoned, it had not been
significantly altered since its construction and could have been restored.
For those who made the trip to Catalina Island, the memories of seeing the
house standing high on the hillside, delicately stepping down the steep
slope almost without touching it, the sensibility in the articulation of its
volumes, the ingenuity of its interior layout, the playfulness of its built-in

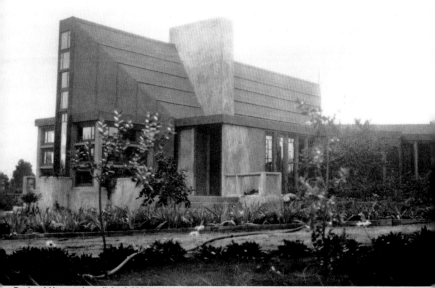

Packard House, demolished 2001.

furniture and the discovery of a ramp (unique in Schindler's work) leading to the roof terrace where one could enjoy a panoramic view over the bay and the ocean, have been moments of intense architectural emotions. The Wolfe House was Schindler's most-published house during the 1930s, a symbol of "space architecture." These savage destructions remind us that architectural and historical values are often secondary concerns when confronted with land value and real estate opportunities.

We should also mention here the current complex restoration of Frank Lloyd Wright's Freeman House, through the efforts of the University of Southern California and supported by a grant from the Getty. The house was badly damaged in the Northridge earthquake. Structural retrofitting is completed and the restoration of the textile block is currently being done with the help of USC students. The restoration of the house will include the preservation of Schindler's built-in furniture in Harriet and Harry's bedroom on the lower level, but at the time of this publication, the destiny of Schindler's furniture in the living room is less clear. It would be a shame to remove Schindler's sofas, table and bookshelves, which were designed to fit the relaxed social life of this intellectual couple. We deeply hope that they will remain as a testimony to Schindler's ability to both play with the architecture of Frank Lloyd Wright and speak his own language.

Last, but not least, is the controversy regarding the construction of a new condominium complex on the adjacent property south of the Schindler House on Kings Road. The MAK Center has been instrumental in raising the awareness of the impact of this project on the Kings Road House and its garden and in exploring alternative design solutions. Schindler's houses were often the first to be built in their neighborhood, with an awareness that they would soon be surrounded by other buildings. Schindler always took great care in orienting his houses toward the views that could not be obstructed while protecting the interior spaces from the property limits and the street. At Kings Road, he surrounded the large double lot with tall bamboo, turning the garden into a large introverted and private outdoor living space. Most Schindler houses survived quite well the presence of undesirable adjacent construction. However, the scale, the height and the proximity of the planned condominium will inevitably alter the reading and the experience of the house and its garden, as well as the solar exposure (as has already happened with the condominium built on the north and east sides).

Some important houses were forgotten in the first edition of the Schindler guidebook. Among those are the Rodriguez House in Glendale (a great example of Schindler's work from the 1940s), and the Armon House located in Mount Washington (still missing in David Gebhard and Robert Winter's 5th edition of the Architectural Guide to L.A., but brought back into light by Judith Sheine's publications and monographs). This second edition of the Schindler guide gives us the opportunity to repair these mistakes.

Armon House.

For those interested in hunting for Schindler houses off the beaten track, the Toole House in Palm Desert has survived, thanks to the love and care of its current owners who have been living there for the past thirty years. Some remodeling has been done, including the enclosure of the carport and the extension of the living room facade under the roof. However, the tent-like structure with its fan-shaped plan, its overlapping roof canopies and its central fireplace, remains a fascinating example of Schindler's vision for living in the desert.

David Leclerc, architect and art critic

Kings Road House (Schindler House), 1922

835 Kings Road, West Hollywood

Front yard, 1995.

In his article *Care of the Body,* Schindler describes the house of the future: "Our rooms will descend close to the ground and the garden will become an integral part of the house. The distinction between the indoors and the out-of-doors will disappear. The walls will be few, thin and removable. All rooms will become parts of an organic unit instead of being small separate boxes with peep-holes."[1] This house, designed by Schindler as a "cooperative dwelling" for his family and their friends, the Chaces, exemplifies these principles. Its innovative typology, combined with the application of utopian ideals, was remarkably innovative at the time of its construction, and contributed to the development of a uniquely Californian residential architecture. Originally considered radical and unconventional, the house is now recognized as one of the most important buildings in modern architecture.

Located on a large city lot, 100 by 200 feet, the house is set back from the street, occupying the middle portion of the site, but extends almost to the property limits on each side. The genius of the plan is in the integration of the building and landscape. Schindler considered the entire lot as living space, divided into enclosed and open

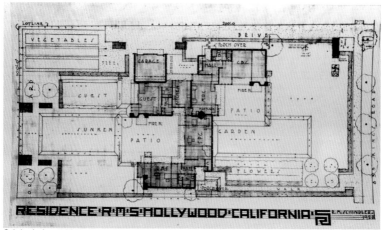

Original plan, 1921.

zones. The plan has a pinwheel configuration and is composed of four studios, a guest quarter, and a garage. Each pair of studios forms an L and opens through sliding canvas doors onto a patio used as an outdoor living room. The concrete floor and roof canopy extend two and half feet into the outdoor patio, creating a transitional zone between interior and exterior spaces that is also used also as a secondary circulation path between studios. Walls of shrubbery and bamboo extend the lines of the house into the landscape, protecting it from the street, insuring privacy to each patio, and articulating the garden into different functional zones.

When describing the architectural scheme of the house, Schindler wrote: "Each room in the house represents a variation on one structural and architectural theme. This theme fulfills the basic requirements for a camper's shelter: a protected back, an open front, a fireplace, and roof... The shape of the rooms, their relation to the patios, and their alternating roof levels create an entirely new spatial interlocking between the interior and the garden."[2] The house is on one level, with the exception of the sleeping baskets on the roof. Two different ceiling heights are used to articulate the interior spaces, creating different zones within each room and providing a space for clerestory light to enter. While each person receives a large private studio for working, relaxing or simply entertaining, each couple shares a common entrance hall, a bathroom, and a "sleeping basket" on the roof to sleep out in the open. A "utility room" containing a kitchen and laundry equipment is used by all inhabitants in common, and is located in the center of the house.

Pauline Schindler's room, 1995.

The house sits on a flat concrete slab poured directly on the ground, used both as foundation and final floor, avoiding expensive excavation for a basement. The slab was also used as the surface for the on-site prefabrication of the wall; tilt-up panels were poured on the slab and lifted up to create a solid back wall for each unit. The three-inch slot remaining in between them is filled with concrete, frosted glass or clear glass, providing three possible degrees of transparency. The rest of the structure is made of a light red-wood frame infilled with different materials: clear glass, frosted glass and Insulite, a rigid insulation board. "This house is a simple weave of a few structural materials which retain their natural color and texture throughout."[3]

Marian Chace's room, 1995.

1 R. M. Schindler, Care of the Body –
 Shelter or Playground,
 The Los Angeles Times, May 2, 1926
2 R. M. Schindler, A Cooperative Dwelling,
 T-Square, February 1932
3 R. M. Schindler, A Cooperative Dwelling,
 T-Square, February 1932

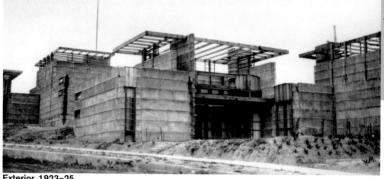

Exterior, 1923–25.

Pueblo Ribera Apartments, 1923
230 Gravilla Street, La Jolla

Schindler's interest in merging together indoor and outdoor spaces, exemplified in his own house on Kings Road, is further explored in his first multi-dwelling complex, Pueblo Ribera Court, in La Jolla. The program called for 12 individual units on a sloping site facing the ocean, which were to serve as minimal shelter for an informal ocean-side lifestyle.

Detail, 2004.

The site plan is organized so that the back wall of one unit also forms the garden enclosure for its neighbor, generating a series of private garden courts. This theme is repeated with variations throughout the scheme, creating a great variety of outdoor spaces. The site is divided by a public alley which accesses three garage buildings, while private walkways lead to the entrance of each unit. The overall feeling of the plan is organic and random, but it is the product of a highly hierarchical circulation diagram and careful space planning, making each unit as private as possible. Each U-shaped unit is made of two lateral masses framing a central living area. They open onto a private garden court, which is to be used as an outdoor living room. The roof terrace, covered with a suspended trellis, is accessed by an outdoor stair and used as a porch for living, sleeping and viewing the ocean.

The ingenuity of Schindler's space planning is reinforced by the use of innovative construction techniques. For the first time, Schindler utilized his "slab cast" wall technique. The concrete wall was cast in 16-inch horizontal bands, the wood plank formwork being moved up after each cast, leaving a thin, recessed shadow line between them. These horizontal lines match the window mullions and redwood siding to visually and proportionally unite the materials. Over the years, the project has been severely altered. Some units were destroyed by fire. Others have been remodeled beyond recognition. Only a few remain close to their original condition.

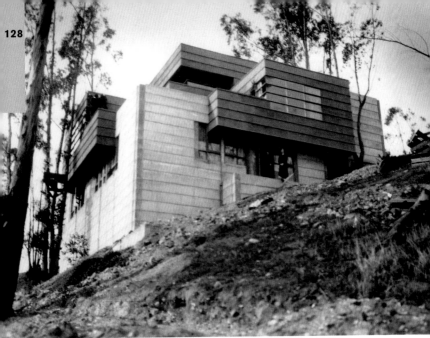

Exterior, viewed from north.

Residence for J. E. How, 1925

2422 Silver Ridge Avenue, Silverlake

The How House represents a turning point in Schindler's early work on the manipulation of space.

In this house, Schindler's interest in geometry and proportion as a generator of space is combined with a sensitive use of materials. It is located on a ridge with two opposite views – the Los Angeles River Valley to the east and Silverlake to the west. The house encounters both of these views like the bow of a boat steered toward the horizon. The steep slope of the site required a confined footprint. Therefore, the house is made of two structures: the lower portion is a square concrete base set at a 45-degree angle to the slope and built with the "slab-cast" technique used at Pueblo Ribera, while the upper portion is a light wood frame. The sleeping areas and the garage are housed in the base. The main living spaces are located in the upper level and are organized in an L-shaped plan around a corner terrace. Two wings extend beyond the base toward the street and provide the main entrances to the house.

The spatial experience of the house is intimately related to the geometry out of which it grows. The tall square volume of the living room dominates the center of the composition and opens to the two opposite outlooks through large corner windows, thus emphasizing the diagonal axis around which the plan is symmetrically organized, and visually reuniting the distant horizons that the house has interrupted by its very presence on the hilltop. The interior space is the result of a complex layering process. Schindler describes it as follows: "The arrangement of the rooms features the two outlooks which the location offered. The

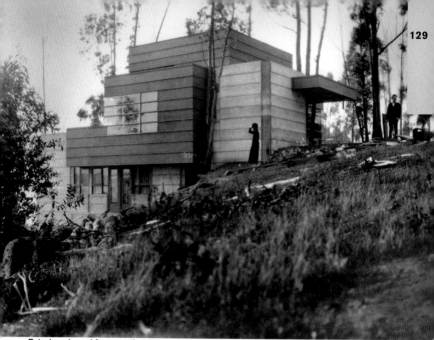

Exterior, viewed from northwest.

rooms form a series of right angle shapes placed above each other and facing alternatingly north and south. This scheme provides sufficient terraces necessary for outdoor life. The angles are further placed in such way as to frame an open shaft between them. This shaft illuminates the hall downstairs. It affords a direct view from the lowest floor to the highest ceiling of the living room, thus emphasizing the spatial unity of the structure."

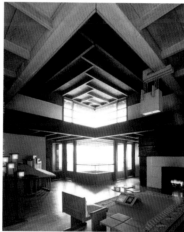

Living room.

The light wooden upper structure of the house is woven carefully into the massive concrete base, interlocking the two systems. The strong contrast between the materials is mitigated by Schindler's ability to unite them visually. The 16-inch module of the slab-cast wall matches the horizontal "drip strips" used both as a batten for the redwood siding and as a mullion for the glazing of the windows, creating a continuous pattern of horizontal lines throughout the structure. "This horizontal stratification ... is used as a contrast to the towering eucalyptus trees," Schindler said. The house has been restored and stands today as a unique example of Schindler's early work.

Wading Pool and Pergola for A. Barnsdall, 1925
Barnsdall Park, Olive Hill, at Hollywood Boulevard
and Vermont Avenue, Hollywood

In 1920, while working for Frank Lloyd Wright in Taliesin East, Schindler was sent to Los Angeles to supervise the construction of Wright's projects for Aline Barnsdall on Olive Hill (known today as Barnsdall Park). While Wright exerted a seminal influence on Schindler's architectural ideas, Schindler's influence on Wright's designs for Olive Hill is more difficult to assert. Historians have recently argued, for example, Schindler's paternity of the director's residence located at the entrance to the park. After a falling out with Wright, Aline Barnsdall commissioned Schindler, who had recently started his own practice, to work on several projects: the remodeling of a bedroom and a bathroom at the upper level of the Hollyhock House (1924/25), followed by an extensive remodeling of Residence B – originally designed by Wright as a guest house – and resided in by Barnsdall after she donated the main house to the City of Los Angeles in 1927 (Residence B was destroyed by fire in 1954).

A smaller project, the Wading Pool and Pergola, was designed in 1925 by Schindler and the young Richard Neutra, who had recently arrived in Los Angeles. It remains in very poor condition on the west side of the hill. Schindler used the left-over concrete blocks and foundation work planned for one of Wright's unbuilt projects and turned it into a small garden organized around a pergola and a wading pool, overlooking the city. The sculptural arrangement of volumes, columns and cantilevered wood beams stepped down the hillside is a moving testimony to Schindler's sensitivity to the site, and his mastery in the articulation of primary architectonic elements.

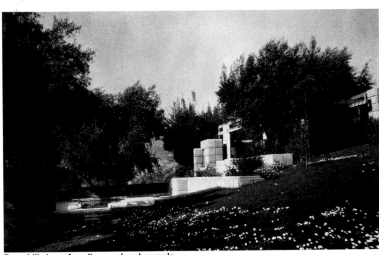

Downhill view of wading pool and pergola.

Beach House for P. Lovell, 1925–1926

1242 Ocean Avenue, Newport Beach

Exterior view towards the beach, 1947.

The Lovell Beach House, a summer residence for a well-known health practitioner, is a pivotal work in Schindler's architectural development. Its complexity results from the intertwining of several different concerns: Schindler's growing interest in site-specific structural design, his emerging vocabulary of "space forms," and his belief in architecture as a vehicle to change peoples' behavior. Based on a new and unconventional set of architectural and social ideas, the house was designed to promote the healthy and informal way of life espoused by Dr. Lovell.

Located on the Balboa Peninsula in Newport Beach, on a lot facing the beach, the house is elevated on piers to provide the living spaces with an unobstructed view of the ocean (and some privacy from the public boardwalk), but also to free the small lot for an outdoor covered living space, equipped with its own fireplace. "The motif used in elevating the house was suggested by the pile structure indigenous to all beaches", wrote Schindler. The house is organized around a two-story, large, informal room, which opens to the ocean view through a finely articulated glass facade. The second floor, cantilevering into this volume, forms a balcony leading to four individual dressing rooms and sleeping porches beyond. The roof is used as a terrace, with a portion of it partitioned off for private sun bathing. While the street facade emphasizes the sequence of the five concrete frames moving toward the

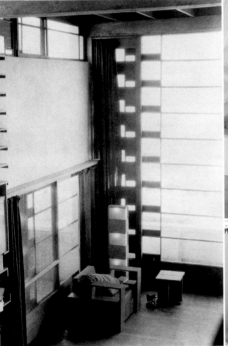
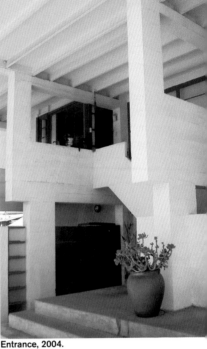

Two-story living room, 1926. Entrance, 2004.

ocean, the beach facade simply exposes the last frame, thus revealing the building's sectional idea.

For the first time, Schindler makes a clear distinction between structure and enclosure. The concrete frames were cast in place with a single re-usable form; the walls, made of metal lath and cement plaster, are non-structural and simply suspended between them. The repetition of the frames is countered by the formal versatility of the enclosure and its intense articulation.

The Lovell Beach House has been one of Schindler's most controversial projects. While historians have often insisted on the ambiguity and contradictions that characterize the project, it is now considered one of the most important buildings of the Modern Movement. Its rejection from the International Style exhibition led, more than any other event, to Schindler's marginalized status within modern architecture.

Manola Court, Apartment Building for H. Sachs, 1926–1940

1811 to 1830 Edgecliff Drive, Silverlake

Following the financial and technical problems encountered with the use of concrete in his earlier projects, Schindler was forced to abandon this modernist material in favor of the indigenous wood frame construction with stucco skin. Although Schindler had previously described this system as "an inorganic, unelastic plaster slab supported by means of an organic swelling and shrinking skeleton," it surprisingly fulfilled his prediction (stated in his 1913 manifesto written in Vienna) of an architecture no longer concerned by structure but primarily with space. The Sachs Apartments reveals a new language focused on the manipulation of volumes and a poetic use of common materials, but the most innovative aspects of this project remain its remarkable massing.

The site is a steep hillside, with a view facing west to the Hollywood Hills, bounded by streets at the top and bottom. In the first phase of the project, built between 1926 and 1928, residential units are organized along a stepped public walkway, dividing the lot down the center and connecting the two streets. At the top of the site, a U-shaped building, placed around a sunken entry court, houses larger apartments and a two-story studio. The profile of the building is kept low on the street side to match the residential scale of the surroundings, but its downhill facade is a dramatic, three-story volume, taking full advantage of the view. Below,

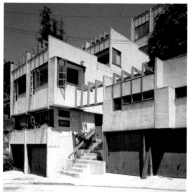

Front view, 1995.

smaller apartments built on top of parking garages are stepped down the hillside. An additional building with four apartments was added on the adjacent lot in 1939.

Schindler uses the large window openings to break down the scale of the facade. He extends the window mullions into the stucco wall, creating a pattern of vertical wood battens which connect the windows and emphasize the verticality of the facade. Vegetation was intended to grow from built-in planters, further integrating building and landscape. The Sachs Apartments reveals the possibility of providing a dense urban fabric without compromising the assets of the "American Dream": because each apartment has a separate outdoor entrance, each one seems as private as an individual home. Schindler masterfully creates a building that is both urban in its massing, yet organic in its sensitivity to its hillside site.

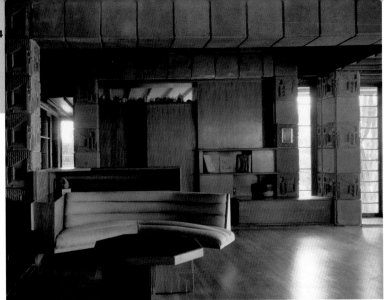

Living room, 1995.

Furnishings and remodeling of residence for S. Freeman, 1928, 1938 and 1953

1962 Glencoe Way (Hollywood Hills)

The most fascinating aspect of Schindler's remodeling of the Freeman House is the confrontation between his furniture and Frank Lloyd Wright's architecture. The overlapping of these two design languages creates a fascinating dialogue throughout the house. Following the completion of the house – and after great difficulty between Wright and his client – the Freemans hired Schindler to design furniture and to remodel the bedroom area downstairs. The stiffness of Wright's original furnishings was inappropriate for the relaxed social life of this intellectual couple. Schindler designed each piece of furniture as a specific response to its location in the house. His built-in furniture, such as the bookshelves in the northwest corner of the living room, scrupulously respect the proportional grid of Wright's textile block wall. However, when the furniture extends into the room, as is the case with the two sofas in the living room, they reiterate

Schindler's spatial ideas and formal language.

In Harriet Freeman's bedroom, Schindler designed several pieces of cabinetry. Their complex geometry contrasts strongly with Wright's architecture. On opening, the enigmatic containers unfold into the room revealing their hidden contents. The static object becomes suddenly animated – volumes pivot, panels unfold, and secret drawers slide, reminiscent of the ingenuity of the old-fashion traveling trunk. The smooth surfaces and golden color of the birch plywood enhance the dark and rough texture of the textile block. The inventiveness and formal versatility of Schindler's interventions, within the atmosphere of Wright's architecture, have the strength of a manifesto.

The house is currently under extensive renovation and is closed to the public at the time of this publication (see introduction).

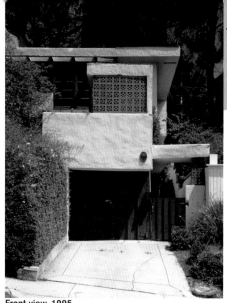

Front view, 1995.

Residence for D. Grokowski, 1928
816 Bonita Drive, South Pasadena

The modest Grokowski House represents Schindler's emerging awareness of the potential offered by a wood frame covered with a stucco "skin," and the possibility of adapting this construction system to his own spatial language.

Located on a small lot in South Pasadena, Schindler uses the sloping site to his advantage. The garage, placed between the house and the street, provides a roof terrace for the living room above. A stepped walkway, running along the side of the building, leads to the main entrance located at the back. Inside, a double-height living room is intersected by a bedroom loft space. Schindler brings his visitor directly into the vertical, double height volume and uses the intimate area below the loft for the fireplace.

The plan, almost square at the entrance level, becomes highly articulated on the second floor as rooms are allowed to project out of the confines of the box. Various roof levels articulate the interior space and bring natural light into unexpected areas. To avoid the usual leaks inherent in a flat roof, a series of gabled roofs improve water drainage, but their shallow slopes remain recessed from the facade, giving the appearance of a flat roof when viewed from the street. In addition to his rich use of natural light, Schindler continued his experiments with artificial light. By simply placing light bulbs in the spaces between the wall studs and covering them with frosted glass on both sides, he creates built-in fixtures which glow simultaneously on the inside and the outside of the house. This enhances the reversible quality of his new "skin design," in which the continuity of surfaces and finishes, from inside to the outside, has the quality of erasing the boundaries between the two.

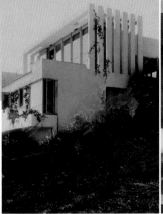

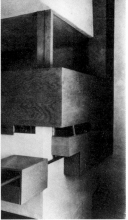

Exterior view.

Interior detail:
rear of kitchen cabinets.

Residence for R. F. Elliot, 1930

4237 Newdale Drive, Los Feliz

Although the original massing of the house was altered with the addition of a studio in front, designed by Schindler in 1939, the Elliot House remains one of Schindler's greatest hillside designs. The house, modest in size and surprisingly compact on the site, exemplifies Schindler's elaborate articulation of the enclosure.

Located on an uphill site in the foothills of Los Feliz, the house is placed near the top of the lot in order to take advantage of the view. Its orientation ignores both the street and the property lines to respond exclusively to the topography and views. The garage acts as a marker on the street to announce the presence of the house in the background. To avoid expensive excavations, the building is raised above the slope, its stepped volumes following the natural grade. By expanding the small entry hall into the living room above, Schindler introduces a two-story vertical space in the center of the house filled with natural light. By taking advantage of this vertical dimension and visually connecting the two stepped floors, he makes the small house feel much larger

than it is. The extruded section of the living area opens out onto the garden at the rear and a roof terrace over the bedrooms at the front.

Schindler is now fully aware of the formal flexibility provided by wood frame construction, shaping walls to create deep spaces for outdoor planters and built-in furniture and modulating ceiling height to differentiate areas within the space.

A unique feature of the house is its "trellis", a series of parallel bands which wrap around the living room and reappear on the garage. Schindler describes it as a "hood" to shield the living spaces from the adjacent properties. Although the house seems as though it wants to detach itself from the sloping site, Schindler envisioned that vegetation would grow over it, blending it into the planted hillside.

The house has been restored by Marmol Radziner Architects. Unfortunately it has become totally invisible from the street due to a dense landscaping.

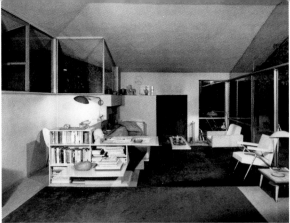
Interior view, 1959.

Residence for W. E. Oliver, 1933–1934
2236 Micheltorena Avenue, Silverlake

The ambiguous, almost hybrid, nature of the Oliver House is unique in Schindler's career. It illustrates, more than any other house, Schindler's ability to simultaneously express and resolve the tension between several contradictory design intentions. Here, "space architecture" had to meet local design requirements, such as the use of a pitched roof.

Side view.

Located in the exclusive upper terraces of the hills surrounding Silverlake, the L-shaped house is built on the hilltop, with the garage below at the street level. It is turned 45 degrees to the street to take advantage of splendid views to the ocean, the lake, and the San Gabriel Mountains. The plan appears as if it has been cut off at its extremities in order to fit within the property limits. The living area is organized in one wing, and the bedrooms are in the other. The children's quarters can be reached by an outdoor porch from the parents' bedroom. Another room was planned above the children's, but was never built. Instead, a roof terrace, accessible by an outdoor stair, provides spectacular views of the surroundings. The most unusual aspect of the house is its roof design: the street facade presents a skillfully articulated "modernist" box, seemingly covered with a flat roof, while in reality, a gable roof is fully revealed on the patio elevation and floats above the house like an umbrella. This kind of ambiguity, which would have been denounced as an anathema by the tenants of modern architecture in Europe, is used by Schindler to create an element of surprise. While the roof, viewed from the outside, seems to visually complete the flat top of the hill, its complex shape reinforces the sense of spatial continuity throughout the interior space, providing a very sculptural quality to the rooms underneath it.

Residence for J. J. Buck, 1934

5958 Eighth Street, at Genessee Avenue, Mid-Wilshire

8th street view, 1995.

The Buck House's highly-articulated volume appears alien in its urban environment – a Mid-Wilshire residential neighborhood of Los Angeles with single-family homes designed in historic styles – although it preceded most of these pastiches.

Located on a flat corner lot, the house is carefully composed to create two private outdoor living spaces protected from the street. The main residence is organized on one level, forming an L-shape around a secluded patio, while a one-bedroom rental apartment, located above a three-car garage opens onto its own private court-

yard. The skillfully articulated facade on 8th Street reveals Schindler's mastery for interlocking volumes, and creates continuity between vertical and horizontal surfaces. While windows are kept high to shield the living spaces from the street, the house fully opens onto the patio through an uninterrupted glass facade.

Inside, the complex variation of ceiling heights contrasts with the continuity of the floor slab and becomes Schindler's means to differentiate spaces. It also allows natural light to enter through clerestory windows creating a remarkable modulation of light

Garden, 1995.

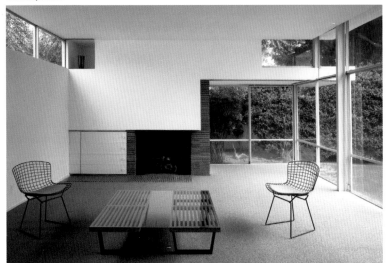

Living room, 1995.

throughout the house. The Buck House epitomizes Schindler "skin design" of the '30s; the house seems to be made of one single expanse of material which has been folded to shape enclosed space. The distinction between indoor and outdoor spaces is further erased by treating the architectural envelope like a reversible skin. The small rental apartment, which has a separate entrance from the street, is a fine example of Schindler's ability to make a space seems larger than it is.

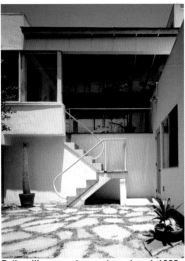

Patio with access to guest apartment, 1995.

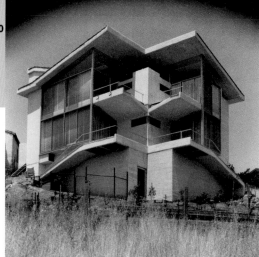

Downhill facade.

Residence for E. Van Patten, 1934–1935

2320 Moreno Drive, Silverlake

The Van Patten House is an original response to the downhill site conditions that generated so many of Schindler's great houses of the 1930s. The plan is literally the transcription of a diagram sketch by Schindler on the presentation drawings, showing the divergent views from the site towards the lake and the mountains. At the street, three attached garages, covered with an unusual overlapping shed roof, step back from one another, focusing the viewer's attention to the side, where an entrance ramp is revealed. Behind the garages, and invisible from the street, is a two-story Y-shaped house with a dramatic downhill facade embracing the view of Silverlake. The two orthogonal wings open toward the view with full-height corner glass facades, while the central axis is interrupted by a service core that blocks an undesirable view facing the house. The main living area and the master bedroom are at street level under the roof canopy, and two guest bedrooms are on the lower floor. The slope of the inverted gable roof is repeated in the balconies and the ramp, creating a dynamic downhill facade, which rises up in a counter motion. The house is once again conceived as an organism which embraces – rather than simply faces – the view, incorporating it into its internal spatial experience. It is clearly designed from the inside out. Typical of Schindler's work of this period, the house often seems an odd composition when viewed from the outside, while its logic is fully revealed on the inside. Therefore, it can only be understood through actual experience and is indeed an enriching place to live in.

Living room.

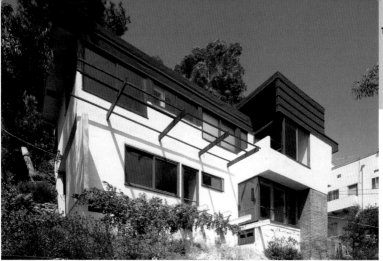

Downhill facade, 1995.

Duplex Residence for J. De Keyser, 1935

1911 Highland Avenue, Hollywood Hills

As its previous owner used to put it, it is amazing how much architecture Schindler can make out of almost nothing; the De Keyser House was built for $2.00 a square foot. Perched on a hillside on the west side of Highland Avenue, just below Frank Lloyd Wright's Freeman House, the house was originally composed of two separate apartments. To minimize foundation cost, Schindler abandons his "stepping" strategy and stacks the units on top of each other, generating a vertical volume on the slope. A shared outdoor entrance hall, located on the side of the building, provides access to each unit. The roof, covered with overlapping bands of asphalt roll roofing, is visually detached from the stucco box by windows. The same roofing material is used over some portions of the facade, suggesting that the roof has been folded over. The upper apartment is made of two interlocking volumes, one for living, the other for sleeping. Each room has direct access to an outdoor space, whether it is the rear patio, a covered deck, or a corner balcony. On entering the living room, one disco-

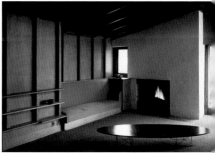

Living room.

vers that the roof, which appears flat from downhill, is in reality a sloping shed roof hidden behind a large fascia on the front elevation. Clerestory windows bathe the exposed rafters and plywood ceiling in warm, southern light. By playing with different materials and built-in furniture, Schindler transforms the interior space into a three-dimensional collage of plywood, plaster and glass.

The original color scheme of the house was derived from the natural colors of the eucalyptus found on the site: light tan of the upper layer of the bark for the stucco, brown red of the inner layer of the bark for the window trims, green of the leaves for the roofing material.

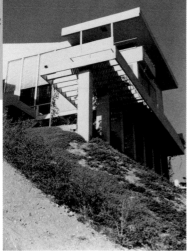

Downhill facade.

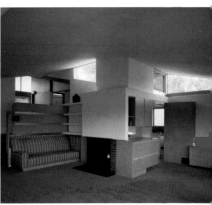

Living room.

Residence for R. G. Walker, 1935–1936

2100 Kenilworth Avenue, Silverlake

Schindler describes three different "form schemes" for the hillside houses: "balancing above the hill, cascading down with the slope, and rising up in a counter motion."[1] While the Van Patten House illustrates the third category, the Walker House exemplifies the second strategy. Typical of Schindler's downhill designs, the street elevation is kept low while the house expands to the maximum on the downhill side and takes full advantage of the view. A long clerestory window detaches the roof plane from the volumes housing the garage and the maid's quarters on the street side. Shielded behind them, the main living area, organized around a core formed by the fireplace and the kitchen, is fully open onto the view; the bedrooms and a playroom occupy the lower level.

The location of the stairs along a large window on the side facade makes one constantly aware of living on a steep slope. This feeling is reinforced by the sloping ceiling of the living room and its complex geometry, which follows the topography of the hillside. The roof canopy is further lifted from the wall, allowing clerestory light into the space.

The articulated base of the building is one of its best-known features. A row of eight concrete columns elevates the volume of the house while creating a porch underneath it. The trellis, which cantilevers from this structure, expands on the side to become an overhanging balcony for one of the bedrooms. Views are framed in sensitive ways, giving each room a different relationship to the outside – some open widely onto outdoor terraces while others are intensively closed up, barely lit by clerestory light.

1 R. M. Schindler, Contribution for the Directory of Contemporary Architecture, collected by the School of Architecture, USC, 1949

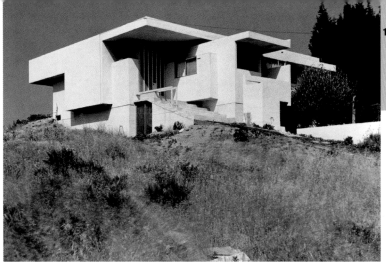

Downhill facade.

Residence for V. McAlmon, 1935

2717–2721 Waverly Drive, Silverlake

T he McAlmon House is one of the most sculptural pieces of architecture that Schindler ever produced. The intensely articulated body of the main house is set on the hilltop, like a sculpture on a pedestal, in a precarious state of balance. Rather than using a "tabula rasa" approach, Schindler takes advantage of an existing bungalow, located on the street, and remodels it as a prelude to the main house beyond. He

Living room.

wraps the existing structure in his vocabulary of space-forms, with the exception of the original pitched roof, which emerges like a reminder of a past life. The asymmetrical street facade of the bungalow focuses the viewer's attention to the side, where the walkway leading to the main house is located. A skillfully calculated distance separates the two structures. Climbing up the hill, along the side wall of the bungalow, one experiences Schindler's ability to articulate the house so that it responds to the visitor's approach; the volume of the kitchen, detached from the roof plane, projects out to reinforce the reading of an adjacent recess, which is used as an entrance porch. This counter movement, pulled-out versus pushed-in, engages the visitor with the composition while terminating the carefully controlled axis of the approach.

Once inside, the procession has come to an end, and now the goal of "space architecture" is to provide a place for human life. The interior space, subtly articulated on two different levels to differentiate day and night activities, is calm in comparison with the dramatic sequence of entry, suggesting a sense of settlement. The main living area, organized around an outdoor breakfast room, opens wide to the backyard and enjoys a magnificent view of the Los Angeles River Valley.

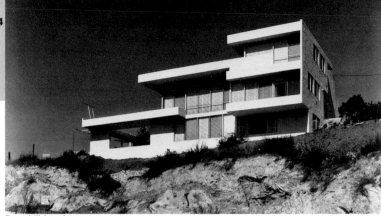

Downhill facade.

Residence for C. C. Fitzpatrick, 1936
8078 Woodrow Wilson Drive, Hollywood Hills

The house appears on the uphill side of Laurel Canyon road just before reaching Mulholland drive, behind a screen of eucalyptus trees. It was built as a real estate come-on to attract buyers to the area, which explains its high visibility from the road. The horizontal layers of stepped roof canopies and floors plates cantilevering out to protect the steel mullion glass facade from the southern sun come close to the imagery promoted by the International Style. Set on the edge of the cliff, the facade acts as an eye-catching device. It extends beyond the house itself into a free-standing wall with a large opening that protects an outdoor logia located behind it. A bridge connecting the living room to the garden forms a canopy above.

Unlike the stretched facade on Laurel Canyon, the house footprint is rather compact, as one can discover upon entering the property from Woodrow Wilson drive. The reference to International Style disappears and Schindler's subtle composition of interlocking volumes takes over. The plan is a simple L-shape. The living room enjoys tall ceilings and ample views of the canyon while offering direct access to the front garden. The rest of the house is organized in a two-story wing perpendicular to it. A lower level, which takes advantage of the slope at the edge of the property, houses a playroom and maid's quarters. This rational layout goes along with Schindler's ability to create spatial flow throughout the interior by modulating walls, openings and ceiling heights.

The house has been recently restored and has fully recovered its original beauty.

Living room.

Street facade, 2004.

Bubeshko Apartments, 1938 and 1941
2036 Griffith Park Boulevard, Silverlake

Schindler's idea of making the building an abstraction of the hillside is once again reiterated in this multi-family dwelling complex. The building is located on an uphill site in Silverlake. The lot is cut at a 45-degree angle by Griffith Park Boulevard at the bottom. A series of parallel walls defines the edge of the street and creates partitions between the garages. Several layers of thick roof canopies, stacked on top of each other, slide into the hillside like drawers. This stepping composition breaks down the scale of the building and integrates it into the hillside, while providing each unit with a large private roof terrace on top of the apartment below. Schindler's "pancake" strategy is clearly visible on the north facade, where each spatial layer is detached from the one below by a continuous row of windows or simply differentiated by cantilevering out. Stepped walkways running along the property lines are protected by these overhanging roof canopies, allowing access to the apartments on either side. Each unit has its own outdoor entrance porch, making them as private as individual homes. Living rooms open onto roof terraces and the outside of the

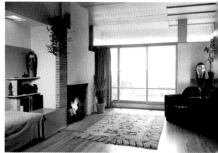
Living room.

lot, while bedrooms and service areas are mainly organized along a central alley.

Inside, the rooms are highly articulated with elaborate built-in furniture. By using different finishing materials, Schindler emphasizes the continuity between vertical and horizontal planes; plain sheets of plywood alternate with a ribbed pattern of board and batten, plastered walls, and glass, thus transforming the room into a three-dimensional collage.

The building is rational and efficient in its organization, without being monotonous or repetitive. On the contrary, the diversity of exterior spaces and interior treatments gives each unit its own identity.

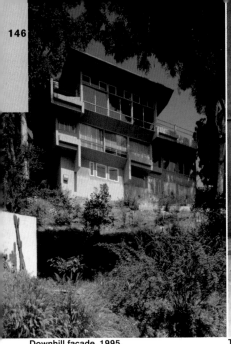

Downhill facade, 1995.

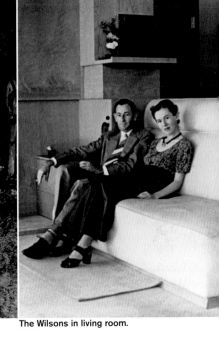

The Wilsons in living room.

Residence for G. C. Wilson, 1935–1938

2090 Redcliff Street, Silverlake

The Wilson House is located on a downhill lot with a magnificent view of Silverlake. The garage acts as a buffer along the street and remains parallel to the curb, while the house, attached to the back of the garage, turns at an angle to get the best views of the lake. The house is entered at its highest level. Living areas are located at the street level, while bedrooms and private rooms are located further down the slope.

The dramatic three-story downhill facade was originally symmetrical (before several remodelings by Schindler) and rested on a base which extended on the north side, providing a terrace for the lower level. This rather unusual symmetrical condition is transformed by Schindler's manipulation of the section: each floor projects out above the lower one, creating a triple cantilevered facade which culminates

with a dynamic tapered roof plane, suggesting a sense of motion toward the view. The roof canopy, in the shape of a butterfly, allows clerestory light to enter from above the garage into the dining room. The living room was originally flanked on both sides by small symmetrical balconies, like saddle bags (the one on the north side is now a large terrace). The stairs act as a pivot between the garage and the house, and generate a complex sequence of hallways and landings which play against the double orientation of the plan.

As in many other houses, the richness of the interior space is further enhanced by Schindler's ability to draw the outdoor world in.

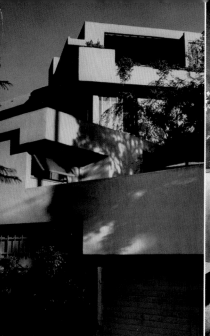

Street facade. Living room.

Falk Apartments, 1939–1940

3631 Carnation Avenue, Silverlake

The Falk Apartments are a striking example of Schindler's ability to create four interlocking living units on a difficult site, without compromising any of the principles developed in his single-family houses. The triangular shape of the lot, located on a hillside overlooking Hollywood, generated the complex massing of the project. Playing with an overlay of two grids, Schindler creates a composition of volumes which twist and turn to take full advantage of the view. He further uses the garages to articulate the corner of the street, shielding the four apartments, and provides each unit with a private roof terrace. A small courtyard, accessed from the street by narrow passages, forms the intersection of these volumes. From this void the spatial complexity of the project can be fully experienced. The building is urban in that it respects the alignment of the street, and organic in that it re-creates the hillside in a highly sculptural manner.

The penthouse offers magnificent views over its surroundings. Housed under a heavy roof canopy, covered on the inside with a pattern of interlocking sheets of plywood, the main living area extends out at its two extremities onto two opposite outdoor spaces: a roof terrace overlooking the cityscape at one end and a densely vegetated private patio on the opposite side. Schindler also plays with visual transparency between rooms, creating a continuous spatial flow throughout the apartment. The variety of natural light entering into the interior space progressively dissolves the reading of the enclosure.

Commercial Buildings for William Lingenbrink
Modern Creators, 1936–1938 and 1946

Corner of Holloway Drive and Palm Avenue, West Hollywood
Stores on Ventura Boulevard, 1939–1942 (now called
Coldwater Curve Shops)
12634 to 12670 Ventura Boulevard, Studio City

Schindler designed and built a number of stores, offices and restaurants throughout his career. His most important commercial comissions, located in Hollywood, have been destroyed – the Sardi's Restaurant and Lindy's Steak House, both of 1932–1934. Very few examples of Schindler's commercial architecture remain today in Los Angeles. Two complexes of stores designed for a developer and friend, William Lingenbrink, have sustained severe damage from successive remodelings, but their spirit is nonetheless alive.

At the Modern Creators, Schindler respects the original lot subdivision and breaks down the complex into smaller buildings, each with its own identity, thereby acknowledging the typical urban landscape along commercial strips. The same principles found in his residential projects apply to this commercial building – roofs are lifted and detached from the wall, clerestory windows bring natural light to areas that usually remain dark, display windows become volumes of glass projected out and angled to catch the driver's or pedestrian's attention. Special care is given to make signage and lighting an integral part of the architecture. Schindler's ideas of "space architecture" are here adapted to commercial use.

The Lingenbrink Shops on Ventura Boulevard are Schindler's interpretation of the now common typology of the "mini-mall." Rather than making all of the stores into one single building, Schindler designed each one as a variation on a theme. Visibility for each shop is heightened by staggering the facade. Flat roofs fold vertically to generate a series of blank walls, perpendicular to the street, for signage display, thus giving the building its jagged skyline. Three materials – flagstone, stucco, and glass – create a continuous pattern of interlocking forms throughout the store's facades, unifying the overall complex. Schindler, once again, reveals in this project his interest in reflecting the diversity and heterogeneity of the urban landscape in his architecture.

Modern Creators Storefront.

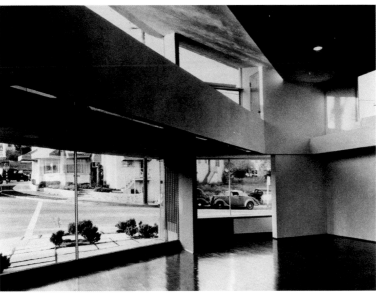

Store interior.

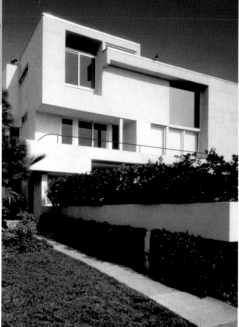

Living room, penthouse apartment.

Street facade, 1995.

Mackey Apartments, 1939
1137 South Cochran Avenue, Los Angeles

The Mackey Apartment Building is an interesting example of Schindler's ability to transform the most common typology of apartment building found in the Los Angeles area and adapt it with his own spatial language.

The building is located on a flat lot in a typical residential neighborhood of Los Angeles. Like all the other apartment buildings on this street, it has a front yard and a driveway on the side, which accesses a garage court located in back. This layout, imposed by zoning, proscribes any private outdoor living spaces around the building. Schindler reclaims the front yard by creating two small private gardens for the ground floor units. A fence is created out of a low stucco band, lifted off the ground, used in combination with high shrubbery, to insure privacy from the street. The building is compact, but nonetheless, highly articulated.

The coexistence of four living units is expressed by interlocking "space forms" on the facade. Schindler further utilizes deep walls and recessed windows to break with the typical flat stucco facade, creating a dynamic and asymmetrical composition with strong volumetric presence.

While the apartments are almost symmetrical on the ground floor, the introduction of a two-story volume for the owner's penthouse above dramatically changes the spatial organization of the upper floor and allows rear access to a roof terrace. Inside the apartments, partition walls are visually separated from the ceiling with glass panels, providing visual transparency among the rooms. In typical Schindler fashion, the roof is lowered in the center of the building to allow natural light to enter into the most removed interior areas through clerestory windows, thereby avoiding dark corners.

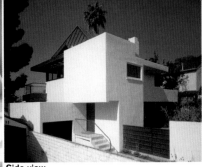

Side view.

Second floor space.

Yates Studio 1938–1947
1735 Micheltorena Street, Silverlake

I n 1938, Peter Yates – a music critic for Entenza's Arts and Architecture magazine – and his wife, Francis Mullen – a concert pianist – wanted to create a studio space to perform the music of modern composers such as Bartok, Ives, Busoni, and Schönberg. They originally thought to put the studio behind their small two-bedroom bungalow but Schindler convinced them to place the space on top of the house itself to take advantage of the panoramic view from Downtown to the Hollywood Hills. The concert series were thus entitled "Evenings on the Roof" and continued in this space until 1954 (after which they moved to the LA County Museum of Art and became the "Monday Evening Concerts" that continue to this day). Locating the main stair volume on the south corner of the house above the entry walkway, Schindler was able to create a rich sequential experience for concert visitors with an extreme economy of means. The large abstract stair volume compressed the visitors as they entered, while simultaneously giving the small house a larger presence on Micheltorena Street. Once inside, the visitors entered a vestibule enveloped by green stained plywood cascading down the stairs from the studio above. The visitors ascended the darkened stairs, arriving at the large performance space flooded with light and volume. The front elevation is important in the further development of Schindler's vocabulary. Here, the white abstract forms common in his earlier work are now treated more like fragments, asymmetrically balanced against both the wood siding of the existing bungalow and the inventive use of composition roofing material as exterior siding for the second story bathroom.

Amy Murphy, University of Southern California School of Architecture

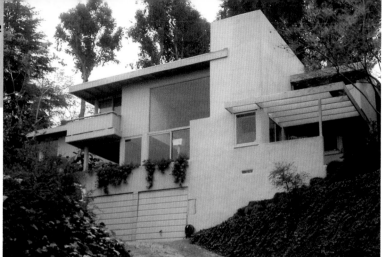

Street facade, 2004.

Residence for G. Droste, 1940

2035 Kenilworth Avenue, Silverlake

Schindler's projects from the '40s become increasingly subjective and more difficult to read from the exterior. The Droste House is clearly a transitional design that introduces his post-war period.

The house is located on an uphill lot with a view over Silverlake, at a sharp bend in the street. The difficult access to the site forced Schindler to dedicate the area in front of the house to parking and to raise the living spaces above. The house is composed of two volumes organized parallel to the slope. The front is a three-story high volume that houses a two-car garage at its bottom with a two-story living room on top. The living room opens laterally onto a terrace entrance on one side and a patio on the other. The rest of the house is organized into a one-story volume attached to the back of the living room at its upper level. Although the separation of the living area on two different floors is a rather unusual layout for Schindler, he managed to create a spatial interplay between them – the dining room becomes a loft space overlooking the living room below.

The massiveness of the front contrasts with the modest and generic aspect of the rear elevation. A gable roof which remains, as usual, invisible from the street, is used to reinforce the spatial continuity between the two volumes. Schindler adjusts the slope of the roof to introduce clerestory windows, bringing natural light to a dark corner or to frame some elements of the landscape outside. For example, a small triangular opening placed under the gable end provides a glimpse of the eucalyptus trees up the hill.

Living room.

Front facade, 2004.

Rodriguez House, 1940–1942

1845 Niodrara Drive, Glendale

The house sits on a large sloping lot and is surrounded by lush vegetation. Similar to the Oliver House, the L-shaped plan is turned at a 45-degree angle to the street and the property limits. This optimizes solar orientation and views while allowing the house to "embrace" the garden. The architect plays here with two opposite tectonic languages – exposed stone walls (which are in reality veneered stone over wood studs) create a base upon which wood framed volumes are resting. Schindler took advantage of the slope to organize the living spaces on the upper floor, while providing a direct access from the living room to the backyard through a porch. The bedroom wing bridges over a passageway that connects front and back garden. On entering the house, a stair comes up directly in the middle of the living area, leading the visitor toward the view of the rear garden. A complex set of built-in furniture wraps around the stair shaft and articulates the transition between the living room and the dining room. Unlike the "skin design" from the '30s, Schindler is now interested

Balcony, 2004.

in exposing structural members. In the living area, he extends the exposed rafters of the sloped roof and turns them at a right angle to connect them back to the beams supporting the floor below. This series of frame protruding outside suggests a rotated volume. As in the later Kallis House, Schindler plays with different roof heights and inclinations to introduce a continuous row of clerestory windows throughout the house that provides double exposure to all rooms.

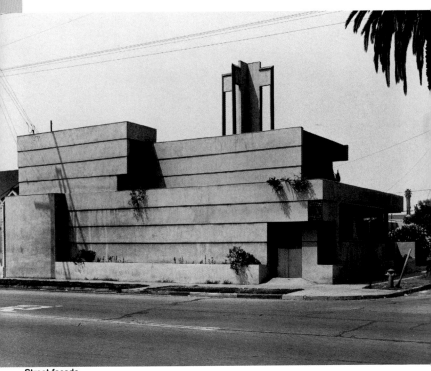

Street facade.

Bethlehem Baptist Church, 1944

4900 South Compton Avenue, at 49th Street,
South Central Los Angeles

The Bethlehem Baptist Church is Schindler's only public building still standing and his sole church design. Located in South Central Los Angeles, on a corner lot, the L-shaped church defines the street edge along Compton Avenue and shields the lot behind it. A covered walkway connects the church's rear facade to a secondary building located at the rear of the property, while creating an edge around a patio used for outdoor social gathering. The roof terrace of the rear building was to be used for an open air theater with an outdoor stage.

Driving on Compton Avenue, the only identification of the building as a place of worship is a tower in the shape of a cross, which rises out of a skylight, hovering above the congregation. An exterior pattern of wide horizontal bands of stucco, repeated inside the church, conveys the impression that the building is covered

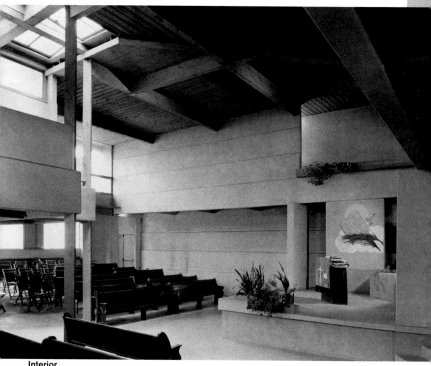

Interior.

with oversized lap board siding, providing a monumental scale to this rather small church. This motif is also used to articulate several layers of facade, creating a "deep wall" that allows natural light to enter laterally into the interior space.

The L-shaped plan is organized to focus the congregation's attention on the corner, where the pulpit is located. Its diagonally symmetrical layout (recalling the How House designed twenty years earlier) is reinforced by the exposed timber structure of the roof and the light penetrating from the skylight. While the facade on Compton Avenue closes off the church to protect it from the heavy traffic, giving the building its "bunker" look, the radiant composition of the rear facade embraces the outdoor patio and invites the public to enter inside.

Residence and Studio for M. Kallis, 1946

3580 Multiview Drive, Hollywood Hills

Downhill facade, 1995.

Set on a north-facing downhill lot with a view over Studio City and the San Fernando Valley, the Kallis House is nestled into the hillside, its shape closely following the contour of the site. It was originally composed of two structures: a painter's studio with an independent small, two-bedroom apartment beneath it and a one-bedroom residence. These buildings were linked by a terrace built around existing oak trees. From there, the view of the valley was framed by two massive stone fireplaces. The terrace has since been enclosed, unfortunately joining the two structures, but in a manner sympathetic to the architecture of the house.

The drive-through garage acts as a signal along the road while protect-ing the house located below. The linear plan, composed of parallel bands with differentiated roofs, is constantly changing in section; in the bedroom area, the outer roofs slope inward, while the central corridor – designed as a gallery for the owners' collection of paintings and objects – is raised to allow light to enter from above. In the living room, the ceiling becomes horizontal to create a larger volume, while the sloping roof remains on the uphill side to maintain clerestory light in the room. On the downhill side, the distinction between walls and ceilings tends to disappear; the tilted facade folds to become roof creating a rotated volume; on the uphill side the roof projects over the wall to protect clerestory windows from the southern light. The facades were once covered with large overlapping plywood boards, giving the house the feeling of a hull. Parts of the downhill facade are wrapped with "split stake fencing," revealing Schindler's interest in using new "off-the-shelf" industrial material. This irregular and rugged material makes the house appear as though it has been camouflaged to blend into the hillside.

Interior toward kitchen.

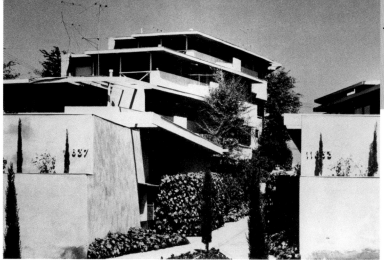

Street facade.

Laurelwood Apartments, 1946–1949

11833–11837 Laurelwood Drive, Studio City

Schindler's post-war work is often understated, and sometimes simply blends into the generic urban landscape of Los Angeles. The Laurelwood Apartments in Studio City could easily be taken for a standard apartment building of that period, if a closer look did not reveal Schindler's ingenuity in organizing twenty units on a narrow lot, making each of them as private as a house.

Interior.

From the street, the complex is hardly visible; a series of stepped terraces covered with dense vegetation forms an artificial hillside which blends into the residential neighborhood. Enclosed garage courts act as a buffer between the building and the street while forming a gateway to the central alley. Ten two-story units with an apartment on each floor are organized into two symmetrical rows separated by a central garden court. A staggered layout provides each unit with good views and multiple orientations. The layout is inverted on the hilltop so that the last two units can benefit from opposite views of the valley. Following the principle applied to his earlier hillside apartment buildings, Schindler steps the units upward to follow the natural slope of the site. Ground floor units have private patios, while second floor apartments each have a terrace on the roof of the adjacent unit. Outdoor staircases and private entrances allow each tenant the feeling of living in their own house. Primarily oriented toward the outside of the lot, the small, two bedroom apartments exemplify Schindler's ability to make a space feel bigger than it is, by using glass partitions to provide visual transparency between rooms. The ceiling and the part of the wall above the door header are covered with stained wood, in order to minimize the cost of painting between tenants.

Exterior view, 2004.					Living room, 2004.

Residence for M. E. Toole, 1946–1948
44–870 Cabrillo Avenue, Palm Desert

As early as 1922, Schindler built a small cabin in Coachella, a desert town South of Indio, applying the principles of "space architecture" to the desert landscape and climate. Unlike Richard Neutra, who had several opportunities to build in Palm Springs, or Albert Frey, who dedicated his life to the desert landscape, Schindler had to wait until 1946 to build again in the Mojave Desert. Today, the Toole House is surrounded by a suburban environment of Spanish-style real estate, gated communities and golf courses. But back in the 1940s, Palm Desert was just a field of bushes, cacti and rocks.

The house is located in the middle of the lot, originally accessible by a drive-through carport used as a terrace above. The fan-shaped plan is closed on the street side by stone walls to protect the living spaces from the driveway and the access road. The building's apparent symmetrical footprint, reinforced by the roof composition, is challenged by the interior spatial layout. On entering, one discovers a complex arrangement of partitions and built-in furniture that wraps around the fireplace, creating an organic composition of volumes and spaces under the layered roof canopies. This spatial flow makes this modest one-bedroom house feel much larger than it is.

The living spaces are "shaded by an ample but lightly poised roof reminiscent of a giant leaf" according to the architect's description. Once again, Schindler goes back to his recurrent theme of a house as both a cave and a tent. Stone walls, assembled in opus incertum with light-color mortar to create a "panther's skin" pattern, anchor the house to the ground and establish a strong feeling of enclosure and protection. By contrast, the light wood frame and tent-like structure of the roof, detached from the walls by clerestory windows, suggest a fragile and ephemeral settlement. The roof design was probably in response to the client's penchant for oriental aesthetic.

The house underwent several remodelings (the carport has been enclosed, the living room extended into the original covered porch) and a garage was built on the adjacent lot. Nonetheless, most of its original beauty has been preserved.

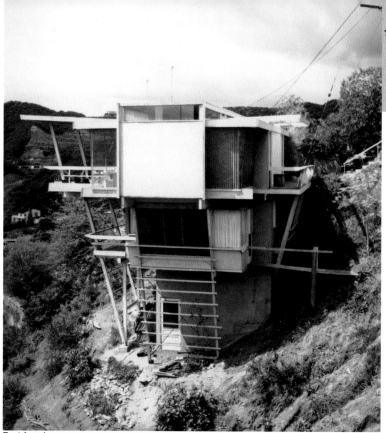

East facade.

Residence for E. Janson, 1948–1949

8704 Skyline Drive, Hollywood Hills

Schindler never came closer than the Janson House to illustrating a recurring theme of his hillside designs – that of a tree house. The steepness of the site forced Schindler to abandon his usual strategy of stepping the volumes of the house down the slope in favor of stacking them on top of each other. The footprint of the building is therefore kept as small as possible to minimize the cost of the foundation, and the volumes are allowed to project over each other, giving the house the odd volumetry of an inverted pyramid. Schindler exploits the contrast between stucco volumes and exposed wood timber. Decks and trellises cantilever out to provide ample outdoor living space. Angled wood supports, designed like huge ladders, connect these suspended platforms together. All of these elements appear to be the product of ad-hoc design. Building materials and components remain in an "as-found" state, applied to, rather than absorbed into the house, creating an unusual collage aesthetic. The incompleteness and instability of the overall composition give the viewer the impression that the building "just happened" and is still under construction. Unfortunately, this also had the disadvantage of inspiring the subsequent owner to "complete" the design, enclosing and extending most of the terraces and trellises, enlarging the house beyond its original, tree house-on-stilts appearance.

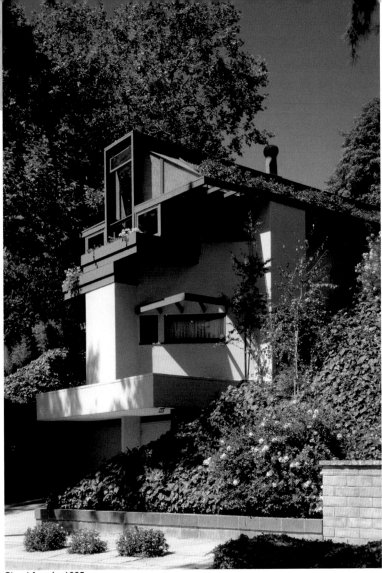

Street facade, 1995.

Residence for A. Tischler, 1949–1950
175 Greenfield Avenue, Los Angeles

With the Tischler House, Schindler returns to his dream of a translucent house, originally conceived in his unrealized scheme for Aline Barnsdall in 1927. Viewed from the street, the house resembles the bow of a ship protruding from the trees. The vertical, highly sculptural street facade acts as a frontispiece, behind which the horizontal volume of the house is extended. The symmetry of the front elevation is broken by a complex orchestration of differentiated windows, which are wrapped around the volume of the living room, subtly controlling the view.

In order to negotiate a very steep slope and avoid expensive excavations, the main house is elevated to form a bridge. While supported at the rear on the natural grade, the longitudinal volume of the house,

Interior views, 2004.

positioned along the edge of the lot, rests at the street front on a "pier" composed of a two-car garage with a small separate apartment stacked on top of it. As exemplified by many of his houses from the 1940s, Schindler uses the roof as a device to unify the plan and provide spatial continuity between rooms. The steep gable roof is sheathed in blue corrugated fiberglass panels, forming a big tent, under which the living spaces are freely organized. Partition walls remain at door height, with upper portions of glass, so that one can see through the overall volume simultaneously, without obstruction. While located in a dense residential neighborhood, the feeling inside the house is that of floating in the trees in complete privacy and isolation.

Unfortunately, the fiberglass panels used for the roof were the source of numerous leaks, unbearable heat, and an unattractive blue light flooding the interior space. Today, the upper two thirds of the panels have been doubled with plywood on the inside. The house has the distinction of being one of few Schindler houses that are still inhabited by their original owners. It was declared a historic cultural monument by the City of Los Angeles in 1991.

TRAVELING SCHINDLER – A SELF-GUIDED TOUR

Reagan Kelly: Star Walk, 2004

Traveling Schindler

1920 at the time Schindler arrived in Los Angeles, the city had just reached the one million mark. The agricultural wealth of the 19th century, combined with oil findings, the establishment of the movie industry, and the invention and proliferation of the automobile at the beginning of the 20th century, put L.A. on the path of steady growth that is continuing today.

During Schindler's lifetime, the valleys transformed from orchards into sprawling developments, movie colonies took over the hills and beaches, and freeways replaced railways. In that time of radical transformation of landscape and culture, the basic appeal of Los Angeles remained alive: "space, climate, light and mood" – identified by Schindler in his quest for architecture and particularly suited to Southern California, with its slight seasonal variations, its plentiful but diffused sunlight, its subtle colorings of atmosphere and its possibility of almost year-long outdoor living.

Dozens of houses created between 1922 and 1952 are the result of Schindler's ongoing exploration. All of them are truly individual, built on a moderate budget, yet experimenting with new materials and techniques, thus challenging common practices and ultimately the traditional mores of the day.

Reacting against the hodgepodge of arbitrary historic styles dominating L.A.'s vernacular architecture and distancing himself from what he called the one-dimensional, thus self-limiting International Style, Schindler led a lifelong argument for the modern dwelling as "a quiet, flexible background for a harmonious life."

"**Modern architecture can not be developed by changing slogans. It is not in the hands of the engineer, the efficiency expert, the machinist or the economist. It is developing in the minds of the artists who can grasp 'space' and 'space forms' as a new medium to serve as a vehicle for human expression. [] It's not merely the birth of a new style, or a new vision of the old play with sculptural forms, but the subjection of the new medium to serve as a vehicle for human expression – simulating and fulfilling the urge for growth and extension of our own selves.**"
RM Schindler Space Architecture, Dune Forum 1934

However, the notion and importance of style is integral to the surface of Los Angeles. For better and for worse, the energy of the city embraces a light-hearted gait inviting imagination and fluidity. Then and now, it creates fertile ground for new artistic movements from the case study program to gangsta rap and continues to attract artists and thinkers from around the world. Style serves as the vehicle not only to define but also to bridge the differences of the city's cultural and ethnic diversity.

Our self-guided day trip, the Schindler Sampler, features a selection of Schindler's most visible and well-maintained buildings while highlighting the contemporary qualities of Los Angeles. Accompanied by easy-to-follow driving directions and a set of neighborhood maps, the route gives a comprehensive cross section of his work through four decades while sampling some distinct L.A. neighborhoods.

We invite you to explore the city and to experience how the interaction of "space, climate, light and mood", elemental to Schindler's approach, renders his architecture timeless. ENJOY.

Andrea Lenardin Madden, architect

The language of design, architecture, and urbanism in Los Angeles is the language of movement. [] So, like earlier generations of English intellectuals who taught themselves Italian in order to read Dante in the original, I learned to drive in order to read Los Angeles in the original.

Reyner Banham: *Los Angeles – The Architecture of Four Ecologies*, UC Press, 1971/2001

Schindler Sampler

F rom the **Schindler House** (Map 1) heading west on Melrose Avenue, the PDC (Pacific Design Center, designed by Cesar Pelli) and Robertson Boulevard offer a blend of show-rooms, boutiques, and cafés with a local dressed-down celebrity vibe such as Le Pain Quotidien or the Urth Café. Continuing west on Santa Monica Boulevard through Beverly Hills, you pass Rodeo Drive, the highly polished, most exclusive streetscape in town featuring luxury brand flagship stores including the Prada LA Epicenter designed by Rem Koolhaas/OMA.

Turning west on Wilshire Boulevard takes you toward Westwood. The pedestrian oriented Westwood Village serves as the commercial extension of the UCLA campus. (A good food option here might be a stop at the famous local fast food chain "in and out"; the Westwood branch is designed by Kanner Architects.) Heading north past the campus, the route takes you by the **Tischler House**. Mr. Tischler, a metal artist who commissioned Schindler in the late 1940s, still lives there. See Map 2. Passing through Bel Air Estates you wind up on Coldwater Canyon headed for "the Hills" which stretch from the beach toward down-town. Once territory of the mountain lion and habitat of a large variety of indigenous fauna and flora, the area is now densely populated.

Narrow canyons connecting the city with the San Fernando Valley traverse the Hills. Along the crest runs Mulholland Drive. Named after the city's water czar William Mulholland, this road offers the most stunning views of the city on both sides. While the area has many archi-tectural gems, most of them are well camou-flaged by greenery. The **Fitzpatrick House** and the **Kallis House** are both in excellent condition

1 Schindler House, 1921
835 Kings Road, West Hollywood, CA 90069 [page 124]

 on Kings Road
→ right on Melrose Ave (west)
→ right on Robertson Blvd (north) 2 miles

← left on Santa Monica Blvd (west)
 Beverly Hills
→ right on Wilshire Blvd (west) 4 miles

 Westwood
 Westwood Memorial Park (Marilyn Monroe's grave)
 Armand Hammer Museum 6 miles

→ right on Westwood Blvd (north)
← left on LeConte Ave (west)
→ right on Gayley Ave (northwest)
 UCLA
→ right on Veteran Ave (north)
← next left on Cashmere St (west) 8 miles

→ next right on Greenfield Ave (north), on your left:

2 Tischler House, 1950
175 Greenfield Ave, Los Angeles, CA 90049 [page 160]
→ right on Sunset Blvd (east)
 Bel Air 10 miles

 Beverly Hills
← left on Beverly Dr (north)
→ merge right on to Coldwater Canyon Dr
→ sharp right on to Mulholland Dr (east)
 at Laurel Canyon Blvd look right: Fitzpatrick House
 Cross Laurel Canyon Blvd
 Hollywood Hills
→ next right on Woodrow Wilson Dr (southeast), on your right:

3 Fitzpatrick House, 1936
8078 Woodrow Wilson Dr, Los Angeles, CA 90046 [page 144]
→ backtrack to Mulholland Dr, continue east (right) 20 miles

← left on Multiview Dr
 on your right:

4 Kallis House, 1946
3580 Multiview Dr, Los Angeles, CA 90068 [page 156]
 continue down on Multiview Dr
← left on Broadlawn Dr 22 miles

→ right on Cahuenga Blvd (south)
 Universal City
 Cahuenga Pass
 Cahuenga Blvd becomes Highland Ave
 just past the Hollywood Blvd on your right, up the hill:

and therefore featured on this route. Map 3 indicates additional Schindler projects.

> One of its most common features is the haze that fractures the light, scattering it in such a way that on many days the world has almost no shadows. Really particular, almost dreamlike.
>
> Robert Irwin quoted by Lawrence Weschler, in: *Vermeer in Bosnia/"The Light of LA"*, Pantheon Books, 2004

Heading down toward Hollywood you pass the **De Keyser Duplex**, which is adjacent to Frank Lloyd Wright's **Freeman House**, that Schindler later remodeled.

Cruising on Hollywood Boulevard eastbound you pass the well-known Walk of the Stars. Lined with souvenir shops, movie theaters, restaurants and nightclubs, on Sundays it is also site of the Hollywood Farmers Market (at Ivar Street). Traversing town along the boulevards that web through the city, one can uncover its most treasured secrets. L.A. boulevards with miles of repetitive urban landscape defined by strip malls and parking lots, traffic signals and palm trees are the veins through which barrios bleed into one another; where you can find first generation Koreans speaking fluent Spanish, where pastrami sandwiches and *carne asada* are served side-by-side.

Continuing along Hollywood Boulevard east to Thai Town, try lunch at one of the numerous authentic restaurants in the neon strip malls lining the boulevard, such as Samaluong. Barnsdall Art Park, Frank Lloyd Wright's **Hollyhock House** comes up next as you are heading toward Los Feliz. The stores, cafés and restaurants on and around Vermont Avenue have an eclectic casual feel; among the well-established lunch places is Café Figaro.

Heading northeast through what is called the Franklin Hills, the **Schlessinger House**, Schindler's latest project, is at the quasi gateway to Silverlake. Bounded by Sunset and Glendale Boulevards, made up of a hip, diverse

5 De Keyser Duplex, 1935

1911 N Highland Ave, Los Angeles, CA 90068 [page 141]
above De Keyser, best viewed from the NE corner of
Franklin and Highland:

6 Freeman House, renovation by Schindler 1928, 1938

1962 Glencoe Way, Los Angeles, CA 90068 [page 134]
Hollywood
← left on Hollywood Blvd (east)
Thai Town
on your right:

7 FLW Hollyhock House –
remodel and wading pool/pergola, 1924–27

Barnsdall Park/Olive Hill, 4808 Hollywood Blvd,
Los Angeles CA 90027 [page 130]
← left on Vermont Ave
Los Feliz 26 miles
→ right on Franklin Ave (east)
just before Shakespeare Bridge, on your left:

8 Schlessinger House, 1952

1901 Myra Ave (at Franklin), Los Angeles, CA 90027
continue across the bridge
← left on Saint George St (northeast)
→ right on Rowena Avenue (east)
Silverlake 28 miles
← left on Fletcher Drive (north)
→ immediate right on Silverlake Blvd (east)
← left on India St
→ right on Silver Ridge Ave, on your left:

9 How House, 1925

2422 Silver Ridge Ave, Los Angeles, CA 90039 [page 128]
← backtrack to Silverlake Blvd left: 30 miles
→ follow Silverlake Blvd (southwest): turns right and
crosses Glendale Blvd
continue Silverlake Blvd around reservoir
Enclave of Richard Neutra projects on your left:
left on Earl Street to Neutra Place
→ right on Van Pelt Place (west)
→ right on West Silverlake Drive (northwest)
← left on Balmer Ave
← left on Kenilworth Ave
as you are turning left look up to see the Walker House
on your left in a hair needle turn:

crowd of Angelinos who interact easily with its long-standing European, Hispanic and Asian communities, Silverlake is home to the largest concentration of Schindler's projects.

The **How House**, **Droste House**, **Walker House**, **Wilson House**, **Oliver House** and the **Bubeshko Apartments** are highlights on this tour. Map 4 identifies additional Schindler projects in the area.

Now heading back west, the drive takes you through a multi-ethnic neighborhood along east Melrose, through Hancock Park, a wealthy compound around the private Wilshire Country Club, to Mid Wilshire and the last two projects featured on this tour.

The **Mackey Apartments** (Map 1), owned by the Republic of Austria, is the base of the Artists and Architects in Residence program founded by the MAK in 1994 (inquire about special tours at the MAK Center). Nearby, the **Buck House** is one of the most spacious Schindler projects and is in excellent condition.

Entering the Fairfax district, you cross the stretch of Wilshire Boulevard known as the Miracle Mile. A variety of museums, galleries, the La Brea Tar Pits and a number of landmark buildings gave this area its name. As you are closing the loop, you find a wide range of shopping opportunities, as well as a tempting selection of dinner choices at restaurants such as A.O.C.

The [third] unfortunate characteristic of the American car is due to the designer's conviction that quality and luxury are best expressed by bulk and weight. The innocent American vehicle, whose sole purpose is simple motion from point to point, bears down the road with a defiantly pro-truding, wedge-shaped glittering, grimacing tank-like mask. The European designer is much more likely to understand that lightness, elegance, and charm are the really priceless attributes of development. The present American car could lose twenty percent of its length, height and weight, and emerge much more civilized.

R. M. Schindler: *Postwar Automobiles*, in: *Architect and Engineer*, 1947

10 Droste House, 1940

2025 Kenilworth Ave, Los Angeles, CA 90039 [page 152]

 continue on Kenilworth and look up to your left:
 Wilson House. On your right:

11 Walker House, 1936

2100 Kenilworth Ave, Los Angeles, CA 90039 [page 142]

← left on Moreno Drive
← left on Redcliff St, on your left: 32 miles

12 Wilson House, 1938

2090 Redcliff St, Los Angeles, CA 90039 [page 146]

→ immediate right on Rock St
→ right on Micheltorrena St, on your right:

13 Oliver House, 1933

2236 Micheltorrena St, Los Angeles, CA 90039 [page 137]

 continue on Micheltorrena ← 180° left on Angus St (west)
← left on Griffith Park Blvd (south), on your left:

14 Bubeshko Apartments, 1938/41

2036 Griffith Park Blvd, Los Angeles, CA 90039 [page 145]

→ right on Landa St (west)
← left to Fountain Ave (west) 34 miles
← left on Virgil Ave (south)
→ right on Melrose Ave (west) 36 miles

 Paramount Studios
← left on Highland Ave (south)
 Hancock Park 40 miles

 past Olympic Blvd → merge right on Edgewood Pl
 cross La Brea, continue on Edgewood
← left on Cochran Ave (south), on your right:

15 Mackey Apartments, 1939

1137 S Cochran Ave, Los Angeles, CA 90019 [page 150]

← U-turn on Cochran Ave, continue north to 8th St
← left on 8th St (west) 42 miles

 on your left at the corner of Genesee Ave:

16 Buck House, 1934

805 S Genesee Ave, Los Angeles, CA 90019 [page 138]

 continue on 8th west
→ right on Fairfax (north)
 Miracle Mile at Wilshire
 LACMA
 Farmers Market/ The Grove 44 miles

← left on 3rd St (west)
→ right on Crescent Heights (north)
← left on Melrose Ave (west)
→ right on Kings Road (north) to return to the starting point

1 **Schindler House**
835 Kings Road

15 **Mackey Appartments**
1137 Cochran Ave

16 **Buck House**
5958 8th Street

kings road

willoughby

1

waring

crescent heights

la cienega

I first learned to love L.A. through the
work of David Hockney, in art class at
junior high school years before I ever
visited here. His early, colorful, acrylic
paintings – of pretty boys in swimming
pools and art collectors in spare Modern
houses with sprinklers watering their
generous yards – oozed a liberating sense
of space, of big summer skies, and limit-
less horizons; they spelled escape from
gray places and gray mind-sets. Then I
came here and found gems of experimen-
tal architecture that expressed the same
spirit, in buildings that carve up space
with light and soft breezes and shadows
cast by lush foliage.

Even though Hockney later withdrew
from L.A., and even though much of
the cityscape here is dross, that sense
of liberation still pulsates through
Los Angeles; it's what sustains me.

Frances Anderton, Host, DnA, KCRW

san vicente

Schindler sampler
Schindler house on the route 3
Surface street
Park land / country club

1 mile

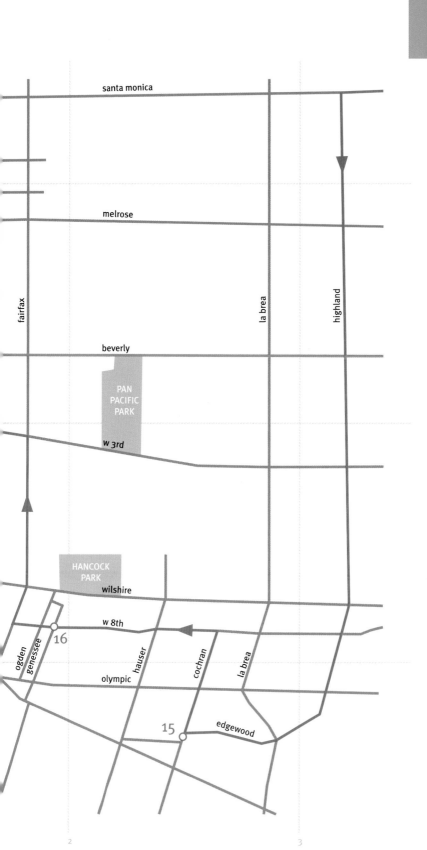

santa monica

melrose

fairfax

la brea

highland

beverly

PAN
PACIFIC
PARK

w 3rd

HANCOCK
PARK

wilshire

w 8th

16

ogden

genessee

hauser

cochran

la brea

olympic

15

edgewood

2 Tischler House
175 Greenfield Ave

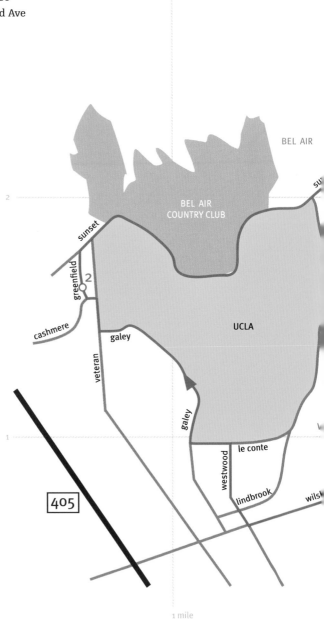

BEL AIR

BEL AIR
COUNTRY CLUB

sunset

su

greenfield

2

cashmere

galey

veteran

UCLA

galey

le conte

westwood

lindbrook

wils

405

1 mile

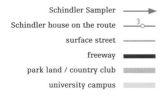

Schindler Sampler

Schindler house on the route

surface street

freeway

park land / country club

university campus

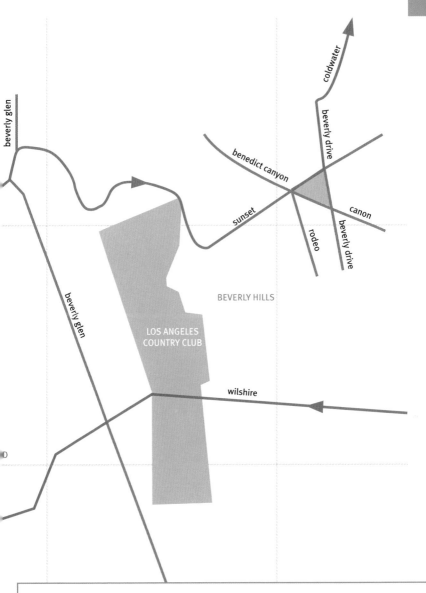

Once considered the agricultural Mecca of the country, Los Angeles lost its strawberry fields, bean rows, citrus groves, and grape vines to commerce, shelter, and freeways. Today, the farmers return to the city as modern day missionaries setting up camp in parking lots, malls, and city streets to sell the fruits of their labor in the open markets. In this rich land, no city dweller should be deprived of real food. The market is the place I find my community and my solace. A place all of us come to forage together in a miraculous meeting of urban and rural.

Teri Gelber, cook, writer, & public radio producer

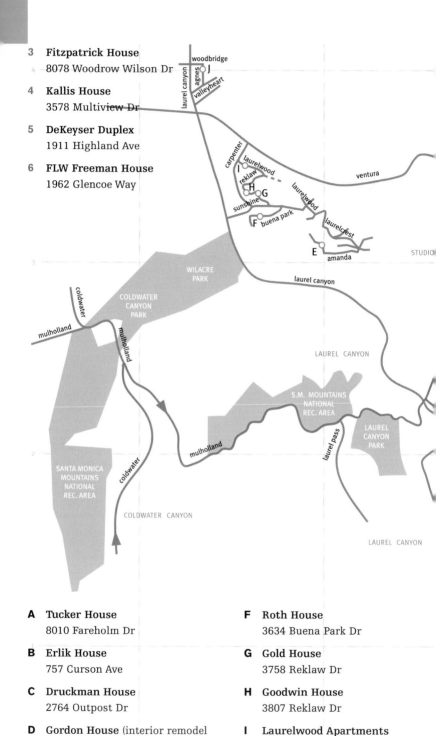

3 Fitzpatrick House
8078 Woodrow Wilson Dr

4 Kallis House
3578 Multiview Dr

5 DeKeyser Duplex
1911 Highland Ave

6 FLW Freeman House
1962 Glencoe Way

A Tucker House
8010 Fareholm Dr

B Erlik House
757 Curson Ave

C Druckman House
2764 Outpost Dr

D Gordon House (interior remodel
only) 6853 Pacific View Dr

E Lechner House
11606 Amanda Dr

F Roth House
3634 Buena Park Dr

G Gold House
3758 Reklaw Dr

H Goodwin House
3807 Reklaw Dr

I Laurelwood Apartments
11837 Laurelwood Dr

J Presburger House
4255 Agnes Ave

In contrast to the fluidity of its urban fabric, the social fabric of
Los Angeles is fragmented; it is not a single city but a collection of
micro cities defined by visible and invisible boundaries of class, race,
ethnicity, and religion.

Margaret Crawford: *Blurring the Boundaries: Public Space and Private Life;
Everyday Urbanism,* Monacelli Press, 1999

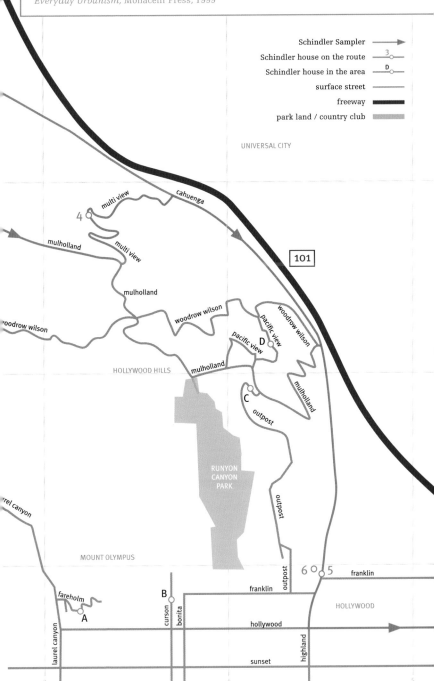

7 **FLW Hollyhock House**
4808 Hollywood Blvd

8 **Schlessinger House**
1901 Myra Ave

9 **How House**
2422 Silver Ridge Ave

10 **Droste House**
2025 Kenilworth Ave

11 **Walker House**
2100 Kenilworth Ave

12 **Wilson House**
2090 Redcliff St

13 **Oliver House**
2236 Micheltorrena St

14 **Bubeshko Apartments**
2036 Griffith Blvd

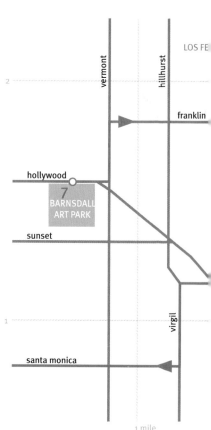

K **Elliot House**
4237 Newdale Dr

L **McAlmon House**
2717 Waverly Dr

M **Van Patten House**
2320 Moreno Dr

N **Yates Studio** (remodel)
1735 Micheltorrena St

O **Westby House**
1805 Maltman Ave

P **Sachs Apartments**
1809-1815 Edgecliffe St

Q **Falk Apartments**
1810-1830 Lucille Ave

Schindler Sampler
Schindler house on the route
Schindler house in the area
surface street
freeway
park land / country club

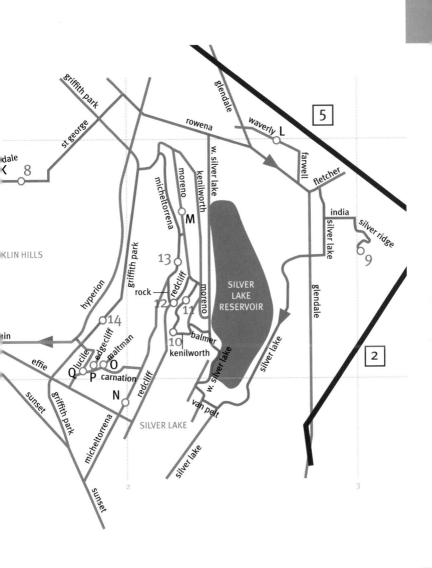

If you live in Los Angeles, you become used to having your city explained to you by others, most frequently by others who jet in for a week or two and report on the world that they find within a few miles of their Beverly Hills hotel suites. Los Angeles is a city of nets, we are told, or a city of angels, the capital of the third world, or a universe captured wholly within the whirring, oversize Rolodexes maintained by Jeffrey Katzenberg. Sometimes visitors will stumble across, say, a Cambodian neighborhood large and self-sustaining enough for a person with modest needs to spend his entire life speaking nothing but Khmer, and naively assume that nobody on the Westside or in Pasadena has experienced such a thing.

Jonathan Gold: *Counter Intelligence: Where to Eat in the Real Los Angeles,* LA Weekly Books, 2000

Magdalena Jetelová: „Domestication of a Pyramid"
(installation in the MAK Columned Main Hall), Vienna 1992

VIENNA /
LOS ANGELES

MAK BETWEEN TRADITION
AND EXPERIMENT

MAK

The MAK – Austrian Museum of Applied Arts / Contemporary Art, Vienna and the MAK Center for Art and Architecture

Following Peter Noever's appointment as director of the MAK in 1986, the Viennese institution began to redefine its exhibition and museum program. In addition to the research and scientific evaluation of the traditional collection of applied art, the MAK has made it a priority to address the art, architecture and design of today. The MAK is aimed at gradually resolving the conflict between "applied" and "fine" art, facilitating exchange between artists, philosophers, architects and scientists.

The activities in Los Angeles are an extension of the museological strategies developed within the MAK Vienna, which are focused on internationalism, experimentation, and the promotion of art and architecture. As a branch of the MAK, the MAK Center for Art and Architecture at the Schindler House is a catalyst for trend-setting activities, initiating on-going dialogues in contemporary art and architecture. The MAK Center concentrates on theoretical and communicative work, facilitating a regular exhibition program, lectures, seminars, workshops, and small selective publications. Fostering new approaches, the MAK Center also cooperates with local universities, international artists, architects and students.

Because it is sited in Los Angeles (a focal point for current trends in art and a link between the cultures of Asia, South and North America, and Europe) the MAK Center has acquired international relevance. At the same time, as an Austrian initiative aimed at exchanges of artistic activity, it has had an important retroactive effect on Austrian culture.

The cultural axis between Austria and Los Angeles has long been well established; Austrian émigrés in Los Angeles have made important contributions to the city's collection of experimental literature, architecture, theater and music. The architecture of Rudolf Schindler and Richard Neutra broke ground for generations of subsequent architects. The influential Max Reinhardt directed stage productions of Shakespeare at the Hollywood Bowl and established a theater festival in California. Arnold Schoenberg revolutionized modern music by abandoning tonality and developing a

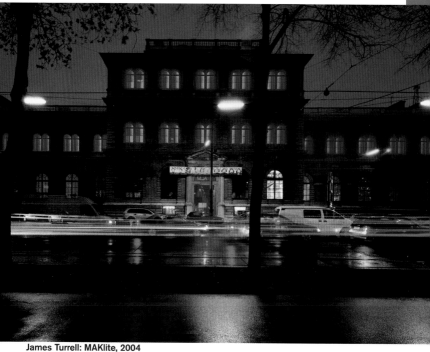

James Turrell: MAKlite, 2004
Permanent installation at the MAK facade, Stubenring 5, 1010 Vienna.

twelve-tone "serial" technique of composition. Hollywood's "Golden Age" in the 1930s and '40s is indebted to the influx of Austrian refugees that included directors Billy Wilder, Otto Preminger, Fritz Lang and Josef von Sternberg. Émigrés Salka Viertel and Jan Lustig provided the screenplays for classics such as *Queen Christina* and *The Town without Pity,* and Austrian actors include Peter Lorre, Oscar Homolke and Helene Thimig. Austrian actress Hedy Lamarr, considered during her peak to be one of the most beautiful women alive, received acclaim not only for her acting, but also for her invention, the torpedo guidance system, which preceded its time by two decades. More recently, Austria has been the provenance of actor Klaus Maria Brandauer and Arnold Schwarzenegger, who won the California recall election for Governor in 2003.

MAK permanent collection Empire Style Biedermeier
Artistic intervention by Jenny Holzer.

Artistic Interventions

The reinstallation of the MAK's permanent collection and redesign of the gallery spaces by contemporary artists was the first experiment to be realized in the course of the Museum's search for a new identity. Here, for the first time, one can sense what the notion of fruitful confrontation between traditional collections and new artistic trends signifies. A conscious decision was made not to have architects design any of the spaces. It was hoped that different new positions and viewpoints in relation to the objects in the collections would supply the objects with fresh, contemporary legibility in a way that re-educates our eyes and our perception toward the specific sensitivities and strengths of the individual materials.

Objective display is impossible in a museum; to display is at once to present, to interpret, and to evaluate. The MAK chooses to realize the viewpoints of significant contemporary artists, who reinstalled the permanent collection after intense collaboration and long discussions with the responsible curators.

The permanent collection is arranged in chronological order – not, however, with the intention of "covering" each stylistic epoch as completely as possible, but rather of introducing the Museum's highlights, its particularly interesting and unique objects. (In the study collection, on the other hand, the Museum's traditional arrangement according to materials has been preserved in a concentrated, orderly form of presentation.) Working

Vito Acconci: The City Inside Us, 1993
Opening exhibition after the renovation and reconstruction of the MAK.

with colors, special lighting installations, electronic text displays, special showcases, enclosures, pedestals, and special perceptual alienation effects, the artists found a variety of spatial solutions for their respective rooms. Particularly striking was that, while pursuing their highly personal strategies, they carried out their tasks with such a respect and understanding for the objects that it always remained unmistakable that displaying these objects was their primary motivation. One has to subject oneself to the qualities of the rooms and decide for oneself whether or not this concept has proved to be right, whether the artistic involvement adds a new dimension to contemporary interpretation, whether it actually contributes to the complexity and multiplicity to which the Museum aspires.

The artists themselves responded energetically to the unusual task, albeit with varying degrees of enthusiasm and periods of intense frustration in the process. Donald Judd, for example, ended up thinking it would have been better to install the Dubsky Chamber underground, partly because he had problems with any kind of museum installation; and Barbara Bloom committed the sacrilege of mentioning the bentwood furniture – the serial, almost minimalist variations of which she made clearly visible – in the same breath as the mass-produced furniture of IKEA. All of the rooms have been the subject of much discussion. But in fact, the Museum could not ask for anything better than to spark off a radical, critical debate about the relation of old to new, about how to bring old, traditional spaces into the present day and into correspondence with the work of contemporary artists.

Peter Noever

The History of the MAK

1863

On the 7th of March, after long efforts by Rudolf von Eitelberger and persuasion from his brother Archduke Rainer, the Emperor Franz Josef finally sanctions an Imperial and Royal Austrian Museum of Art and Industry. The building, inspired by the South Kensington Museum (known today as the Victoria and Albert Museum), was built in 1852. Rudolf von Eitelberger, the first professor for history at the University of Vienna, is appointed director. The Museum is to serve as an exemplary collection for artists, industrialists, and the public, and as a training and higher education center for designers as well as craftsmen.

1864

On the 12th of May, the museum is opened in the Hofburg's Ballhaus.

1865–1897

The magazine "Mittheilungen des k. k. Österreichischen Museums für Kunst und Industrie" is published.

1867

Founding of the School of Applied Arts where theoretical and practical training are united.

1871

After three years of construction, the new building on Stubenring is opened on the 15th of November. Built in the style of the Renaissance according to the plans of Heinrich von Ferstel, it is the first of the museums on the Ring. The objects can now be permanently displayed and grouped according to material. The School of Applied Arts also moves into the house on Stubenring.

1873

World Fair in Vienna.

1877

Opening of the new School of Applied Arts building on Stubenring 3, adjacent to the museum on the Ring. Also designed by Ferstel.

1897

Arthur von Scala, director of the k.k. Orientalisches Museum (later known as Handelsmuseum or Trade Museum), takes over as director of the Museum of

Sepp Müller: Connecting wing, 1991.

Art and Industry. Scala succeeds in getting Otto Wagner, Felician von Myrbach, Koloman Moser, Josef Hoffmann and Alfred Roller to work in his museum and at the School of Applied Arts.

1898
Archduke Rainer resigns as Protector as a result of the conflicts between Scala and the Arts and Crafts Association, founded in 1884, which sees its influence on the museum dissipating. New statutes are established.

1898–1921
A new museum magazine called "Kunst und Kunsthandwerk" is published and soon attains international renown.

1900
The administrations of the Museum and the School of Applied Arts are separated.

1907
The Museum of Art and Industry takes over a large part of the Austrian Imperial and Royal Trade Museum collection.

1909
The School of Applied Arts and the Museum are separated. After three years of construction, the extension on Weiskirchnerstrasse, planned by Ludwig Baumann, is opened.

1919
After the founding of the First Republic, the holdings previously in the possession of the Habsburgs are handed over to the Museum – e.g. oriental carpets.

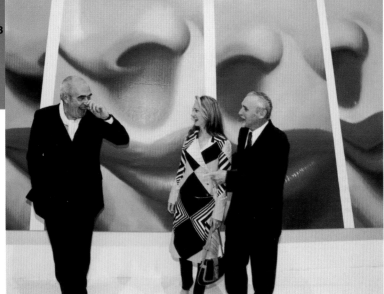

Peter Noever, Victoria and Dennis Hopper, 2001.

1936
The Museum on Stubenring gives a part of its sculpture and and antique collection to the Art History Museum. In exchange it receives the arts and crafts section of the Figdor collection as well as that of the Art History Museum.

1938
The Museum is named "State Arts and Crafts Museum in Vienna" after Austria's Anschluss with the National Socialist German Reich.

1939–1945
Stolen private collections are taken over by European museums.In this way, the collections of the "State Arts and Crafts Museum" also expand. Owing to provenance research, it has become possible since 1998 to return numerous collections.

1947
The "State Arts and Crafts Museum" now calls itself "Österreichisches Museum für angewandte Kunst" (Austrian Museum of Applied Arts).

1949
Reopening of the Museum after repair of war damage.

1955–1985
The Museum publishes the magazine "alte und moderne kunst."

1965
Geymüllerschlössel becomes a branch of the Museum.

1986
Peter Noever becomes director of the Museum.
The Collection of Contemporary Art begins.

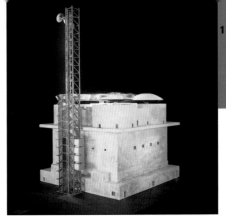

CAT – Contemporary Art Tower
A new programmatic strategy for the
presentation of contemporary art
Peter Noever, Sepp Müller, Michael
Embacher: Model, 2000.

Ilya and Emilia Kabakov: Not every-
one will be taken into the future, 2001
(installed 2002 at the MAK Depot of
Contemporary Art Gefechtsturm
Arenbergpark, Vienna).

1989

A total restoration of the old buildings and the construction of a two-story underground storage area begins. Additionally, a large depot for the collections as well as further exhibition space are built.

1993

The Museum reopens after reconstruction and redesign of the permanent exhibition rooms by artists. The building on Weiskirchnerstrasse, however, is reserved for an exhibition program. The halls on Stubenring house the permanent collection, the study collection as well as the MAK Gallery.

1994

The Arenbergpark flak tower becomes an annex of the Museum. The MAK founds the MAK Center for Art and Architecture, Los Angeles at the Pearl M. Mackey Apartments (1939) and in the Schindler House (1921/22).

2000

The Museum becomes a public scientific institution.

2001–2002

The project CAT – Contemporary Art Tower is presented in Vienna after exhibitions in New York, Los Angeles, Moscow, and Berlin.

MAK Center for Art and Architecture Los Angeles

Schindler House
835 North Kings Road
West Hollywood, CA 90069-5409
Phone: (323) 651-1510
Fax: (323) 651-2340
Email: office@makcenter.org
www.makcenter.org

Opening hours
Wednesdays through Sundays 11 a.m. to 6 p.m. Closed Mondays and Tuesdays.
Bookstore is open 7 days a week, 11 a.m. to 6 p.m.

Admission
$ 7.–, students $ 6.–, admission plus „Schindler by MAK" $ 17.–, students $16.–.
Free admission for children under 12 and for members of the "Friends of the Schindler House" as well as on Fridays 4–6 p.m.; September 10, Rudolph M. Schindler's Birthday; Annual MAK Day

Guided tours
Regular guided tours are available on weekends only.
To arrange for group tours at other times, please call (323) 651-1510.
Note: Photography of the house and its grounds is permitted during the center's open hours.

Directions
The Schindler House is located four blocks east of La Cienega and two blocks north of Melrose, on the west side of the street, behind the row of bamboo plants.

Membership
Membership in the Friends of the Schindler House (FOSH) is $45.00 per year for adults and $25.00 for students.

Mackey Apartments
1137 South Cochran Avenue
Los Angeles, CA 90019
Open to the public only during special events or by appointment, call (323) 651-1510.

Directions
The Mackey Apartments are located six blocks west of La Brea, between Olympic and San Vicente Boulevards.

MAK Governing Committee
Brigitte Böck, Harriett F. Gold, Peter Noever, Barbara Redl, Joseph Secky, Robert L. Sweeney

Director
Kimberli Meyer

MAK Center Advisory Board
Cecilia Dan, Gai Gherardi, Lari Pittman, Michael LaFetra

MAK – Austrian Museum of Applied Arts / Contemporary Art, Vienna
Stubenring 5, A-1010 Vienna, Austria
Phone: (+43-1) 711 36-0
Fax: (+43) 713 10 26
Email: office@MAK.at
www.MAK.at

Opening hours
Tues (MAK NITE©) 10 a.m.–midnight,
Wed–Sun 10 a.m.–6 p.m., closed Mon;
open on Easter Monday and Whit
Monday; December 24 and 31:
open 10 a.m.–3 p.m.
Closed: January 1, December 25.

Admission
€ 9.90 including MAK Guide, € 7.90
without MAK Guide, reduced € 4.–,
family ticket € 11.–
Free admission on October 26, for
MARS Members, children up to the age
of 6, students of the University of
Applied Arts Vienna, school classes,
MAK PARTNER, unemployed persons,
members of the World Federation
of Tourist Guide Associations

Guided tours
MAK TOURS – Sat, 11 a.m. in German;
Sun, 12 noon in Englisch, € 2.–
EXPERTS GUIDE – Tues, 7 p.m.; Sun,
3 p.m., € 2.–
MINI MAK – for children 4 years of age
and over: every third Sunday in the
month, 11 a.m. Free for children up to
the age of 12 and 1 accompanying adult
MAK4FAMILY – one Saturday every
month, 3 p.m., € 4.–
MAK SENIORS – every third Wednesday
in the month, total fee € 12.–.
Booking required.
Reservations: Gabriele Fabiankowitsch,
phone (+43-1) 711 36-298
(Mon–Fri 10 a.m.–4 p.m.),
email: education@MAK.at

Public transportation
U3 / Tram lines 1 + 2 / Stubentor
U3, U4 / Landstraße (Wien Mitte)

MAK Guide +
admission € 9.⁹⁰

EVERY TUESDAY
UNTIL MIDNIGHT ©MAK
FREE ADMISSION
ON SATURDAYS

MAK Depot of Contemporary Art Gefechtsturm Arenbergpark
Dannebergplatz/Barmherzigengasse,
A-1030 Vienna

Opening hours
May to November, every Thursday,
3 p.m.–7 p.m.

Admission
€ 4,–; free admission for holders of a
MAK admission ticket of the same day

Guided tours
May to November, every first Thursday
in the month at 5 p.m. Booking
required. Phone (+43-1) 711 36-298

Public transportation
U3 / Rochusgasse
Bus line 74A / Hintzerstraße

MAK Branch Geymüllerschlössel
– Hubert Schmalix: The Father Shows His Child The Way
– James Turrell: Skyspace "The other Horizon"
Khevenhüllerstraße 2, A-1180 Vienna
Phone (+43-1) 479 31 39

Opening hours / Guided tours
Reservations for admission and guided
tours: Gabriele Fabiankowitsch, phone:
(+43-1) 711 36-298 (Mon–Fri 10 a.m.–4
p.m.), email: education@MAK.at

Public transportation
Tram line 41 / Pötzleinsdorf
Bus line 41A / Khevenhüllerstraße

The MAK in Public Space

Franz West: Four Lemurheads
Stubenbrücke, A-1010 Vienna
U3, Tram lines 1 + 2 / Stubentor
U3, U4 / Landstraße (Wien Mitte)

Donald Judd: Stage Set
Stadtpark, A-1030 Vienna
U4 / Stadtpark
U3, U4 / Landstraße (Wien Mitte)

Philip Johnson: Wiener Trio
Schottenring, A-1030 Vienna
U2, U4, Tram lines 1, 2, 31 /
Schottenring

C.E.O. and Artistic Director
Peter Noever